LAKE GENEVA
Life at the WATER'S EDGE

LAKE GENEVA

Life at the WATER'S EDGE

presented by
MICHAEL KEEFE

with ANDRIA HAYDAY *and* TOM KEEFE

WILDWOOD
BOOKS

Concept: Michael Keefe with Tom Keefe
Project Direction: Michael Keefe

Writing and Creative Direction: Andria Hayday
Principal Photographers: Tom Keefe, Jon Janzen, Bruce Thompson
Additional Photography: Kristen Westlake, Clint Farlinger, Bill Frantz, Terry Mayer
Graphic Design and Art Direction: Alison Mackey

Copyeditor: Dori Olmesdahl
Editorial Assistance: Susan Myers, Denise Schultz, Jennifer Keefe, Mike Sarton, Helen Brandt
Photo Stylist, Architectural Interiors: Jennifer Keefe

Published by Wildwood Books in association with Michael Keefe.

WILDWOOD BOOKS
N2826 Wildwood Dr.
Lake Geneva WI 53147
 Les Krantz, Publisher

Distributed to the book trade by Independent Publishers Group.

Library of Congress Control Number: 2006927577.
First Edition.

Printed and bound in Singapore.

Visit www.lakegenevabook.com for further information.

ISBN 0977363201

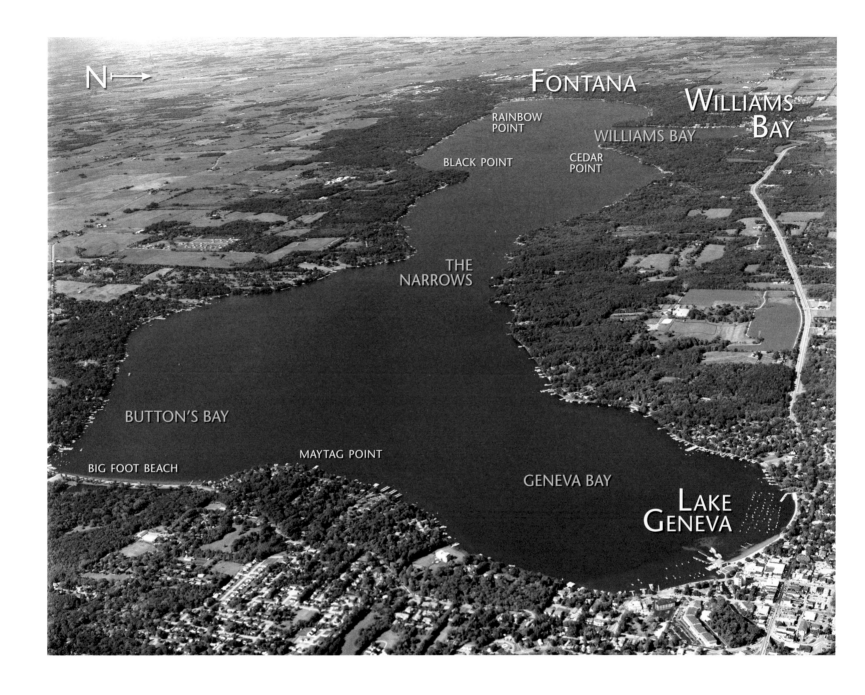

N⟶

FONTANA

WILLIAMS BAY

RAINBOW POINT

WILLIAMS BAY

BLACK POINT

CEDAR POINT

THE NARROWS

BUTTON'S BAY

MAYTAG POINT

BIG FOOT BEACH

GENEVA BAY

LAKE GENEVA

COVER PHOTO **FAMILY AND FRIENDS** enjoy dinner on the pier at the home of John Anderson.

OVERLEAF **BUILT IN THE 1980s**, Hillcroft is the north-shore home of Roger and Darlene O'Neill. Their 20-acre estate is a favorite playground for their grandson and his four-legged friend.

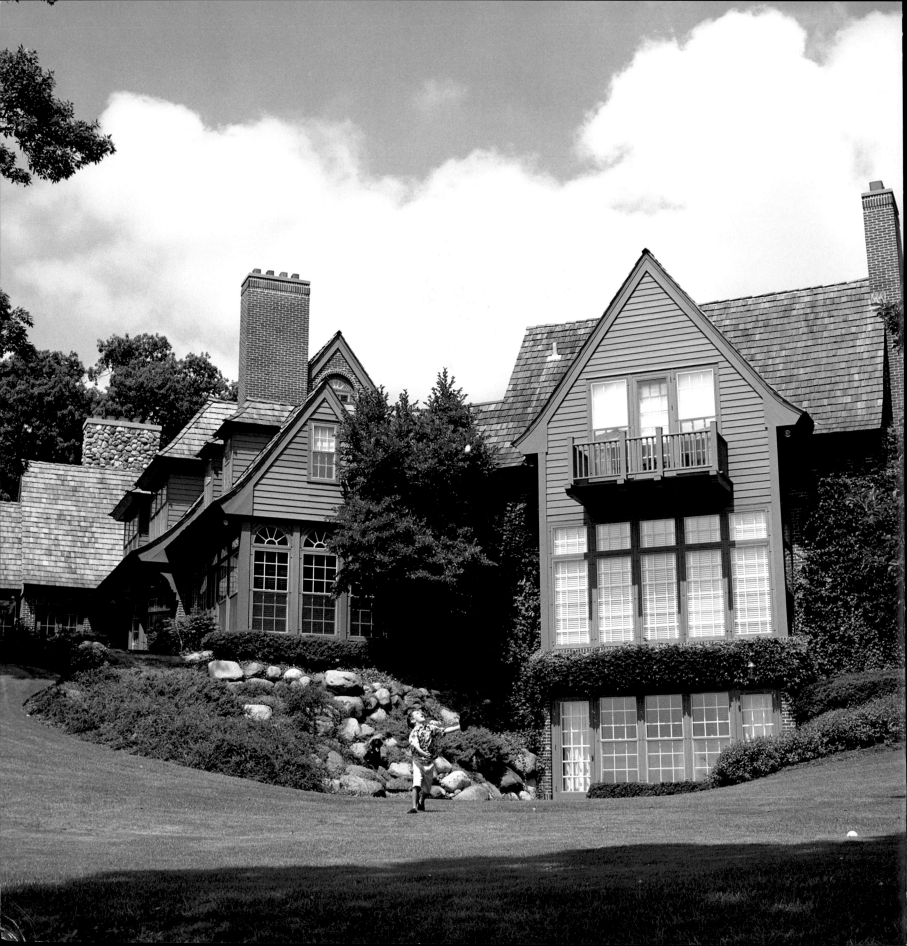

CONTENTS

Notes & Acknowledgments

TOM, MIKE, AND ANDRIA

WHEN I AM TRAVELING, I constantly run into people who know Lake Geneva. They grew up nearby, or they have visited friends here, or they have a second home here or want one. And they proceed to tell me how much it means to them. Of course, I feel the same way, because it has been my home since birth.

I find it difficult to convey the story of Lake Geneva to strangers to the area—to impart to them some sense of what it is all about, not just physically, but in every aspect, from its history to the lifestyle we enjoy here. For these reasons, and because of my personal attachment to Lake Geneva, I decided to produce this book.

When I started this project, it immediately became obvious that something like this, if done properly, takes a lot of time and effort and talent. So, I went searching for help. My first stop was to consult with Larry Larkin, who created *Grand and Glorious,* a coffee-table book on Lake Geneva boats that became a prototype for my original thinking. His assistance has been invaluable, and I thank him very much.

Les Krantz, a local book publisher, became my consultant and ultimately helped me with the printing and distribution. He also led me to Andria Hayday, a freelance writer and editor who became my creative partner and the project quarterback in both the writing and layout of the book, working with Alison Mackey, a very talented graphic designer. Thousands of photos flowed through our hands, and selecting the final shots was not easy.

Of course, a coffee-table book like this lives or dies on the quality of the photography. My goal was to feature shots that are new or never seen before, and to this end I enlisted the help of my son Tom, a professional photographer based in New York City. He and I spent the better part of a summer traveling around the lake together, cameras and tripods in hand, looking for photo ops everywhere. It's not possible to tell the complete Lake Geneva story through one season and one lens, but fortunately, the talent pool of local photographers is deep. I extend special thanks to Jon Janzen for his beautiful and expertly shot architectural photos, and to Bruce Thompson, who shared with us a treasure trove of images depicting the lake's year-round scenery and special activities such as iceboating. Other important contributors of photography include Bill Frantz, Kristen Westlake, Clint Farlinger, and Terry Mayer—without their help, the book would not have been complete.

Thanks also go to my wife and research assistant, Jennifer, who not only put up with a lot of activity and absence, but also helped us track down historical photos and propped several of the architectural interiors for photographing. Special thanks go to my executive assistant, Susan Myers, who helped keep us organized and assisted with a great deal of legwork.

Finally, I extend great thanks to the subjects of the book who opened their homes and their lives to me: You are what makes the Geneva Lake area what it is—you are its true heart and soul. The upcoming pages offer only a sampling from a very long list of beautiful homes and interesting people who kindly offered their help with the project. Had I made the book 1,000 pages long, it still would not have catalogued all the possibilities.

I have tried to present a little bit of everything—the old and the new; year-round as well as weekend residents; activities that are fast and furious, and those quiet, special moments that occur only at daybreak (much to Tom's dismay, since he was with me for all those early morning excursions). I hope you enjoy it, and I thank you for your support.

The net proceeds of this book are being donated to local charities through the Keefe Foundation.

—Mike Keefe

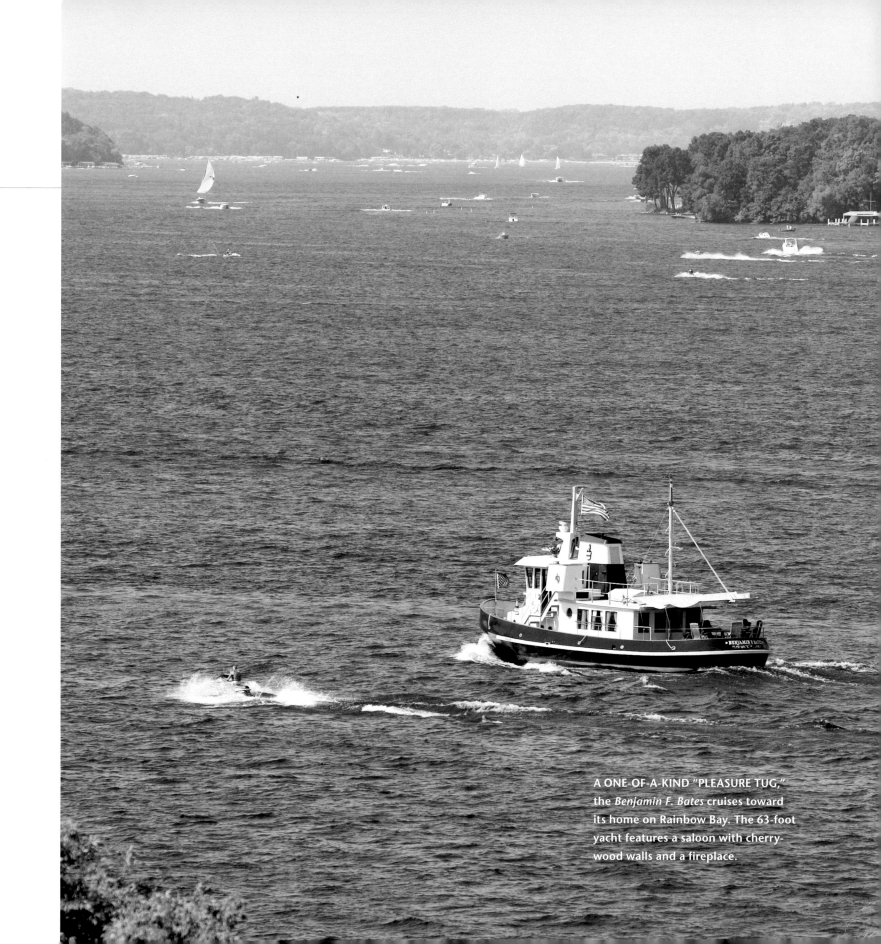

A ONE-OF-A-KIND "PLEASURE TUG," the *Benjamin F. Bates* cruises toward its home on Rainbow Bay. The 63-foot yacht features a saloon with cherry-wood walls and a fireplace.

NORTH AND SOUTH SHORES layer
together in a sunrise view across
Cedar Point.

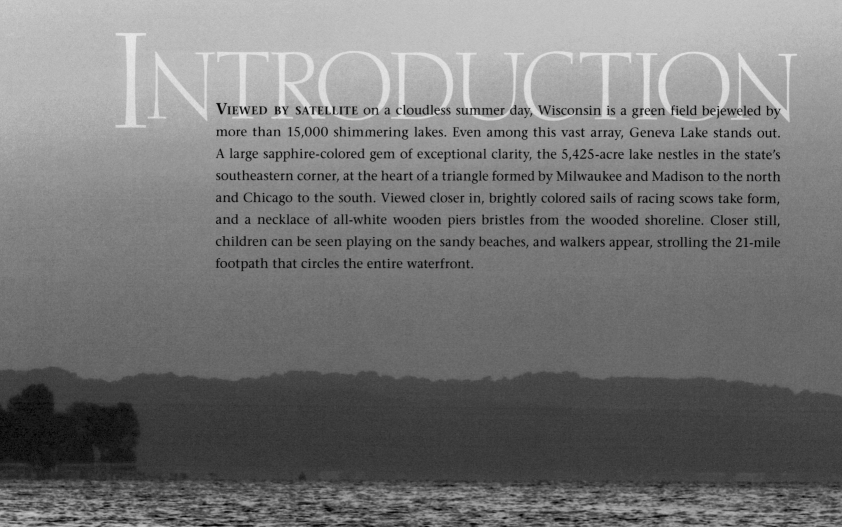

INTRODUCTION

VIEWED BY SATELLITE on a cloudless summer day, Wisconsin is a green field bejeweled by more than 15,000 shimmering lakes. Even among this vast array, Geneva Lake stands out. A large sapphire-colored gem of exceptional clarity, the 5,425-acre lake nestles in the state's southeastern corner, at the heart of a triangle formed by Milwaukee and Madison to the north and Chicago to the south. Viewed closer in, brightly colored sails of racing scows take form, and a necklace of all-white wooden piers bristles from the wooded shoreline. Closer still, children can be seen playing on the sandy beaches, and walkers appear, strolling the 21-mile footpath that circles the entire waterfront.

From the beginning of its recorded history, Geneva Lake has enchanted all who've seen it, and for those who've lingered, it has fostered a deep and abiding love. When the Potawatomi tribe who once lived here was removed to Kansas in the 1830s, their chief stood by the shore and wept. His people's sorrow was soon replaced by the joy of the vacationers and settlers who arrived in their wake. During those early years, word spread of the lake's tranquil beauty, and it became a favorite destination for Chicagoans seeking respite and rejuvenation. By the 1860s, three villages flourished on the shore, scores of campers pitched tents in the woods between them, and excursion boats cruised the lake. By the 1890s, a collection of summer mansions and grand resort-hotels ringed the shore, and the lake's reputation as a haven for Chicago's wealthiest citizens was firmly established.

Today Geneva Lake is the centerpiece of the Midwest's premier resort areas, with more than a million visitors arriving each year. Even with such popularity, the lake remains pristine—and commercial development has been carefully contained. Thanks to a covenant established in the early 1900s, most of the waterfront beyond the quaint towns is deemed "first-class residential." Early lakeshore residents were determined to preserve their way of life, so they banded together and agreed they would never allow their properties to be transformed into an endless string of bait shops, casinos, or similar enterprises.

If you ask anyone why they love Geneva Lake, they will speak first of the lake's beauty and the feeling of peace it inspires. The torrent of compliments that flows after that is as varied as the lake's devotees. For vacationing *bons vivants,* the lake represents luxury, pampering, and fun. For local residents, the setting combines small-town living with cultural opportunities that other rural areas can scarcely match.

This a world of many layers and pleasing contrasts, where black-tie charity balls are as common as street fairs. The lake is alluring in every season, but like any brilliant seductress, she plays many different roles, subtly changing to reflect the desires of her admirers. All that remains, then, is for you to discover her charms for yourself.

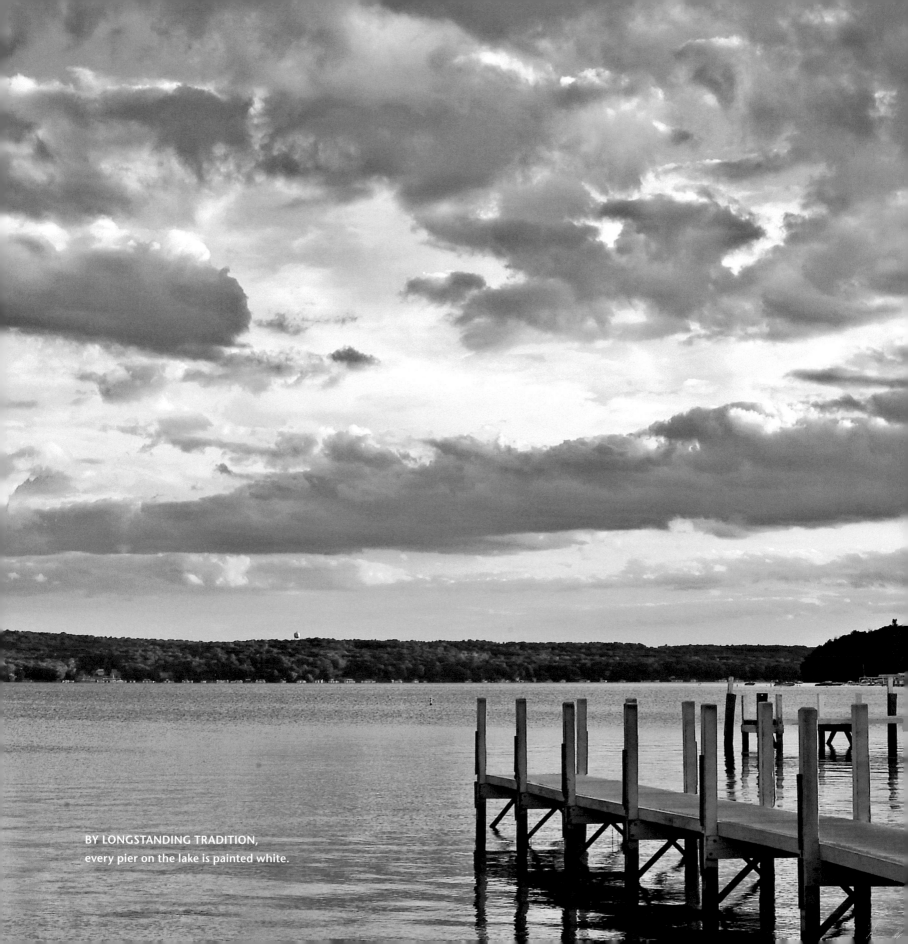

BY LONGSTANDING TRADITION,
every pier on the lake is painted white.

PART I
ECHOES OF THE PAST

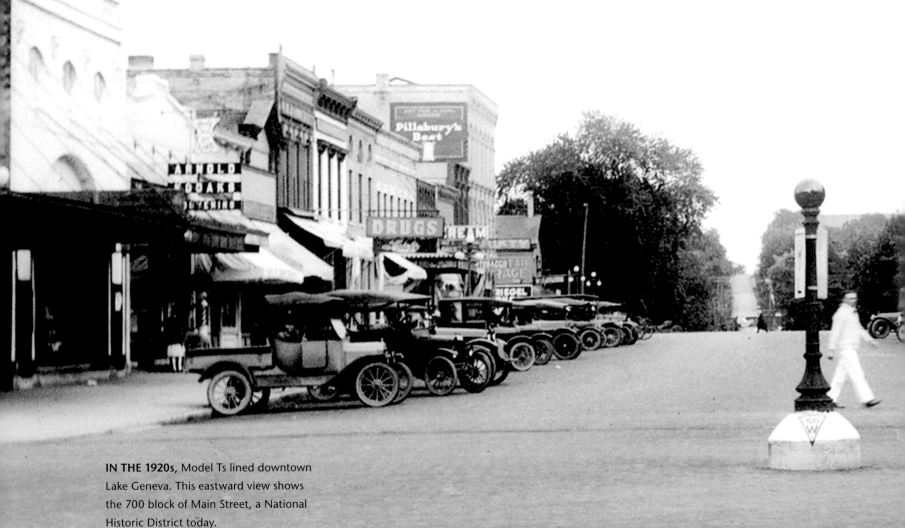

IN THE 1920s, Model Ts lined downtown
Lake Geneva. This eastward view shows
the 700 block of Main Street, a National
Historic District today.

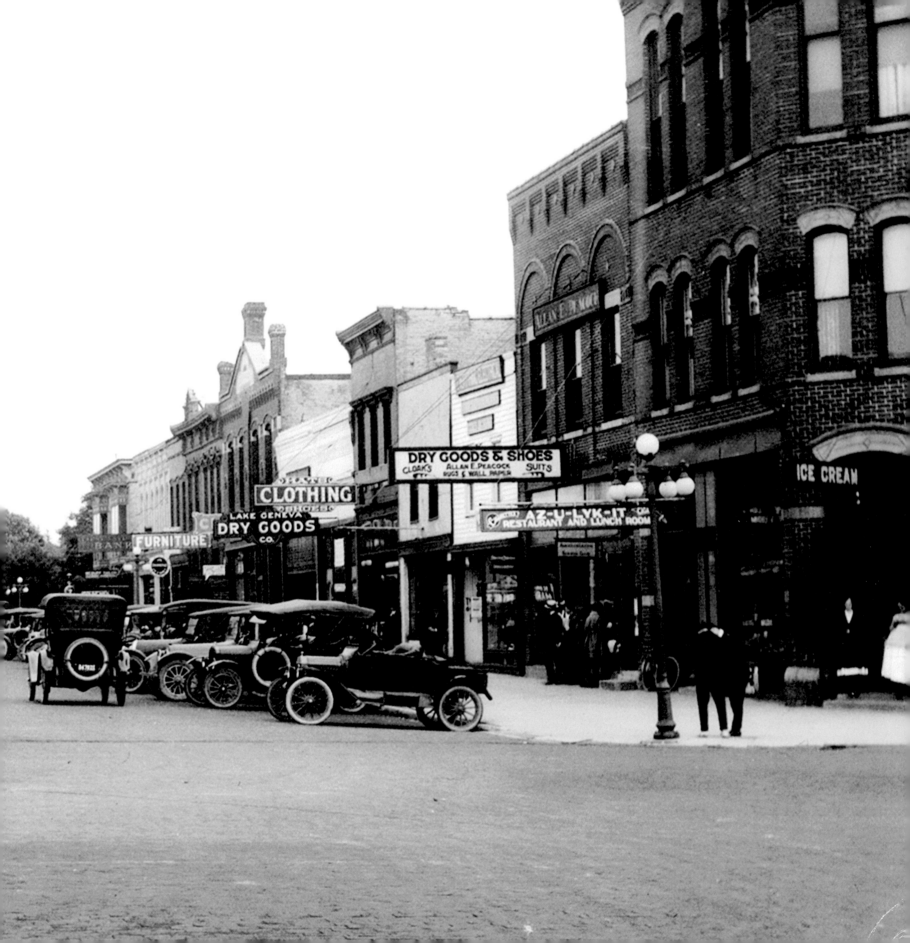

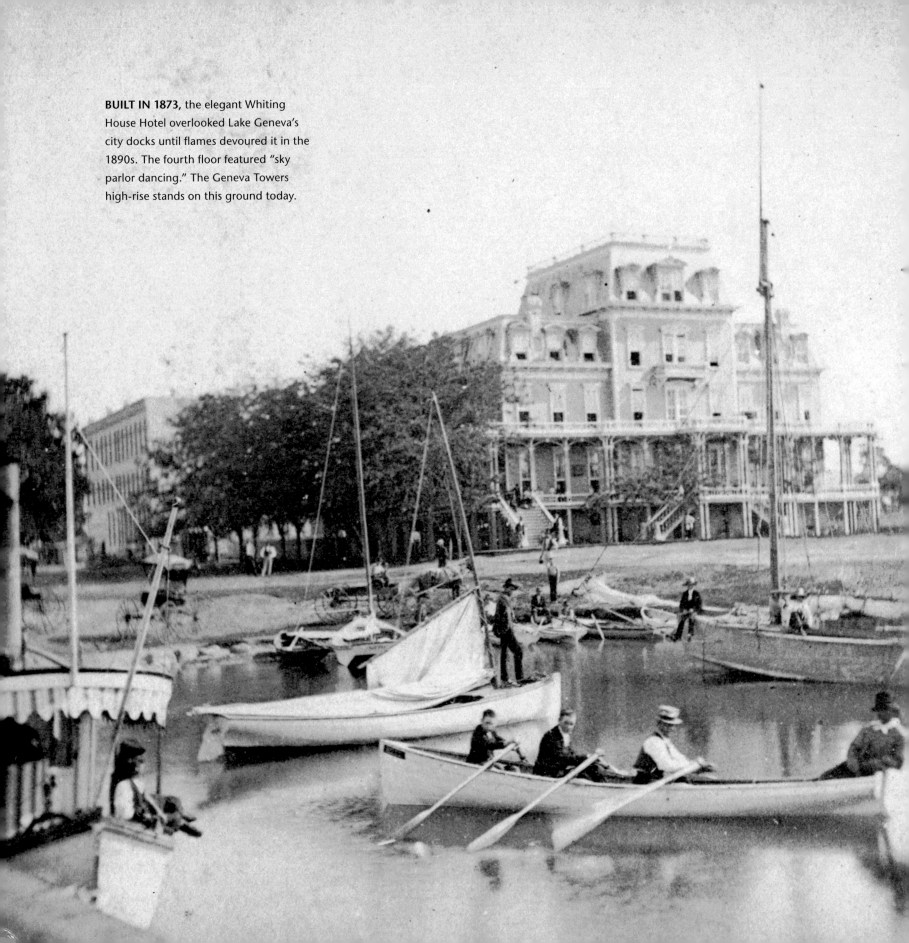

BUILT IN 1873, the elegant Whiting House Hotel overlooked Lake Geneva's city docks until flames devoured it in the 1890s. The fourth floor featured "sky parlor dancing." The Geneva Towers high-rise stands on this ground today.

BEGINNINGS

IN THE SPRING OF **1831**, 24-year-old Juliette Kinzie and her husband, Indian agent John Kinzie, made the first recorded visit by whites to Geneva Lake. Led by guides from Chicago's Fort Dearborn, their small party arrived on horseback at the westernmost shore, near what is now Fontana. Juliette later recaptured the scene in her memoir, *Wau-Bun: The Early Day in the Northwest.*

> . . . *we descended a long, sloping knoll and by sudden turn came in full view of the beautiful sheet of water. . . . Bold, swelling hills jutted forward into the clear expanse. . . . On the nearer shore stretched a bright gravelly beach through which coursed here and there a pure sparkling rivulet to join the larger sheet of water.*
>
> *On the rising ground, at the foot of one of the bluffs in the middle distance, a collection of neat wigwams formed, with their surrounding gardens, no unpleasant feature in the picture. A shout of delight burst involuntarily from the whole party as this charming landscape met our view. What could be more enchanting?*

ABOVE **POTAWATOMI VILLAGES** that once edged the lake were filled with wigwams, not teepees. The dome-shaped huts featured a skeleton of bent saplings overlaid with walls of interwoven reeds and "shingles" of stripped bark.

Through French traders, the party already knew that the lake was called *Gros-pied* (or Big Foot), after the Potawatomi chief who lived here. Unfortunately, Juliette (an adventurous but proper New Englander) did not find the old chief nearly as enchanting as his home, describing him as "rawboned," "ugly," and "sinister." In fairness, she did not find *all* the Potawatomi sinister—she was enthralled by one fetching young man in particular, openly admiring the perfect physique beneath his yellow calico shirt, as well as his copious silver jewelry and mismatched blue and scarlet leggings (she believed it was courting attire). In fact, the encounter between the two groups was quite friendly. When the Kinzies opted to camp high atop the bluffs, the Potawatomi not only toted their trunks uphill and helped

shove a wagon from behind, they also gave the travelers fresh trout for dinner.

Though the Kinzies were the first "official" whites to see the lake, it seems unlikely they were truly the first. French traders began to crisscross Wisconsin as early as the 1600s, and at least one Frenchman had visited the lake, according to historian Paul Jenkins. (Perhaps that accounts for the courtship fashions.) But until the 1830s, the lake seemed a fabled paradise—a place more often described than seen. Without a major riverway to connect it, Lake Big Foot lay well off the beaten path, and many who tried to find it failed.

A FOUNDING FISTFIGHT

THE PATH DID NOT STAY "unbeaten" for long. In 1833, another 20-something adventurer arrived: John Brink. Some historians don't mention this early visit, but his next is certain: In 1835, Brink won a government contract and returned to make an official survey. Disliking the name "Big Foot," he dubbed the lake "Geneva," after his hometown of Geneva, New York (which also has a lake nearby). Brink camped along the White River outlet at the east end, studying the river's potential for millpower. Before he left, he blazed his name and the word "claim" upon two trees.

But when Brink returned in 1836, his claim had been jumped. Earlier that year, a rugged frontiersman named Christopher Payne had built a log cabin there—the first in what is now Lake Geneva. Payne insisted that the

BELOW **FOUNDED IN** 1886, the George Williams Campus of Aurora University began as a lakefront camp where dapper members of the YMCA received training. Recreational pursuits included tennis and tree-climbing.

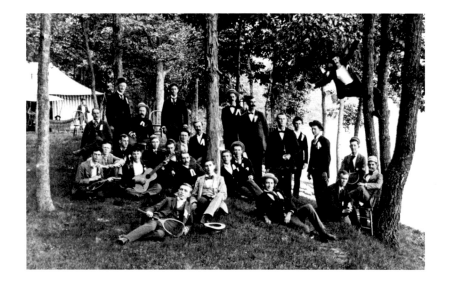

claim was poorly marked; he had never seen any blazes. Both sides gathered friends and faced off. Clashes escalated from harsh words to bloody fistfights, and one night Payne was briefly kidnapped, bullied, and dumped. After five months of strife, Payne paid Brink $2,000, and Brink relinquished his claim.

That same year, under the terms of a treaty, Chief Big Foot's entire tribe moved to Kansas. The sound of cabin-building rang out across the lake, whose shoreline was densely wreathed with lindens, black walnuts, and sugar maples. James Van Slyke and his wife settled in Fontana, and before 1836 had ended, their daughter Geneva became the first white child born at the lake. Captain Israel Williams soon arrived in Williams Bay, giving the peaceful cove its new name.

By 1840, all three settlements on the shore were growing, but none faster than Geneva village. It already boasted a mill, a blacksmith shop, two hotels, and at least one tavern. The village also had its own whiskey-making operation (Geneva Brand Whiskey). By 1847, the population had surged past 1,000. The lake became a popular destination by the 1850s, but when reliable train service finally linked Chicago to Geneva in the summer of 1871, it marked the beginning of an age of elegance, and "the Newport of the West" was born.

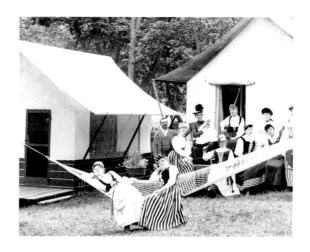

ABOVE **MORE "RESORT"** than "roughing it," private and public tent-camps were a popular way to enjoy the lake in the late 1800s. Most camps including a central dining hall. Here, a Swedish singing group lounges at Porter's Park in Fontana.

RIGHT **EXCURSION BOATS** have departed from the Lake Geneva city docks since the 1870s. This view is circa 1890.

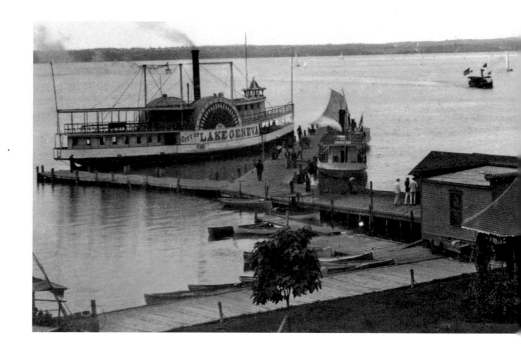

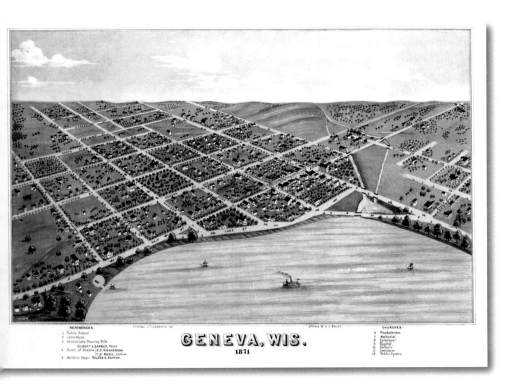

REFERENCES:
1 Public School.
2 Lake House.
3 Geneva Lake Flouring Mills.
 GILBERT & BARBER, Prop'r.
4 Bank of Geneva. E.D. RICHARDSON
 C.B. BUELL, Cashier.
5 Machine Shops. ROGERS & SCHENK.

CHICAGO LITHOGRAPH'G CO. DRAWN BY A. RUGER. BAILEY.

CHURCHES:
6 Presbyterian.
7 Methodist.
8 Episcopal.
9 Baptist.
10 Catholic.
11 Cemetery.
12 Public Square.

GENEVA, WIS.
1871

ABOVE **THE LARGEST COMMUNITY** on the lake was originally called Geneva. Its name was eventually changed to Lake Geneva at the request of the local railroad company, to avoid confusion with Geneva, Illinois. The body of water is officially "Geneva Lake," but in casual parlance, "Lake Geneva" is used for both of them.

NEWPORT OF THE WEST

THE ARRIVAL OF THE TRAIN in '71 was perfectly timed for Chicago banker Shelton Sturges, who had just completed Maple Lawn, the first major estate on the lake. Located on the east end, his summer villa featured wraparound verandas and a five-story tower. Sturges reputedly bought a pack of 500 train tickets to host his extended family and friends, which included his brother-in-law Ebenezer Buckingham. (Kate Buckingham, Ebenezer's daughter, gave Chicago its beautiful Buckingham fountain.) On many a summer's night, the family hosted concerts to benefit a local church, and gay strains of music drifted over Geneva Bay.

Then tragedy struck in Chicago: In October of 1871, Mrs. O'Leary's cow kicked over the fabled lantern, and the city was engulfed in flames. Weary of the ashes, many of its citizens took refuge on Geneva Lake. From the 1870s through the early 1900s, dozens more mansions appeared on the lakeshore, until it became a veritable Who's Who of Chicago's powerful and elite. Drake, Wacker, Wrigley (of Cubs baseball and chewing gum)—all summered on the lake (and their families still do). They were joined by such titans as Maytag, Schwinn, Chalmers (of Allis-Chalmers), Allerton (the Union Stockyards), and Braun (an oleomargarine king).

Until good roads were established in the early 1900s, reaching a lakeshore estate was an adventure in itself. The journey began by train from Chicago, often in a private car. In Geneva village, the station lay several blocks north of downtown. Elegant horse-drawn car-

riages jingled down the dirt street to the city docks, where private steam yachts awaited. It was important to hire a good captain: The ever-competitive yacht-owners liked to race on the way home.

Those glorious mansions—many of which still line the shore today—were as unique as their owners. From the lovely turrets of a Queen Anne called The Echoes to a limestone palazzo known as Stone Manor (both by architect Henry Lord Gay), the lakeshore has reflected virtually every style and taste. Levi Leiter, an early partner of Marshall Field's and a neighbor of the Sturges family, erected a six-story windmill in front of his cream-brick mansion. In lieu of a guard dog, he bought an $1,800 Jersey bull to fend off trespassers. Unfortunately, the bull could not discern friend from foe.

The area was renowned for more than its summer villas. From the late 1800s to the 1920s, Lake Geneva also became a mecca for those seeking cures of the mind and "the will." The city offered visitors their choice of four sanitariums—all of which were affiliated with Dr. Oscar A. King, a Chicago neurologist.

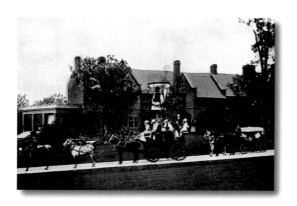

ABOVE **TO GREET GUESTS** at the Lake Geneva depot, financier J.H. Moore dispatched a tallyho with coachmen tooting silver bugles. Now a fading memory, his lakeshore manor was called Loramoor, in honor of his wife, Lora.

RIGHT **SEVERAL BUILDINGS** from the 1893 Columbian Exposition were relocated to Geneva Lake. A Sinhalese temple became the centerpiece of Ceylon Court, an exotic estate where peacocks strutted across the lawn. Later owners included the Maytag family. The mansion was razed in the 1950s.

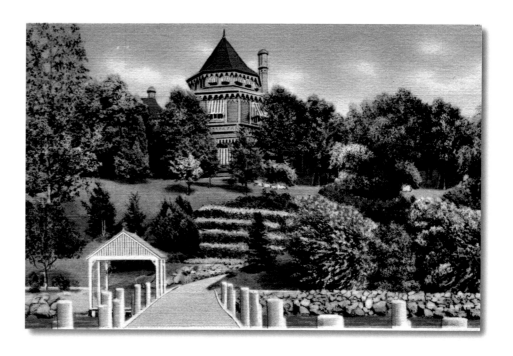

PROFILE
The Hotel Geneva

His reputation sullied by a scandalous affair, architect Frank Lloyd Wright was offered no major commissions in 1911—until a group of local and Milwaukee-based developers asked him to design the Geneva Hotel. Built on Geneva Bay the following year, it was an ultra-stylish prototype for what we now know as the modern motel. The Prairie School design featured Wright's signature deep eaves and a daringly cantilevered roof. Stepping inside, guests faced a heavily ornamented lobby with hanging art-glass lamps and a Roman-brick fireplace with built-in seating. By day, light streamed in through a leaded-glass skylight and three walls of stained-glass windows, whose geometric tulip motif left lake views intact.

Apparently it wasn't an easy place to maintain—or own. During its first three years alone, the hotel passed through three different hands. In the early 1930s, proprietor E.T. Nussbaum was robbed by five men armed with pistols and a machine gun. Unsatisfied by the take, the robbers carted him off to Genoa City, where they handed him a $10 bill and dumped him. Two years later, Nussbaum's partner was also robbed—again by five men.

Hobart Hermansen owned the hotel in the '40s, and it quickly became known for its back-room gambling, including horse-betting, slot machines, and a roulette wheel. The gambling wasn't legal, but according to longtime resident Charlotte Peterson, it was accepted. "It was a fun place," she says. Back then, she worked for the Chamber of Commerce, and she recalls that a friendly phone call forewarned bettors of any raid. "They'd just take all the machines and the toteboards across the alley [to another building], and everyone would follow them like a parade. When the raid was over, they'd march right back again."

In time the hotel fell into sad disrepair and its original glamour was lost. By the 1960s, it featured a tacky tiki-style bar. When crews arrived to demolish the structure in 1970, the building revealed the last of its secrets. According to an architect involved with the project, a bulldozer plunged into a concealed vat of goo—presumably grain mash left over from the Prohibition era.

Dr. King opened his first and largest Geneva sanitarium in 1885. A brooding brick structure perched on "Catholic Hill" (east of downtown), it handled everything from chronic malaise to drug addiction to cases requiring surgery or "tight confinement." Two additional sanitariums opened along the lakeshore in the 1890s. Both were more "spa" than clinic, but a 1909 feature in the local paper says the underlying goal was the same: to remedy "hysteria and many other habit symptoms, the result of a nervous constitution, irrational living, slipshod and vicious education, and idle indulgence—cases that can seldom be treated successfully at home." These days, one might either check into rehab or take a vacation (and Lake Geneva is still a good place to do the latter).

GANGSTER GETAWAYS

THE AGE OF QUIET ELEGANCE and refinement continued into the early 20th century—until the 1920s "roared." It was the era of Prohibition, and bootlegging became big business. With the help of a thirsty nation and a short-sighted government, Chicago gangsters such as Al "Scarface" Capone and his arch rival George "Bugs" Moran attained an unprecedented level of success. And like many Chicagoans, when they needed a little R&R, they headed north to Wisconsin.

Capone's hideaway lay deep in the north woods of Wisconsin, but Moran—nicknamed "Bugs" for his strange outbursts—sought

comfort closer to the Windy City. He befriended a Lake Genevan named Hobart Hermansen, whose family owned a secluded resort on nearby Como Lake. (Today it's the French Country Inn.) Locals still pass along tales of how Moran would sweep in for dinner with a phalanx of bodyguards and sit with his back to the corner, requesting a certain waitress who had the gumption to serve him. ("He was a big tipper," the waitress later told her children.)

Bugs enjoyed more distinctive hospitality at the Hermansen home, which was also located on the shore of Como Lake. Now a B&B called the WatersEdge, the house still has a number of unusual features—including an underground garage with a drive-up vault, perfect for secretly loading and off-loading cars. A former money-counting room with iron bars is perched above it as one of the guest rooms.

"Hobe" Hermansen is still remembered as one of Lake Geneva's most colorful businessmen. During the 1940s, when he owned the Geneva Hotel, he was known as Walworth County's "slot machine king." Some found him rough-edged, but Hermansen hardly shared Moran's lengthy criminal record. The pair did, however, have another connection: Moran's "moll" eventually left Bugs for Hobe, and John Moran, her son, went with her. (Rumor has it that the arrangement was friendly.)

RIGHT **SOGGY WOOLEN SUITS** didn't dampen the enthusiasm of these bathers at the Lake Geneva beach in the 1920s.

BELOW **YERKES OBSERVATORY** in Williams Bay has attracted many distinguished scientists, but none is more famous than Albert Einstein (sixth from the right), visiting in 1921.

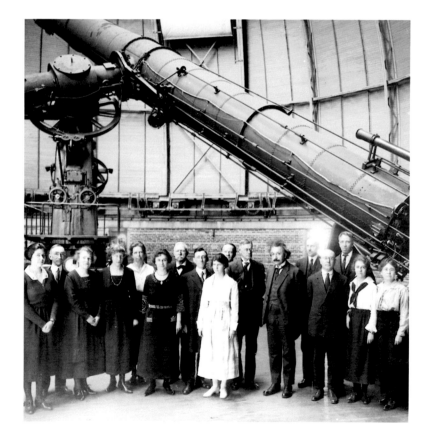

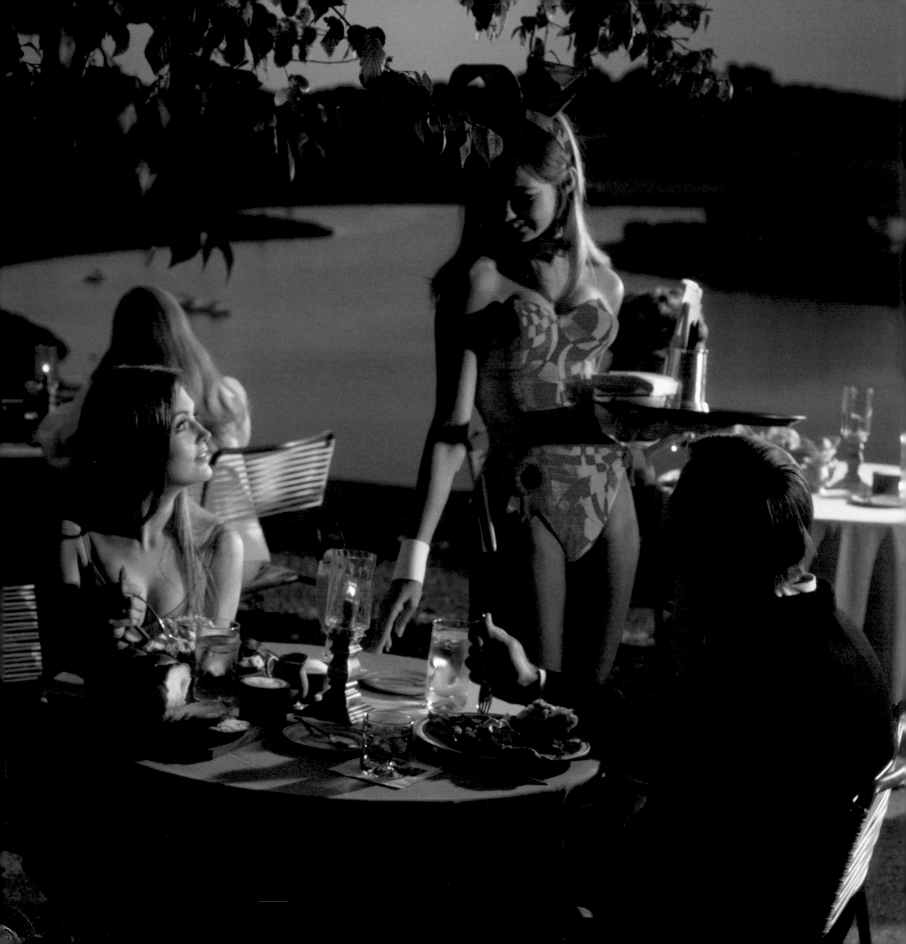

DUNGEONS & BUNNIES

⁓

AFTER THE ROARING TWENTIES and Prohibition had faded into memory, Lake Geneva seemed relatively quiet in the ensuing decades. Then the Sixties arrived. It was the era of free love, and the area gained an unwelcome reputation as a party place, especially for drinking-age youth from Illinois. In 1967, news of a July Fourth "happening" spread across the border by word of mouth, and soon thousands of teenagers and college students had converged on downtown Lake Geneva for a holiday celebration. Unfortunately, it devolved into a rampage of destruction.

One observer later referred to the event as "a happy riot." But many residents feared for their lives as vandals smashed store windows, decapitated statues, and battered parked cars. Understaffed and overwhelmed, local officials called in the National Guard, who sealed off the city. Once the jails were full, revelers were herded into cattle barns at the Walworth County Fairgrounds in nearby Elkhorn until the situation cooled. Fortunately, the worst casualties were damage to property and the city's short-term image.

For many Lake Genevans, however, the "riot of '67" was barely a blip on the historical radar. Two other forces in the late 20th century had a far greater impact on the area's cultural identity: the Playboy Club and Dungeons & Dragons.

OPPOSITE **THE PLAYBOY CLUB'S** terrace overlooked a 25-acre lake (which still exists). Bunnies adhered to strict standards for appearance and behavior. Their custom-fitted costume included a nameplate rosette, but some girls used pseudonyms. Personal jewelry, including wedding rings, was not permitted.

RIGHT **FROM TRAPSHOOTING** to flying lessons to downhill skiing—Playboy offered a seductive array of year-round recreation on its 1,000-plus acres. Naturally, the ski hill included a lodge for _après-ski_ snuggling. The building design echoes the shape of snowflakes.

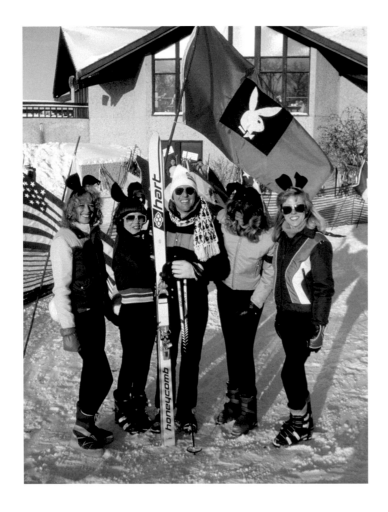

THE BUNNY YEARS

MOST PEOPLE WOULD plunge a silver shovel into the dirt during a groundbreaking ceremony. Not Hugh Hefner. In the summer of '66, the master of sexual symbolism stood in a meadow just east of Geneva Lake and triggered an explosion that launched a fountain of earth nearly 100 feet into the sky. The event celebrated the birth of the Playboy Club, a 1,200-acre luxury resort complete with golf courses, skiing facilities, a glitzy 450-seat nightclub, eight Bunny-filled bars and restaurants, and suites with plush round beds. Eager to spur tourism, local businessmen

LEFT **BILLY KIDD,** the 1964 Olympic silver medalist (pictured at _center_), schussed down the club's white slopes. Bunnies often worked outside the lodge in ski-suits, warming guests by offering hot drinks. Tail-grabbing was taboo, but you could buy a tail in the gift shop for around $20 (detached, of course).

welcomed Hefner with a 7-foot-high floral arrangement in the shape of (what else?) a rabbit. A skydiver quartet dropped out of the clouds, waving Bunny flags. "With Playboy Bunnies overrunning the dozens of hilltops . . . it was a happy day indeed," the *Lake Geneva Regional News* reported.

Roughly two years and $14 million later, the exclusive Playboy Club officially opened its doors to keyholders (the club key cost $25 a year). A huge rabbit-head logo soared atop a pole along Highway 50, spinning hypnotically above the guarded gate. Private jets lined the resort's 4,100-foot runway, and sleek foreign cars with Illinois license plates filled the parking lot. An army of groundskeepers and behind-the-scenes workers fulfilled Hefner's vision of immaculate hedonism. "Not a single blade of grass was out of place," one local businessman reminisces fondly.

Playboy sold men a high-end fantasy with a "naughty but nice" edge, and nearly everyone played by the rules. Bunnies were never to be touched. Hotel room-service was delivered by male wait-staff. And while Bunnies donned fluffy-tailed bikinis to work poolside, unlike Playmates, they never went "buff" on the job. Nor did they openly fraternize with customers—an offense that was punishable by firing.

"Even if someone was drunk at 2 AM and tried to slip you a room key, you could just say, 'Sorry, that's not allowed,' and they'd still leave you a good tip," says Gail Frantz, a former Bunny who grew up in Lake Geneva. Tips were

PROFILE
Dieter Sturm—the Snow Man

He has done some of his weirdest work after dark. In the dead of winter, Dieter Sturm—an Academy award–winning special-effects wizard—used to creep about the city of Lake Geneva, planting black fins in snow banks. Soon newspapers 50 miles away were issuing tongue-in-cheek warnings about "snow sharks."

At the time, Sturm was a public relations manager for TSR, the company behind Dungeons & Dragons. Before that, he handled publicity for the Playboy Club. Through it all, he tinkered with a special-effects sideline that went far beyond phony fins: On weekends, Sturm blew things up and made fake snow for fun and profit.

A self-described "inventor boy," Sturm read countless books on special effects before he started practicing. By age 20, he was a fire-breathing nightclub DJ and a budding explosives expert who worked part-time on corporate promotions.

In the mid-1980s, Sturm quit his job with TSR to join the special-effects crew of the movie *Planes, Trains, and Automobiles*. "It was one of the biggest risks I've ever taken," says Sturm, with no regrets. Today his long list of film credits includes such titles as *Fargo, Michael,* and *The Weather Man.* Though he's still ATF-licensed in the use of large and small explosives, his specialty is snow-making in all its forms. In 1995, the Motion Picture Academy gave him a technical achievement award for his biodegradable snow formula. Between films, he works for such commercial clients as Sears and Target.

For the past 15 years, Dieter has been joined in his business by his wife, Yvonne, a licensed drag racer and former stockbroker. Work takes them on the road, but their roots are firmly in Lake Geneva. Sturm has never been fond of city life. "I lived in Manhattan as a kid and then in Milwaukee. I couldn't wait to escape the city on the weekends. Here, I feel like I'm on vacation every day."

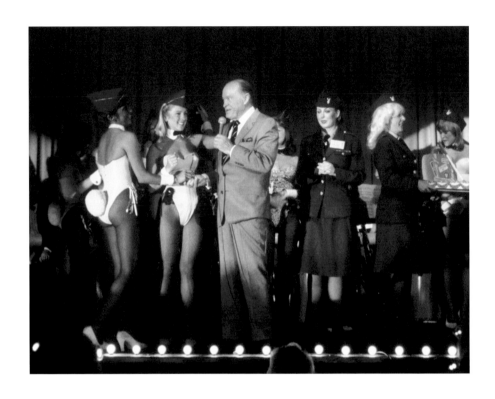

RIGHT **TOP-NAME TALENT** headlined at the Playboy Club Hotel, from Liza Minelli and the ever-popular Bob Hope to then–up-and-coming stars such as Bette Midler and Bill Cosby. Here, Hope jokes around with some fluffy-tailed friends.

BELOW **ARNOLD J. MORTON** masterminded the club's top-flight operations, which included such gourmet restaurants and watering holes as the VIP Room, Playmate Bar (pictured), and the Bunny Hutch *discothèque.*

so good, in fact, that Frantz sometimes pulled in a grand or more a week. For a part-time teenage waitress in 1968, "it was insane."

It was also hard work. Bunnies toted heavy trays while wearing 3-inch heels. Metal corset-stays in their costumes cinched waists to the verge of swooning. Actually patented, the Bunny uniform was custom-fitted to each girl, with one notable exception: the stand-at-attention foam bra came in just two sizes: 34D and 36D. The body within didn't have to measure up; according to an ex-Bunny website, many a spare fluffy tail migrated north for undercover duty.

It was all part of the fantasy. Official policy required every Bunny to look *beautiful, youthful,* and *fresh.* "I'll never forget those three words," Frantz says. No two Bunnies in a club could use the same name; many had pseudonyms. Wedding rings and all other personal jewelry were banished, along with tattoos and obvious tan lines. Bending forward to serve drinks or light customers' cigarettes was strictly taboo; instead, every girl learned an official, "more ladylike" maneuver called the Bunny Dip. "You turned your back to the table, bent your knees a little, and leaned backward," describes Sandra Farwell, a local Bunny from age 20 to a still-youthful-looking 34.

The perks outweighed the challenges. High among them: the chance to see headliners at the Penthouse Showroom (which was later renamed the Cabaret Lounge). "I can't even begin to name all the people I met," Frantz says, then rattles off a list that includes Bob Hope, Sonny and Cher, Tony Bennett, Peggy Lee, and Sammy Davis, Jr. Many mingled with staff. "Where else could you play backgammon by the pool with the Smothers Brothers, or sit down with Bill Cosby for a cup of coffee?" Frantz asks. "I spent a couple of weeks hanging out with Bette Midler." When she and the Divine Miss M played foosball at Chuck's Bar in Fontana, Bette got a little bawdy. "I told her to keep the language down," Frantz says. "I was afraid we'd be kicked out."

At 23, Frantz turned in her fluffy tail and became the youngest Bunny Mother in Playboy history. Part chaperone, part personnel director, she was responsible for every new hire. "I always thought I had the prettiest Bunnies in the country," she says. Like Frantz herself, scores of them initially lived in a dorm at the resort, bunking four to a room and sharing a single phone. Barbed wire ringed the compound and security was tight, but "golfers would always try to hit balls over so they could get a closer look," Farwell adds.

Eventually, the Playboy Club lost some of its mystique. By the late 1970s, "it seemed like anyone could get a key," says Frantz—and indeed, anyone could; eventually the club dues were dropped. Playboy Enterprises was losing millions on its worldwide lineup of clubs, especially in England, where Hefner's casinos were shut down for gaming violations. Supposedly the Lake Geneva resort ran in the black, but in November of 1981, Playboy announced its sale to the family-friendly Americana Hotel Corporation. Tea towels were hastily draped over posters of Playmates. By March of 1982, hangouts like the Man-at-His-Leisure Bar had given way to the Kahootz Disco and Annie's Country Kitchen.

Today the property is the Grand Geneva Resort and Spa, a fully refurbished facility owned by Marcus Enterprises. Fittingly, the hotel concierge is Sandy Farwell, who often finds herself answering questions about her "Bunny Days."

"It's funny," Farwell says. "Almost none of the locals wanted the Playboy Club to come here at first—they thought it would be a den of iniquity. When they saw how nice it was, they were sad to see it go."

BELOW **GOLFER LEE TREVINO** admired the fairways. The resort boasted two championship courses (both recently updated): a rugged layout designed by Robert Bruce Harris and a Scottish-inspired course by Jack Nicklaus and Pete Dye.

A Legacy of Dragons

As Bunnies frolicked at the Playboy Club, mythical beasts inspired another kind of fantasy in Lake Geneva, where the Dungeons & Dragons role-playing game was born. The adventure began in the early 1970s when the game's creator, E. Gary Gygax, quit a ho-hum insurance job to pursue his dream of designing strategy games. It was a bold move, considering he had four children to support and a fifth soon to arrive. Gygax moonlighted as a cobbler in his Lake Geneva basement just to keep food on the table.

The risk paid off. Gygax soon invented a fantasy game in which a band of unlikely heroes embarked on an epic quest reminiscent of the tales of J.R.R. Tolkien. His war-gaming friends weren't particularly interested, so he enlisted the help of his children to play the first version, using a toy dinosaur to represent a dragon. Gygax wrote the rules, but he credits fellow strategist Dave Arneson with contributing key ideas.

In 1973, Gygax formed a company called TSR (short for "Tactical Studies Rules") and began producing games on a shoestring budget. By 1980, a growing creative staff occupied the upper floors of the Landmark Center downtown, with a retail game store below. Supplements for the fantasy D&D game were top-sellers, but the company ventured into other genres as well, including science fiction and the wild west. One day employees were developing a "kidnap the president" idea for an espionage game, where players would have to thwart the plot. Wary citizens who found some design notes contacted the FBI, whose real agents checked out the "threat" and left town with a free game.

By 1982, the fast-growing company employed more than 200 workers and had moved into a remodeled Q-tip factory at the edge of town. Gygax now had two partners, Kevin and Brian Blume, who had invested a modest sum during the lean days. Together they saw TSR's worldwide annual sales skyrocket well past $20 million. Gygax himself moved to Hollywood, overseeing a highly rated D&D cartoon show.

But the fairy tale was not to last. Profits quickly plummeted due to management

BELOW **EVERY DAY IS** a "creature feature" for Lake Geneva artist Jeff Easley, who paints covers and illustrations for fantasy novels and games. His dragons are famous among D&D fans.

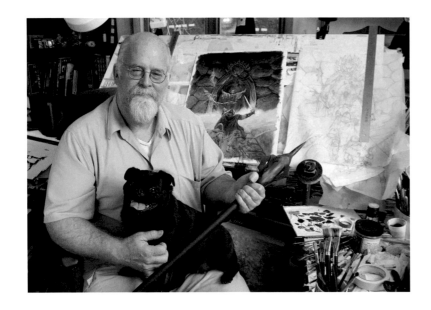

struggles and unbridled expansion; as a result, the company was pitched into a nepotism-filled drama that might have been dubbed "Dungeons and Dallas." The brothers Blume were forced out. In turn, they exercised a stock option and sold their majority interest to Lorraine Dille Williams, heir to the Buck Rogers legacy. When the court battles finally ended and the smoke cleared in the mid-1980s, Gygax had severed ties with TSR and no longer held creative rights to Dungeons & Dragons.

Williams ran the company until 1997, when she sold it to Seattle's Wizards of the Coast (now part of Hasbro). Scores of loyal employees moved west to the Emerald City, but a number of "TSR old-timers"—most already freelance writers and artists—chose to remain in this area. Among them were best-selling authors Margaret Weis, Troy Denning, and Douglas Niles—all of whom have fantasy and science-fiction book sales topping a million copies.

Artist Jeff Easley also opted to stay. From his home and studio on the outskirts of Lake Geneva, Easley, a quiet family man, paints fantasy and science-fiction scenes for scores of games and novels. Originally from Kentucky, he says he has never considered moving back because he'd miss the changing seasons and the constant parade of local events. "I get a real kick out of the small-town stuff . . . like the Corn and Brat Fest, the little circuses, and the county fair," Easley says.

PROFILE
E. Gary Gygax

The press dubbed him "King of the Nerds." Matt Groening, creator of *The Simpsons,* immortalized him with an animated likeness in *Futurama.* Although E. Gary Gygax has achieved fame as the principal creator of the Dungeons & Dragons role-playing game, many Lake Genevans don't know he lives here—or realize the depth of his roots.

Gygax, in fact, represents the seventh generation of his family in Lake Geneva. Born in the Chicago area in 1938, he began summering at his grandparents' Lake Geneva home as an infant, and his family moved to town when he was eight. As he grew up, he often fished for yellow perch off the public pier. He also explored narrow tunnels in the Oakwood Sanitarium—an enormous brick building that once loomed, abandoned and brooding, atop the hill just east of downtown.

"It was great fodder for D&D adventures," says Gary, whose former company, TSR, turned a kitchen-table game of make-believe into a worldwide sensation. Although he cut ties with TSR in the mid-1980s, Gygax went on to publish a string of fantasy novels and books on game theory, as well as other role-playing games.

Today Gary is semiretired, and he and his wife, Gail (an antiques dealer and real-estate agent), live in a pale yellow Victorian in the historic Maple Park district. They're empty-nesters now, but on summer nights, the screened-in front porch is still a gathering place for gamers ages 15 to 50-plus. Gygax occasionally lets someone else direct a role-playing session so he can take on the role of a mutant human with two brains and a very big head. "I have always preferred cerebral games," he says in all seriousness.

When Gygax is out and about, few people recognize him as the father of a cultural phenomenon whose influence is visible in virtually every computer and video game today. "I'm more likely to be mistaken for Jerry Garcia," he notes. Garcia may be gone, but Gygax, of course, plays the role with aplomb.

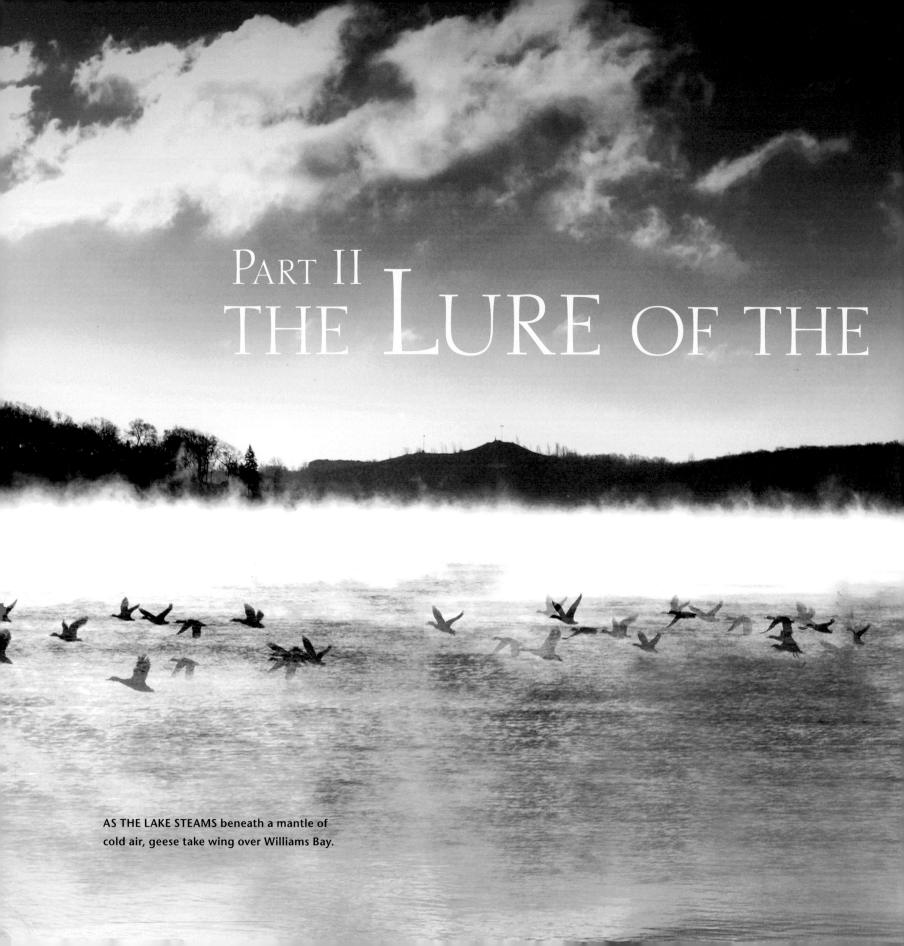

PART II
THE LURE OF THE

AS THE LAKE STEAMS beneath a mantle of
cold air, geese take wing over Williams Bay.

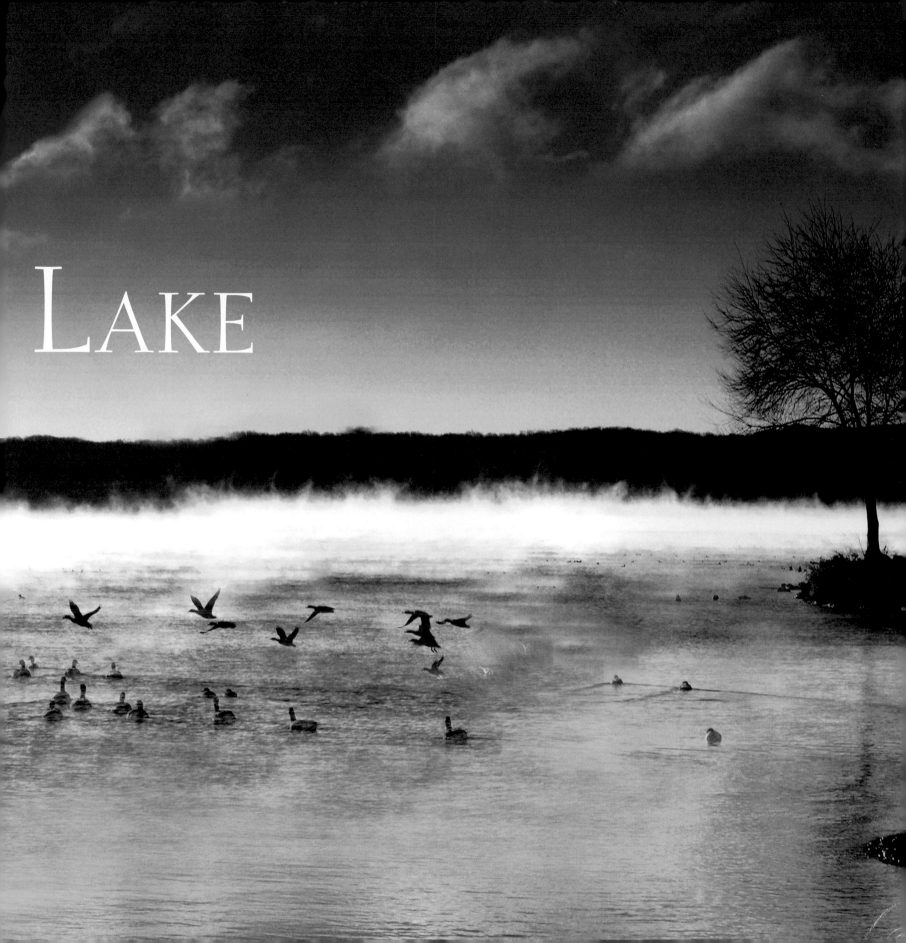

LAKE

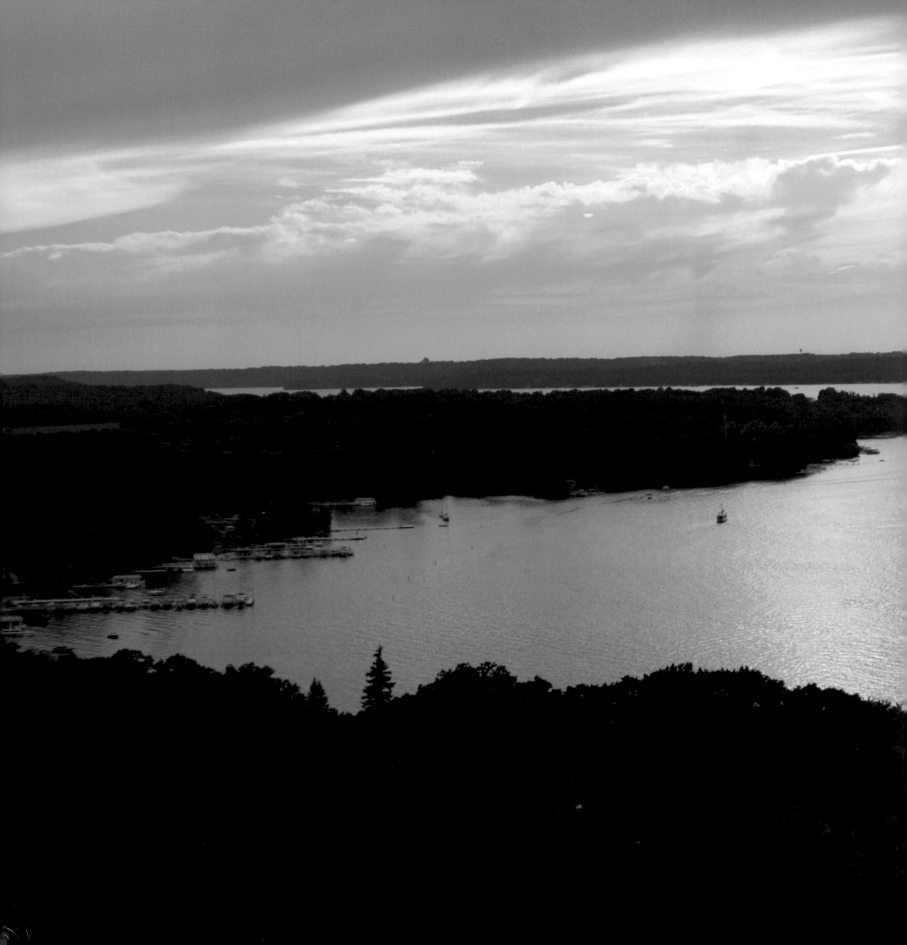

CLEAR WATERS

ᔐᔐ

W HEN THE POTAWATOMI INDIANS made their home on Geneva Lake, they called it *Kishwauketoe*. Some translate this as "clear, sparkling waters"; to others, it means "the water has the light." Either way, it's an apt description. Of all the lakes in this country, only a few share Geneva Lake's extraordinary blend of size, depth, and clarity. The lake measures nearly eight miles long as it curves from east to west and just over two miles across at its widest point. At its deepest—near Black Point, where the steam yacht *Dispatch* sank in a sudden, fierce storm in the 1890s—the bottom plunges more than 140 feet.

Other natural inland lakes may be deeper (Green Lake is Wisconsin's deepest), but few maintain their depth over an equally wide area. Roughly 90 percent of Geneva Lake is deeper than 10 feet, and it averages 61 feet overall. In the calm of winter, its clarity rivals the ocean, with light penetrating nearly 70 feet.

LEFT **WITH ITS STEEP,** wooded bluffs and remarkably clear waters, Geneva Lake more closely resembles an alpine body of water than its many shallower Wisconsin neighbors. A stroll along its undulating shore spans roughly 21 miles.

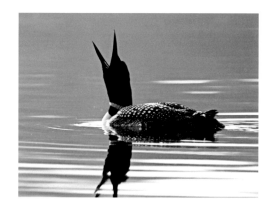

RIGHT **IN EARLY SPRING,** the haunting call of a loon echoes across the water. The migrating birds continue north as summer approaches.

BELOW **NEARLY HALF OF GENEVA LAKE** exceeds 70 feet in depth. Between Williams Bay and Black Point, the bottom plunges more than 140 feet.

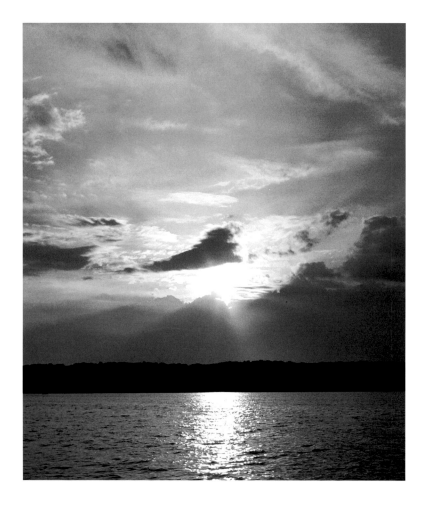

Many residents attribute the water's refreshing quality to the springs that bubble up from the west end of the lake. In the late 1800s, these springs flowed so freely that fashionable spas and resorts rose up around them, touting the water's health benefits. In truth, springs account for a relatively small portion of incoming water. Rainwater contributes the lion's share, followed by a necklace of short, delicate streams (many of which are fed by pure groundwater).

Geneva Lake's clarity is due in large part to its small watershed. Roughly 13,000 acres drain into the lake's 5,200-plus surface acres, so its watershed ratio is 2.5 to 1. (In contrast, nearby Delavan Lake's ratio is about 22 to 1.) As a result, development near the shore may affect water quality, but far-flung farms are seldom a problem.

Geneva Lake also renews itself quickly. With much of its groundwater flowing in from the west and its only outlet to the east, the lake undergoes a complete water exchange every 14 years. Limnologists call this a fast "flushing rate," a decidedly unromantic description for such a glorious body of water.

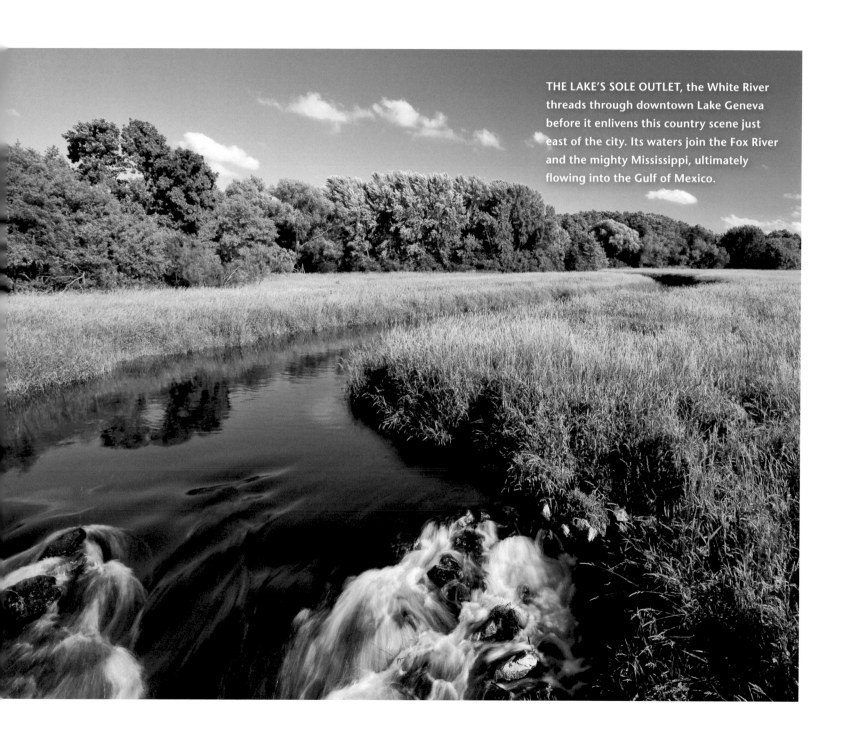

THE LAKE'S SOLE OUTLET, the White River threads through downtown Lake Geneva before it enlivens this country scene just east of the city. Its waters join the Fox River and the mighty Mississippi, ultimately flowing into the Gulf of Mexico.

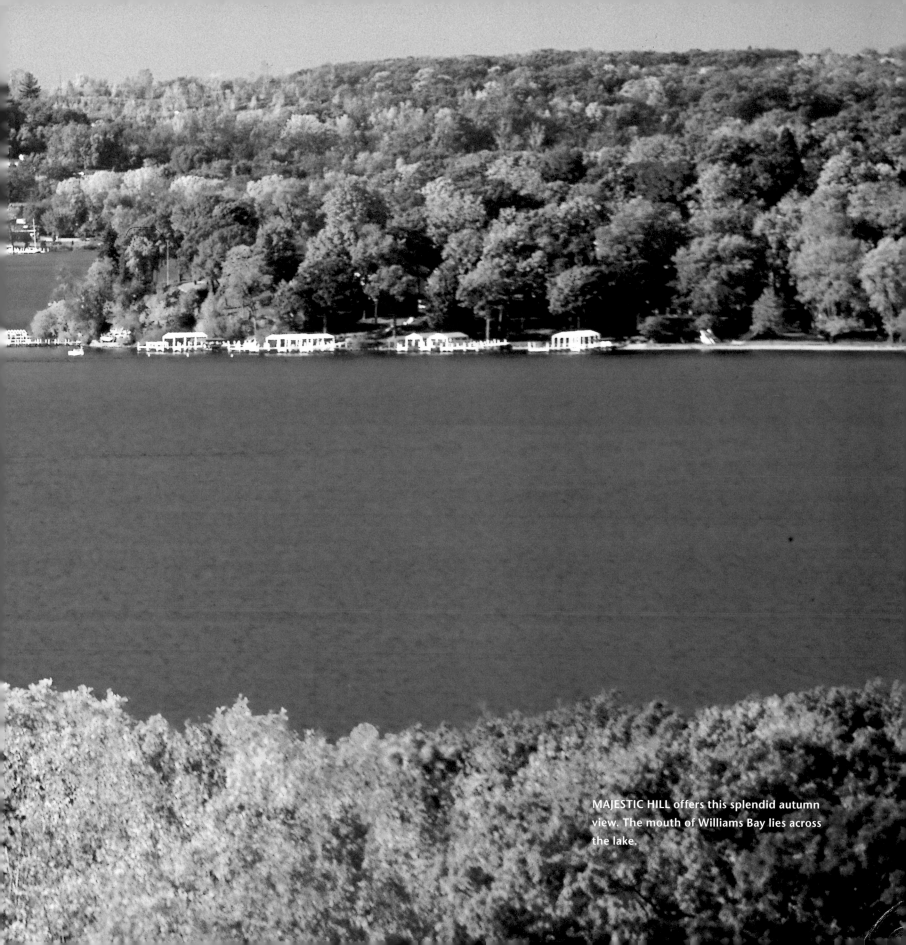

MAJESTIC HILL offers this splendid autumn view. The mouth of Williams Bay lies across the lake.

How the Lake was Formed

BELOW **AUTUMN COLORS** accent Big Foot Beach, a sandy ribbon along the southeast shore. Piers stripped of their decking signal preparations for the coming winter. Like most piers on the lake, these feature permanent underwater cribs filled with boulders or concrete. Lesser structures aren't suited to the lake's deep water and often-vigorous waves.

WE OWE IT ALL to the ice. More than a million years ago, great glaciers began invading the Midwest from Canada, alternately advancing and retreating many times. Moving forward, the frozen behemoths ripped away hilltops and scoured out valleys, and in their watery wake, they deposited vast amounts of *drift*—a mix of sand, mud, gravel, and rock—which shaped much of Wisconsin's landscape. Even our rich topsoil comes from Canada, spread like boulder-studded frosting over a deep foundation of granite and limestone.

It's the most recent glacier, which retreated roughly 12,000 years ago, that created Geneva Lake. Before that invasion, the lakebed belonged to an ancient system of valleys that drained water southwest toward the Mississippi. (The bed of Geneva Lake was also linked to a small side-valley—now Como Lake—with Como draining into Williams Bay.) Then a tongue of ice known as the "Delavan Lobe" pushed in. Like a plow blade, it shoved a mountain of debris toward the

west end of Geneva, sculpting a steep terminal moraine that dammed the basin's original outlet. Forced to seek a better route, the water reversed its flow and carved a new outlet—the White River—through a gravel terrace at the lake's eastern rim.

The lake owes its depth to a great slipper of ice that stayed behind as the glacier retreated. Glacial drift soon edged the lake with taller bluffs and rolling hills, but the orphaned ice prevented the lakebed from filling with debris.

THE TURN OF THE SEASONS

LIKE ALL DEEP LAKES in a temperate setting, Geneva Lake undergoes a significant change with every season.

During the long days of summer, the water stratifies, forming three layers differentiated by temperature. The hot sun warms the surface so quickly that it becomes less dense and ceases to mix with the waters below. It's a swimmer's boon: By mid-August, temperatures in this upper layer—the epilimnion—typically climb into the high 70s. About 35 feet below the surface lies the thermocline, an area in which the mercury plunges dramatically with depth (as any scuba diver can attest). Beneath that lies the hypolimnion, a dark and shadowy realm with temperatures in the lower 40s. Isolated from the surface, this tomblike layer gradually loses its supply of oxygen during summer, until not even cold-loving fish are likely to visit it.

ABOVE **WITH MORE THAN 200 ACRES** stretching north from Williams Bay, the Kishwauketoe Nature Preserve includes the shoreline's most undisturbed wetland. Conserving such land is vitally important to preserving the lake's high quality.

BELOW **STACKED PIERS** bear silent witness to the final days of winter. Stirred by a brisk wind, frozen shards mingle briefly onshore, then swiftly vanish beneath the waves.

During the cool nights of autumn, the lake's temperatures become more uniform, setting the stage for a refreshing spin-cycle. As November winds push whitecaps across the surface, the entire lake "turns over," bringing fresh oxygen back to the depths.

When the winter freeze sets in, the lake once again forms layers. Now, however, the deepest water is the warmest. That's because 39 degrees—the average reading of the hypolimnion—is the temperature at which water reaches maximum density. Slightly cooler (and less dense) water lies above, topped by the icecap, which is the coldest layer of all.

Finally, the rains of spring arrive, literally breathing fresh life into the lake. The ice melts and the surface gently warms. As March winds blow, Geneva Lake turns over a second time, and the entire cycle begins anew.

Frozen Beauty

SUMMER MAY BE the high season on Geneva Lake, but for many, the lake becomes even more beautiful in winter. Each year lake-watchers mark the "ice on" date, when the icecap stretches completely from shore to shore. It happened as early as December 7 in 1972 (a cold year), but January dates are most common. Bays and shallow areas freeze first. Mild temperatures obviously discourage ice, but so does anything that keeps the water moving, such as brisk winds and even the paddling feet of geese reluctant to fly south.

The ice is like a living thing. Once it acquires strength, it feeds on itself and deepens more quickly. Its structure, however, is constantly changing. Areas near streams and springs are notoriously fragile, but even in the middle of the lake, cracks open, then refreeze again. As the ice shrinks and expands, it rumbles and sings. George Johnson, a local environmentalist, says the best singing happens when the icecap experiences its first warming trend. As the ice starts to thaw and expand, it sings "a song that would make the Arctic narwhal cry," writes Johnson in *The Geneva Lake Book*.

Eventually, of course, the ice disappears again. On Geneva Lake, the "ice out" date typically falls in March. Sometimes it happens so quickly that it seems like magic. One day, the ice is a glistening, incomplete skin. Then it shatters like a mirror against the shore, with all the pieces swiftly drifting out and vanishing beneath the waves.

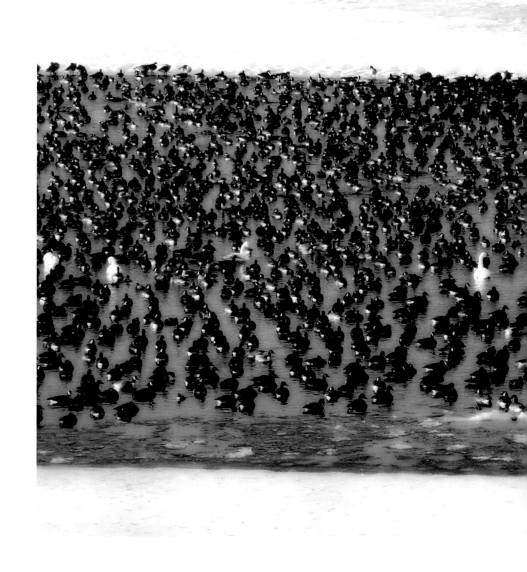

RIGHT **BIRDS OF A FEATHER** (or two) flock in Williams Bay, gathering beside the last remnants of open water.

OVERLEAF **A BROKEN MIRROR,** the last spring ice slowly melts beneath the setting sun.

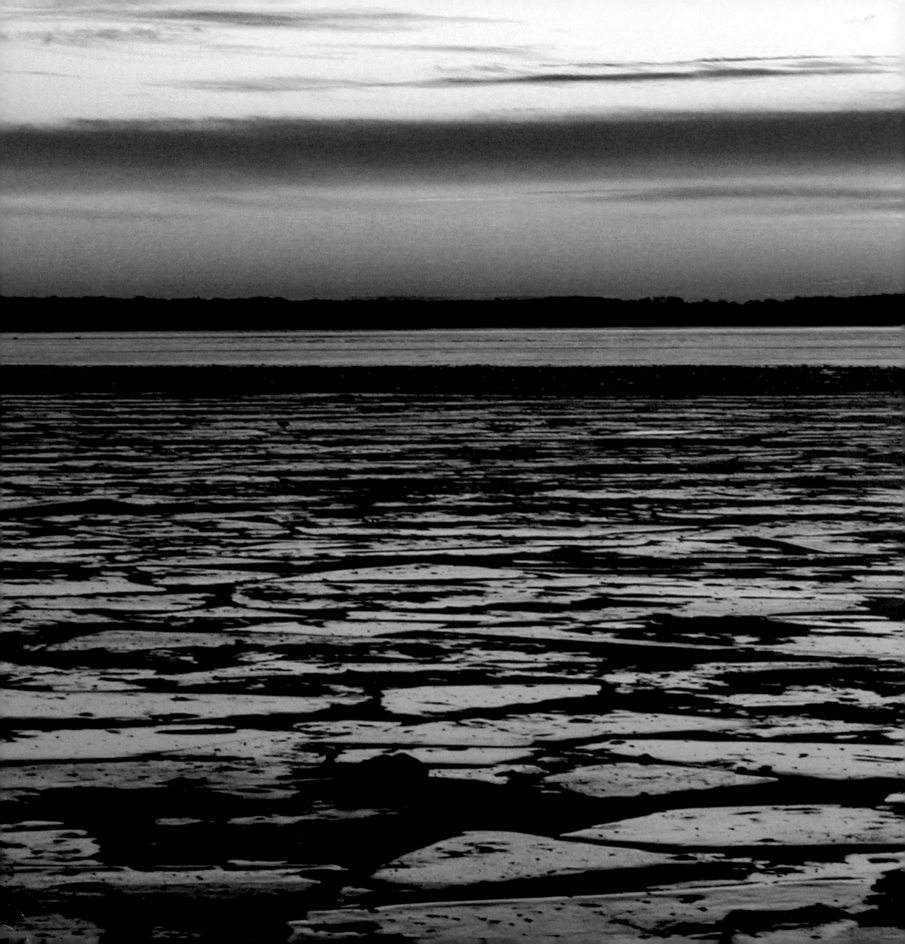

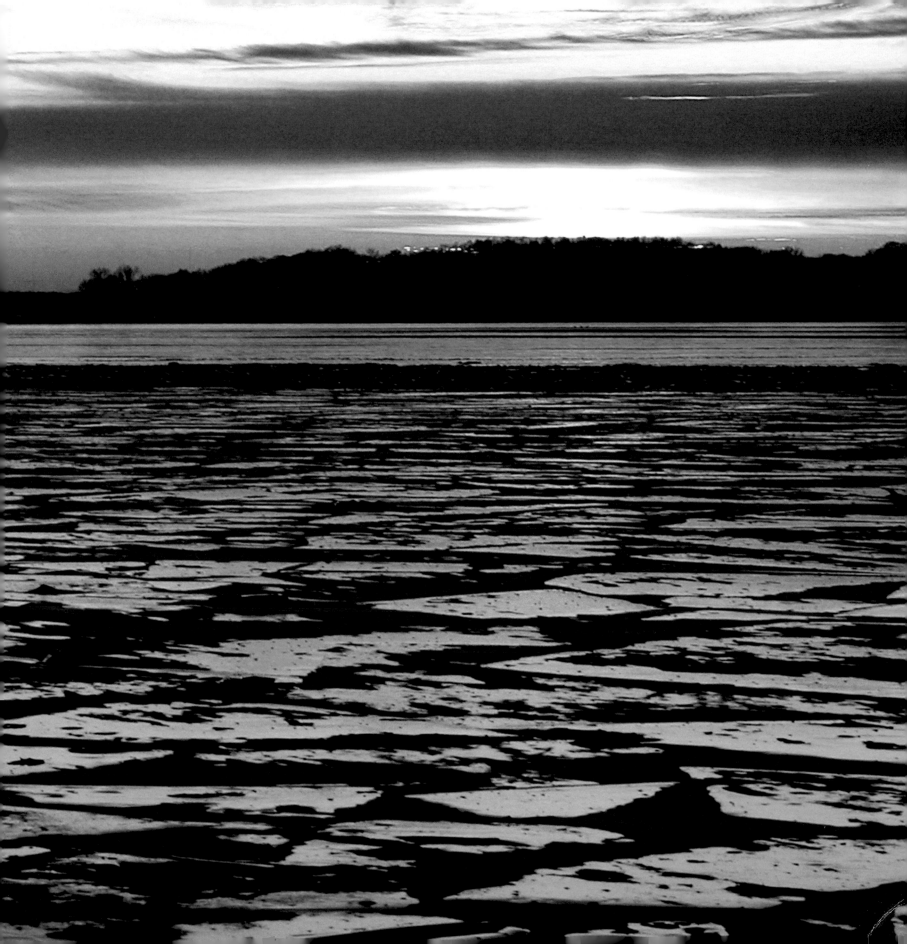

ABOUT TOWN

THREE COMMUNITIES LIE ALONG the shore of Geneva Lake: Fontana, Williams Bay, and the city of Lake Geneva. Each has a unique character, but they also share several traits. For example, each has a broad, sandy beach for sunbathers and crisp white piers for boaters. Each also has a lakefront park enlivened by pink-flowering crab-apple trees, with both casual and upscale watering holes close at hand. And, as you might expect, all three communities are shaped by a lifestyle that centers on the lake.

The largest of the three by far is Lake Geneva, which hugs a mile-wide bay at the lake's east end. The official population of this charming little city is about 6,400, but that number scarcely reflects the throngs of tourists who come here to relax on a hot summer's day. According to the local Chamber of Commerce, a million and a half visitors flock to Walworth County each year—and Lake Geneva sees most of them.

RIGHT **BUILT ON MORE** than 300 piers, Lake Geneva's Riviera Ballroom dates to the 1930s. During the Big Band era, nearly every major headliner played here. Today, shops fill the lower level and the upper floor plays host to private parties. Excursion boats depart from the adjoining docks (*above*).

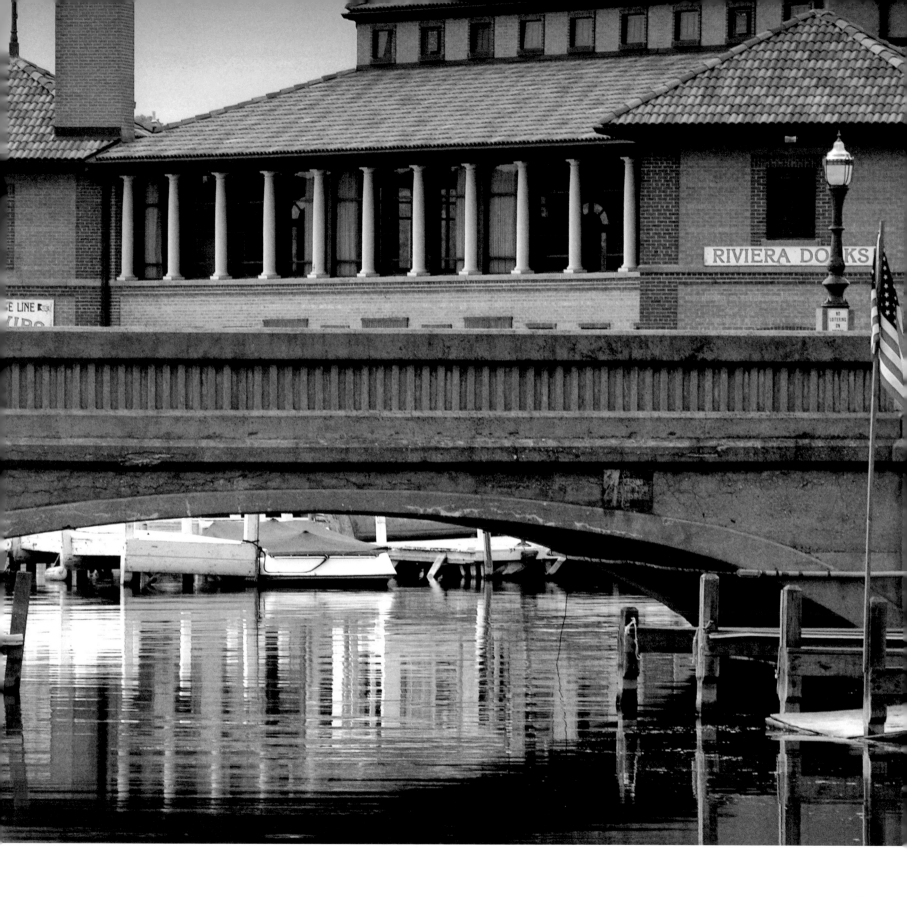

PROFILE
Elmer Zingle

With a scowl and a wink, Elmer Zingle, 93, has fired more teenagers in Lake Geneva than any other employer. It's a neat feat, considering that Zingle hires only a handful of helpers each season for his boat-rental business, a longstanding fixture on the Riviera Docks.

"He fires just about everyone," says cartoonist Joe Martin, whose son Jay is among those sacked. "The trick," Martin adds, "is just to show up for work the next day like nothing ever happened."

When Jay manned the rental hutch, Zingle—then pushing 80—had a unique way of keeping him and other testosterone-laden teens in line. "Jay wanted to argue with me, so I told him to go out on the lawn and practice falling down a lot, because I was going to knock him out," Elmer recalls, then adds deadpan, "He needed to warm up, but I didn't." Jay complied, and Zingle proceeded to demonstrate a few wrestling moves (in fun, of course).

Born in 1913, Zingle moved to Lake Geneva from Chicago in the early Twenties. "My mother thought I'd be Al Capone's right-hand man if we stayed," he jokes. His father soon opened a bakery downtown.

Elmer's first recollection of Lake Geneva is coming down a snowy, ice-covered hill with the moving van. "Then I saw this beautiful lake. . . ." An iceboat was gliding across Geneva Bay. "I knew that was what I'd do," Elmer says. He later built his own boat using bedsteads.

Today his business centers on motorboats, but it began when Zingle, at the tender age of 19, started taking customers for rides on a sailboat he'd refurbished. "I had the first buoy on the bay," he boasts. The 20-foot boat had a tendency to tip, and customers often got dunked. Later, when Zingle sailed a big catamaran, he occasionally lost riders off the back. "I cared what happened to them," Elmer says, "but I couldn't always control it."

The rest is Lake Geneva history. Elmer has survived some tough years (he says one Prohibition-era heavy threatened his life), but at 38, he married his beloved Lois and raised two daughters in town. Today he still spends his days at the docks, overseeing his business and telling stories. Some tales seem a bit "tall," but one thing is certain: Elmer Zingle is a Lake Geneva icon.

The city is bracketed by major resorts to both the east and west, and it offers the largest array of hotels and B&Bs. Gift shops and galleries fill its picturesque downtown, which includes a block-long National Historic District dating to the 1870s. Tourists from around the world often picnic in the shady lakefront park, and as you stroll the long lakefront promenade, it's not unusual to hear several different languages being spoken in turn.

Anchoring the lake's west end, Fontana is a laid-back village with just under 2,000 year-round residents. Less touristy than the east end, it's still a weekend playground, with more second homes and "resident boats" than any other community. Away from the shore, twisting, narrow roads climb the west-end bluffs, threading past an eclectic array of historic cottages.

The village features not one but two quaint commercial centers: a line-up away from the lake with a café and an outdoor sports store, and a block-long waterfront venue anchored by a popular bar and a restaurant. Between these two centers lies the luxurious Abbey Resort and Spa, a Fontana landmark since the 1960s.

Recently refurbished, The Abbey is among the largest employers in the village, but it's not the only "big industry" in the area. Tucked directly against the prairie side of Fontana is the village of Walworth, home to the Kikkoman soy sauce plant. Built in 1972, the plant bottles about 30 million gallons of soy sauce annually. A Shinto priest blessed the site, ensuring that heavenly powers would always smile upon it.

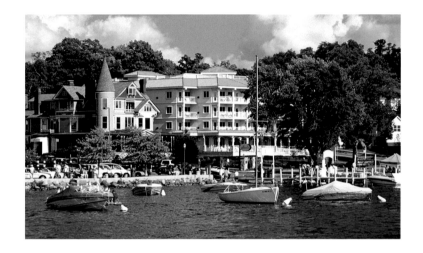

LEFT **HISTORIC LANDMARKS** and modern developments commingle at the Lake Geneva waterfront. The turreted Queen Anne–style mansion (*left*) dates to the 1880s. Today it's home to a gourmet restaurant. Its much younger and larger neighbor (*right*) is an all-suite hotel, linked by a skyway.

ABOVE **GIFT SHOPS AND GALLERIES** line the busy streets of downtown Lake Geneva.

RIGHT **LAKE GENEVA'S PUBLIC BEACH** is a people-watcher's paradise. Visitors pay admission, but local residents swim and sunbathe for free.

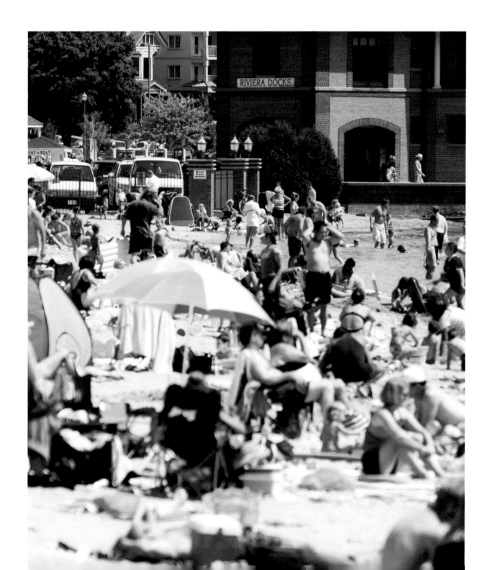

49

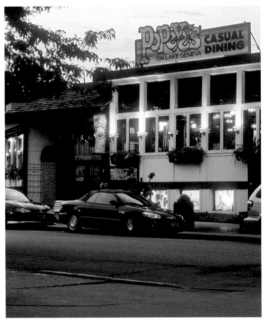

LEFT **THE LINES OFTEN STRETCH** onto the sidewalk outside Popeye's restaurant, a waterfront hotspot in Lake Geneva since 1972. Owner Nick Anagnos (*above*) puts a Greek spin on the menu, but it's the scent of flame-roasted meats slowly turning on the outdoor barbecue that lures customers off the nearby beach.

BELOW **DESIGNED BY A STUDENT** of Frank Lloyd Wright, the Lake Geneva Public Library has over-looked the waterfront since 1954. When summer storms sweep in from the west, readers in the lounge can watch the drama unfold.

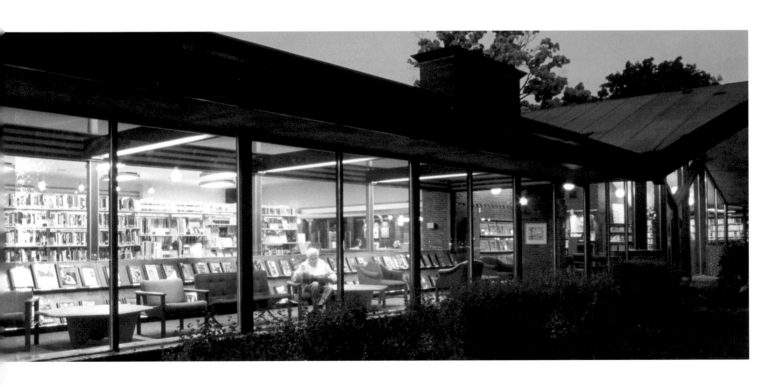

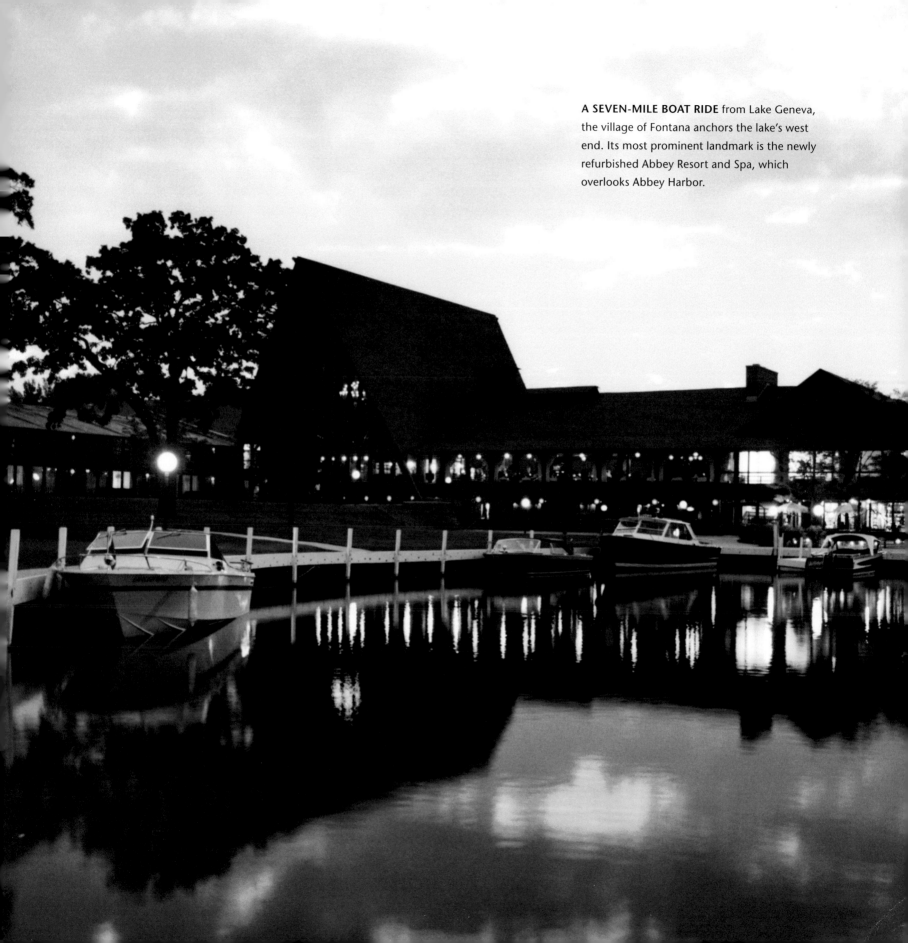

A SEVEN-MILE BOAT RIDE from Lake Geneva, the village of Fontana anchors the lake's west end. Its most prominent landmark is the newly refurbished Abbey Resort and Spa, which overlooks Abbey Harbor.

RIGHT **FONTANA'S LAKEFRONT** scene can be summed up by a single name: Whowell. Here, Tom and Geri Whowell and their family line up across from their waterfront restaurant, Gordy's Boathouse. Next door is Gordy's Lakefront Marine, Gordy's Pro Shop, Gordy's Cobalt Boat Sales, and Gordy's Ski School—all named for Tom's father, the late Gordy Whowell. And just up the street? Tom's brother and sister-in-law operate Chuck's Lakeside Inn, yet another popular hangout.

Nestled along a north-shore cove by the same name, the village of Williams Bay—"the Bay" for short—prides itself on being relatively undeveloped commercially. You won't find a soaring high-rise, a big-box store, or even a national fast-food franchise in the Bay, but the village's quaint business district is growing nonetheless, with a day spa and a collection of independent boutiques. Many of the village's 2,400 year-round residents enjoy their community's quiet character, and they're intent on keeping it. When a futuristic high-rise was proposed for the lakefront some years ago, conservation-minded citizens not only said no, they later set aside prime acreage across from the beach as a wetland preserve.

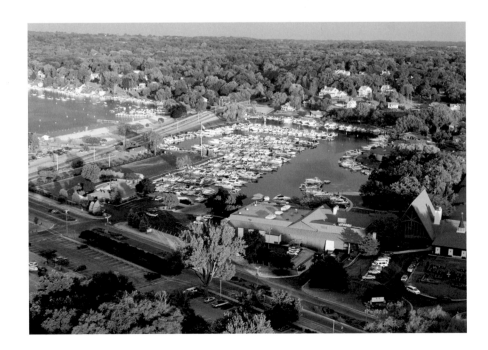

LEFT **THE LAGOON** known as Abbey Harbor was dredged from an 80-acre marsh in the 1960s. A canal provides access to the lake, slipping under a bridge on Lakeshore Drive.

OPPOSITE **EQUIPPED WITH GPS** guidance and ship-to-shore radios, many of these sleek "residents" of Abbey Harbor would be equally at home on Lake Michigan. Fontana has more boats per capita than any other community on the lake.

THE GEORGE WILLIAMS CAMPUS of Aurora University spans more than 240 wooded acres as it climbs toward Yerkes Observatory. Founded in 1886, the campus began as a training institute for YMCA leaders, and it is still used as a retreat for nonprofit groups. Today, however, the university places increased emphasis on education and the arts, offering community music lessons here as well as courses for 11 degree programs.

Although the Bay is the least developed commercially, it's hardly lacking in culture. Within its boundaries lie two of the lake's most important academic landmarks: the campus of Aurora University's George Williams College and Yerkes Observatory. Both are historic institutions dating to the late 1800s. George Williams began as a YMCA camp. With its beautiful old Prairie-style lodges dotting a steep wooded bluff, it is a nexus for the arts,

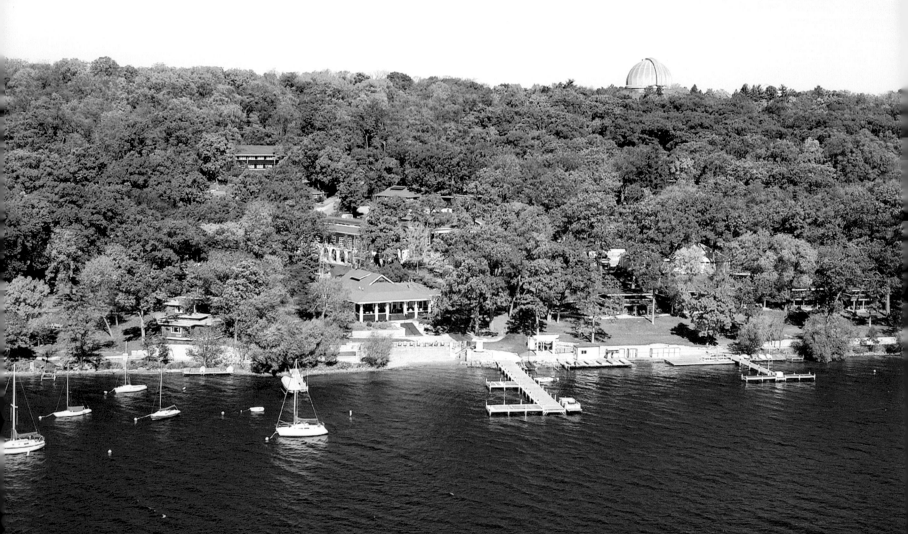

education, and religious retreats. Directly next door, Yerkes has been home to the world's largest refractor telescope since 1897. Astronomers who have worked here include Edwin Hubble, Carl Sagan, and the 1983 Nobel Prize–winner Subrahmanyan Chandrasekhar.

LEFT **YERKES OBSERVATORY** houses the world's largest refractor telescope. Built by the University of Chicago in 1897, the structure forms the shape of a Roman cross, with one great dome at the top and two smaller domes on each "arm." A wonder in its own right, the building's elaborate frieze-work (*above*) depicts myths of the heavens.

OVERLEAF **A RARE AND GLORIOUS** spectacle, the aurora borealis—or the northern lights—paints the midnight sky over Yerkes Observatory.

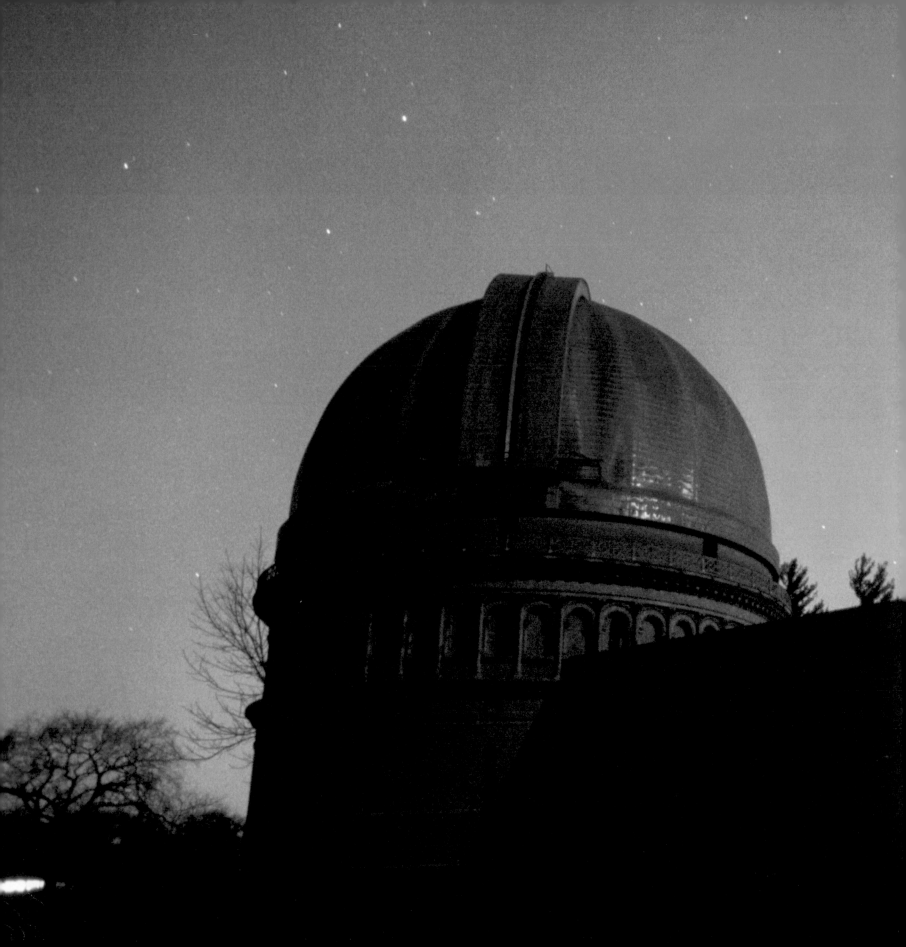

EXPLORING THE SHORE

‿∾

O N MANY DEVELOPED LAKES, the shoreline is impossible to explore. Each lakefront property becomes a tiny kingdom unto itself that no jogger, hiker, or even friendly neighbor might ever pass by, much less visit.

Geneva is different. An enchanting footpath circles the entire lake, seldom wandering more than a few yards from the sparkling waterfront. It began as a rough trail used by Native Americans, and while a few sections remain rugged and wild, today the path is as varied as the homes that border it. Some of the oldest estates feature brick or cobblestone walks worn smooth by more than a century of use. Far from town, the trail may be barely visible in an otherwise unmarked lawn. Elsewhere a stone or crushed gravel walk wends through magnificent gardens, and wooden bridges arch over slender streams.

RIGHT **A 21-MILE FOOTPATH** circles the entire lake, climbing bluff tops when the actual waterfront is impassable. Sometimes rugged but always charming, the path is a public right-of-way. Gardens and piers remain private.

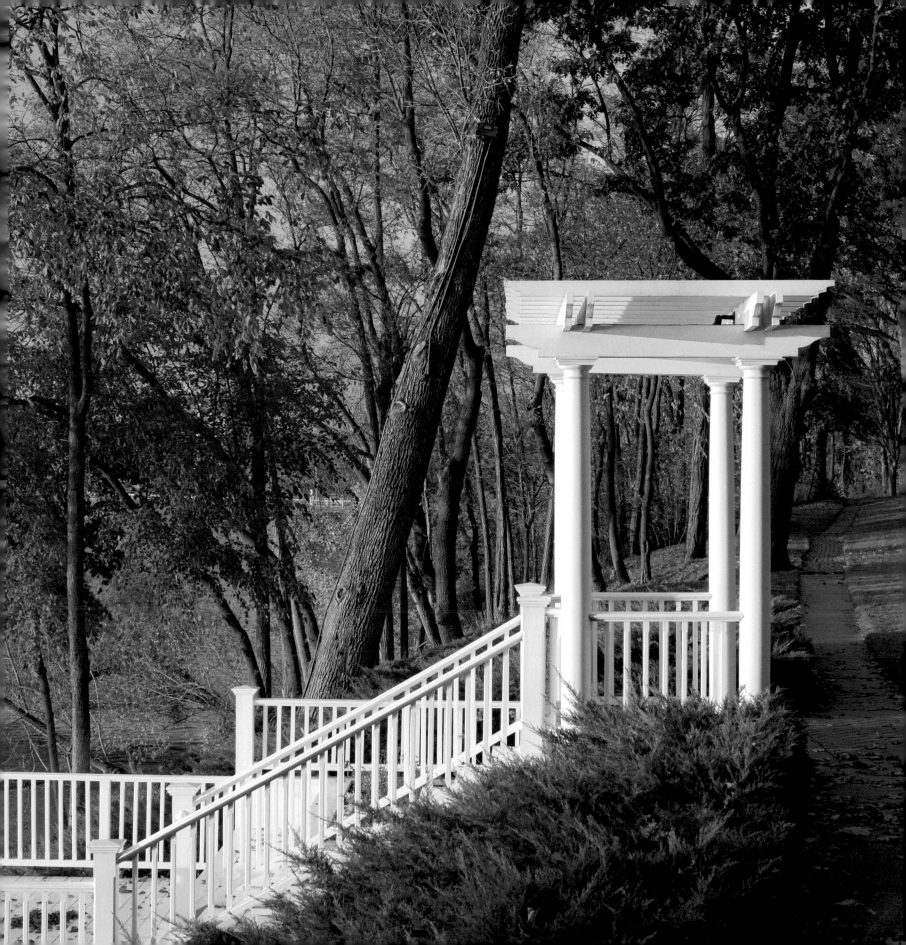

PROFILE
Maggie Gage

Few know the history of the lakeshore and its families as intimately as Maggie Burns Gage, who literally wrote the book on the subject. In the 1970s, she and co-author Ann Wolfmeyer published *Lake Geneva: Newport of the West,* a definitive guide to more than 50 great estates built between 1870 and 1920. The true stories within are an entertaining read, but they've also improved the guided tours on the *Lady of the Lake,* which Maggie's late husband and his father launched in 1963. "Before Maggie came along, we made up a lot of things," admits one former captain.

Maggie met Bill Gage at UW-Madison, where she earned a degree in history and another in journalism. A girl from Green Bay, she first visited Lake Geneva when Bill took her to a ball at Stone Manor. "This has always been a place of great summer romance," she says. Apparently so; the couple married in 1964. By then, Bill was already helping his father, Russell, with a boatyard and an excursion business known as Gage Marine. As they expanded their fleet, Maggie settled in and learned her way around the lake. "I'm still a newcomer," she jokes. "I've only been here 40 years."

By some measures, even Bill's family was new: The Gages had only summered on Geneva Lake since 1916. As Maggie researched her book and raised a son (Bill, Jr., who now runs Gage Marine), she discovered that many of her neighbors could trace their lakeshore roots to the 1800s. That great continuity of family is one of the things she appreciates most about the lake, especially when it's expressed through simple pleasures, such as a friend's annual volleyball game by the shore, with multiple generations at play.

Many Gage family traditions center on boating, and one boat in particular: the *Matriark.* An elegant blue pleasure yacht with clipper-style bow, it first cruised the lake in 1899. Russ Gage bought the 87-foot vessel when Bill was just 13, and they restored it together. Maggie never tires of taking family and friends out to watch the Sunday regattas. "All the children get a chance to steer and ring the bell," she says. "And we don't mind cookie crumbs." Twilight cruises hold a special place in her heart. "We'd be sitting on deck . . . and there would be always a moment of dead silence, with nobody saying a thing. Then finally, someone would whisper, 'It just doesn't get any better than this.'"

Shore-dwellers not only accept this shared right-of-way, most of them embrace it. They lace up their tennies for a morning jog or a moonlight stroll, or use the path to breeze into town and visit friends. For the intrepid, hiking the entire 21-mile trail in a single day is a rite of passage—a goal to be accomplished at least once in a lifetime. Author John R. Powers fondly recalls the time he circled the lake with his 11-year-old daughter at his side. She wanted to share an experience they'd remember forever, and though he doubted she would go the distance, he was wrong. As they walked in darkness at the journey's end, she announced that they had traveled "from the sun to the moon."

Others explore the shoreline one leg at a time. With public access limited to downtown parks and a few roads that intersect the shore, the path naturally breaks into seven segments, each under 3.5 miles. Every jaunt reveals another chapter in the lake's rich history, passing by landmark mansions and century-old camps interspersed with charming 1920s cottages and more modern developments.

The path isn't the only way to explore the shore, of course: Many visitors prefer a more leisurely approach, circling Geneva on the majestic paddlewheeler known as the *Lady of the Lake* or one of her companions in the Gage Marine fleet. Scenic and engaging, these guided tours are a fine way to hear tales of the lakeshore's past and present.

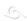

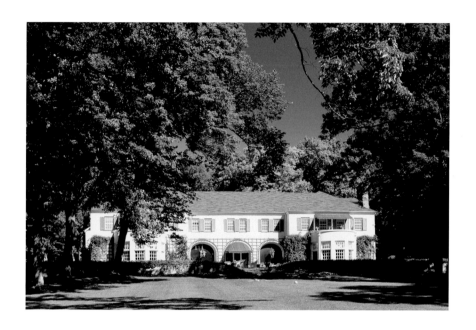

LEFT **A NORTH-SHORE LANDMARK,** "House in the Woods" was constructed under an enormous circus tent during the winter of 1905. (The winter headquarters for several big circuses lay about 10 miles west at the time, and a rogue elephant sometimes roamed the countryside.) With perpendicular wings and a detached artist's studio behind it, the U-shape mansion features an inner courtyard away from the lake.

RIGHT **THE VILLA KNOWN** as Casa del Sueño ("House of Dreams") has graced the south shore since 1930. Former owner William J. Bell created the soap opera *The Young and the Restless* here during the 1970s with his wife, Lee Phillip Bell; they sometimes broadcast her Chicago TV show from the pier. The Bells eventually moved to California, but their children (now grown) still return.

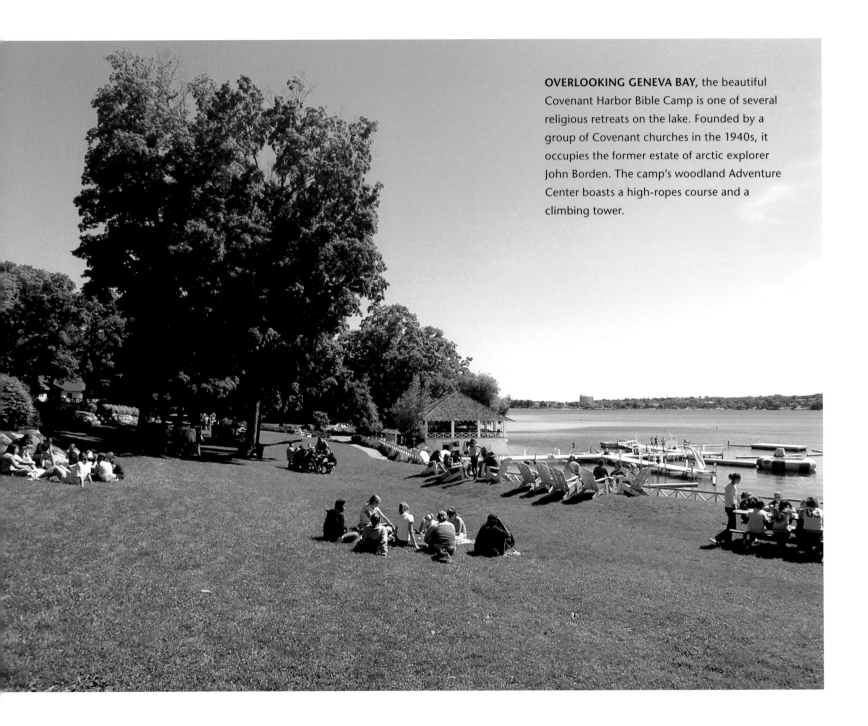

OVERLOOKING GENEVA BAY, the beautiful Covenant Harbor Bible Camp is one of several religious retreats on the lake. Founded by a group of Covenant churches in the 1940s, it occupies the former estate of arctic explorer John Borden. The camp's woodland Adventure Center boasts a high-ropes course and a climbing tower.

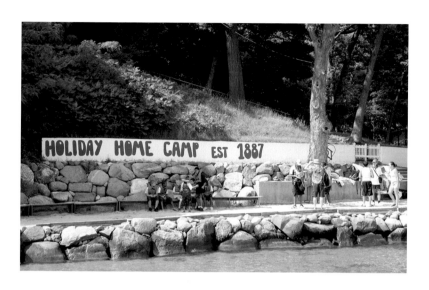

ABOVE **PART OF THE EXCURSION** fleet owned by Gage Marine, the *Grand Belle of Geneva* tours the lake from mid-April through October.

ABOVE **A NORTH-SHORE LEGACY,** the camp known as Holiday Home has hosted inner-city and at-risk urban youth since 1887. It was founded by the Fresh Air Society, a group of Chicago women who gave children working in the city's factories a much-needed summer respite. The camp still relies on donations and grants to cover most expenses.

RIGHT **YEARS AGO,** local newspapers reported sightings of a "lake monster" reminiscent of Scotland's infamous Nessie. (The Lake Geneva library includes a file.) No monsters have been spotted by shore-watchers lately—unless you count this fun-seeking fellow in Geneva Bay.

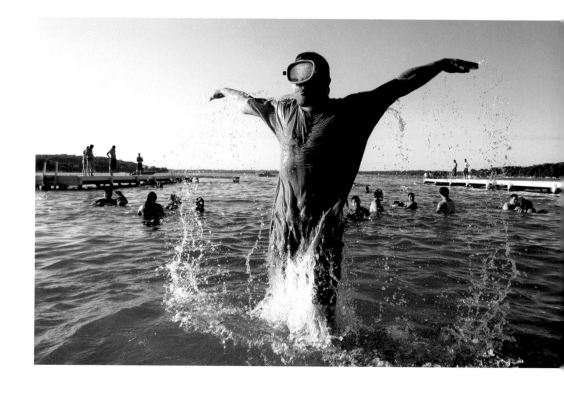

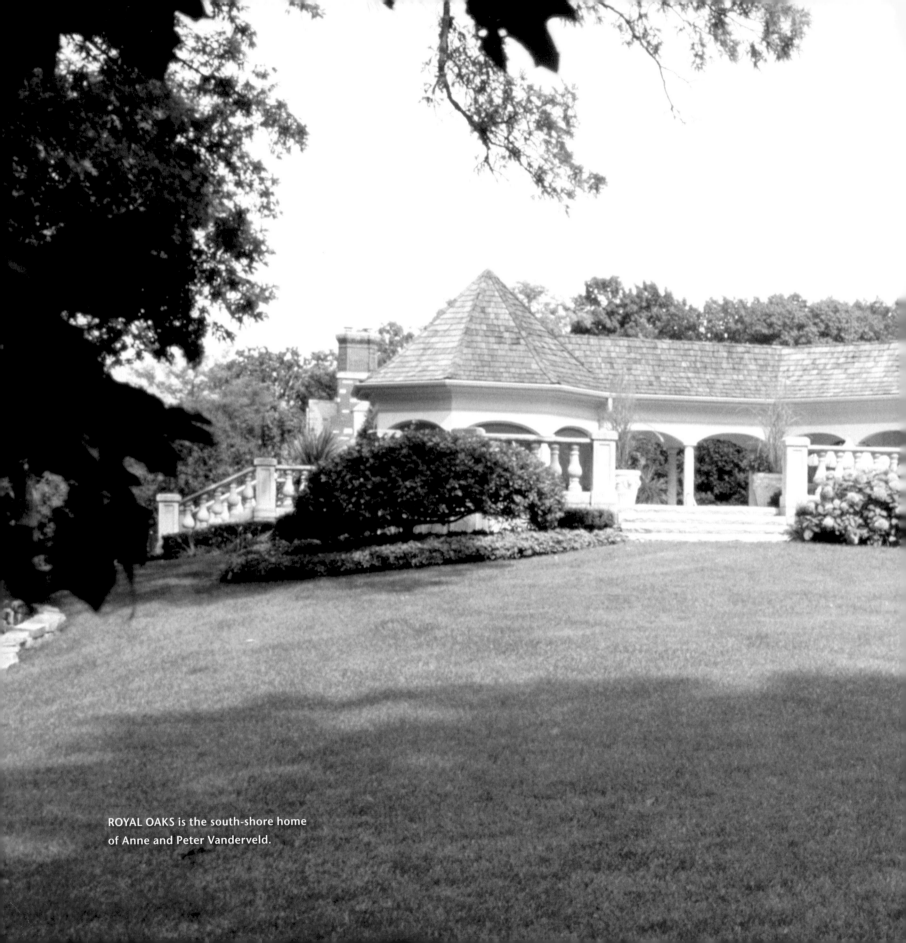

ROYAL OAKS is the south-shore home
of Anne and Peter Vanderveld.

PART III
HOMES & HAVENS

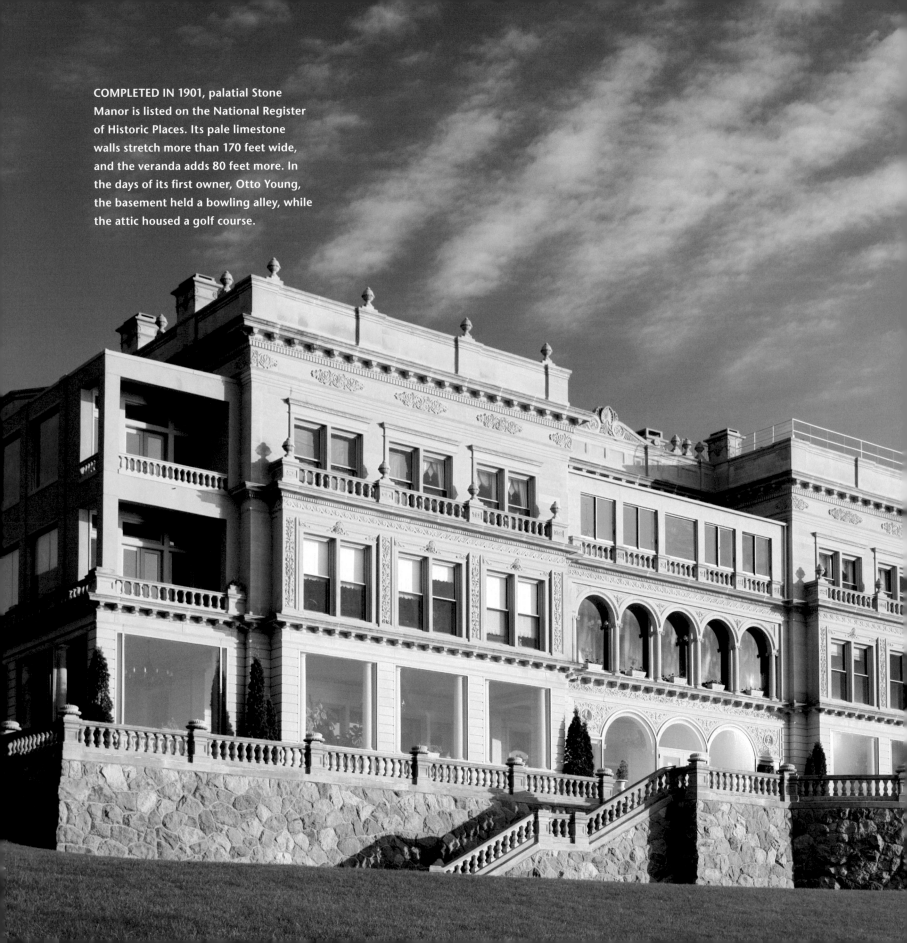

COMPLETED IN 1901, palatial Stone Manor is listed on the National Register of Historic Places. Its pale limestone walls stretch more than 170 feet wide, and the veranda adds 80 feet more. In the days of its first owner, Otto Young, the basement held a bowling alley, while the attic housed a golf course.

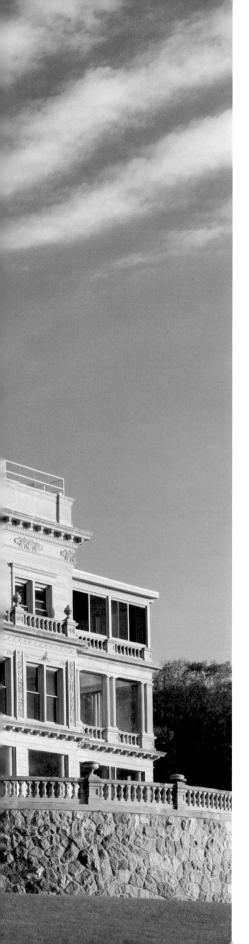

STONE MANOR

⁓

O N THE SOUTH SHORE OF GENEVA BAY, a monolith known as Stone Manor rises from a vast sweep of emerald lawn. If only one home on the lake could be called "palatial," it would this one. Designed by architect Henry Lord Gay and completed in 1901, the 50,000-square-foot landmark is one of the nation's most striking examples of Italian Renaissance style.

The mansion was built for Otto Young, a wholesale jeweler who became a Chicago real-estate tycoon in the wake of the Great Fire of 1871. Even today, rumors persist that Young was not fully accepted by Lake Geneva's early "in" crowd, so he decided to create an estate that would outshine all others. Whatever his reasons, Young poured well over a million dollars into the project—at a time when neighboring mansions cost a tenth as much. Amenities included a ballroom, nine immense bedroom suites on the second floor (each with an adjoining bath), and another fourteen bedrooms on the floor above. The basement featured a bowling alley; the attic, a nine-hole golf course. Despite these extravagances, most of the expense came from the mansion's incredibly lavish interior detail. Hand-carved plaster reliefs and costly murals covered the ceilings, while precious woods and hand-woven tapestries adorned the walls. Strands of crystals and natural pearls dangled from light fixtures plated in silver and 18-karat gold.

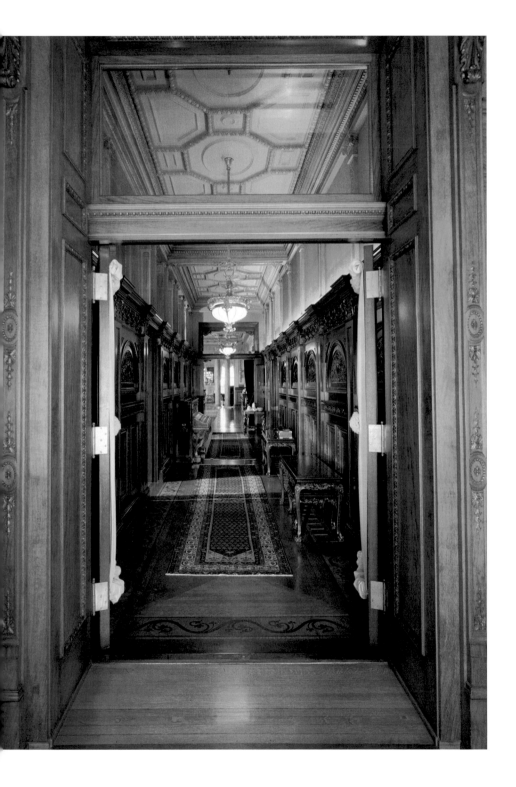

Amazingly, much of that original detailing remains, especially in the first floor, which has become a 12,000-square-foot condominium owned by Drs. Nader and Mandan Bozorgi of Lake Forest, Illinois. The Bozorgis began renovating their lakeshore getaway in the early 1990s, after investor Thomas Ricci bought the upper floors (now four other condos). By that time, the mansion had decayed so badly that it was barely habitable. Water dripped through the ornate ceilings like the tears of a dying landmark. All told, Ricci and the Bozorgis invested more than $4 million in the painstaking restoration. Work in the first-floor apartment alone spanned eight years, and it continues on the floors above.

The Bozorgis have owned property on Geneva Lake since 1972, when they purchased a Fontana home to enjoy with their children. "We bought the house to have family time," says Mandan, an OB-GYN like her husband (both have recently retired from active practice). "For 15 years, we would come straight to the lake to relax."

Now Stone Manor is the Bozorgis' place to relax, in a setting that is matchless. In 1993, one of their children was married here, and today it's a favorite hangout for their grandchildren.

LEFT **OPEN TRANSOMS** on three walls capture sunlight from adjoining spaces to illuminate this inner gallery. Young's precious art collection once hung above the wainscoting.

If These Walls Could Talk...

Touring Stone Manor now, it's difficult to imagine the decay the Bozorgis and Ricci faced when they purchased it—or the checkered past that led it to such a state. Few mansions on the lake have a story this strange.

After Otto Young died in 1906, his wife and four daughters had little to do with it. For decades, Younglands—as Young had called it—was largely abandoned, its furnishings draped in sheets. When questioned after a 1930s robbery, a watchman from the Pinkerton agency claimed he had been clubbed over the head, kidnapped by unknown parties, and then unceremoniously dumped in Chicago.

In 1938, Young's granddaughter gave the estate to the Order of St. Anne for use as a girls' school. When upkeep of the manor proved daunting, the Order sold the estate to Soon K. Hahn, a Korean businessman and a consultant to the U.S. military. Initially, Hahn ran a school of his own. He also set up a perfume factory in the estate's massive coach house, which was originally linked to the mansion by an underground tunnel. (The Tudor structure still stands across Lakeshore Drive, and while the tunnel remains as well, it has been sealed for safety.)

RIGHT **THE MANOR'S ELABORATE** ceilings extend even to smaller rooms such as this parlor between the gallery and the lakefront piazza. An original marble fireplace warms the room.

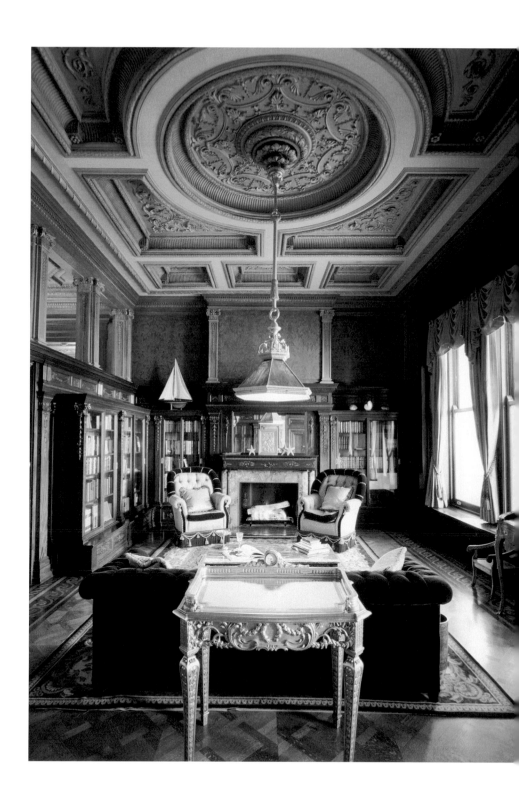

RIGHT MANDAN AND NADER
Bozorgi were passionate about restoring the beauty and the historical integrity of their Stone Manor condo. When buying a piano for the music room—Otto Young's favorite space—they found one matching the age of the mansion.

By the early 1960s, Hahn had transformed the once-elegant mansion into a rough rooming house with a reputation for beer parties and illicit sex. In the words of one county judge, the attractions were not the architecture, but rather "young, unmarried occupants who were apparently more than receptive to the intrusions" of "other outsiders."

Shortly thereafter, John Bihlmire, a businessman and an engineer, snatched up the mansion at auction for roughly $76,000 in back taxes. Despite a string of lawsuits contesting ownership, Bihlmire forged ahead with major renovations. On the first floor, he opened an elegant French restaurant. Overhead, he created apartments. He also installed an elevator that jutted up from the roof like a tin shack, along with a rooftop swimming pool and a ritzy glass-walled penthouse. Like some Hugh Hefner fantasy, the penthouse—essentially a bedroom with a wet bar—could rise from the attic into the open night sky, courtesy of a hydraulic lift.

LEFT THIS MASTER BEDROOM
was originally a formal dining room. The century-old tapestries on the walls, the carefully restored ceilings, the hand-carved woodwork—all are lavishly detailed with fruits of the earth. Glass doors open to the lakefront piazza.

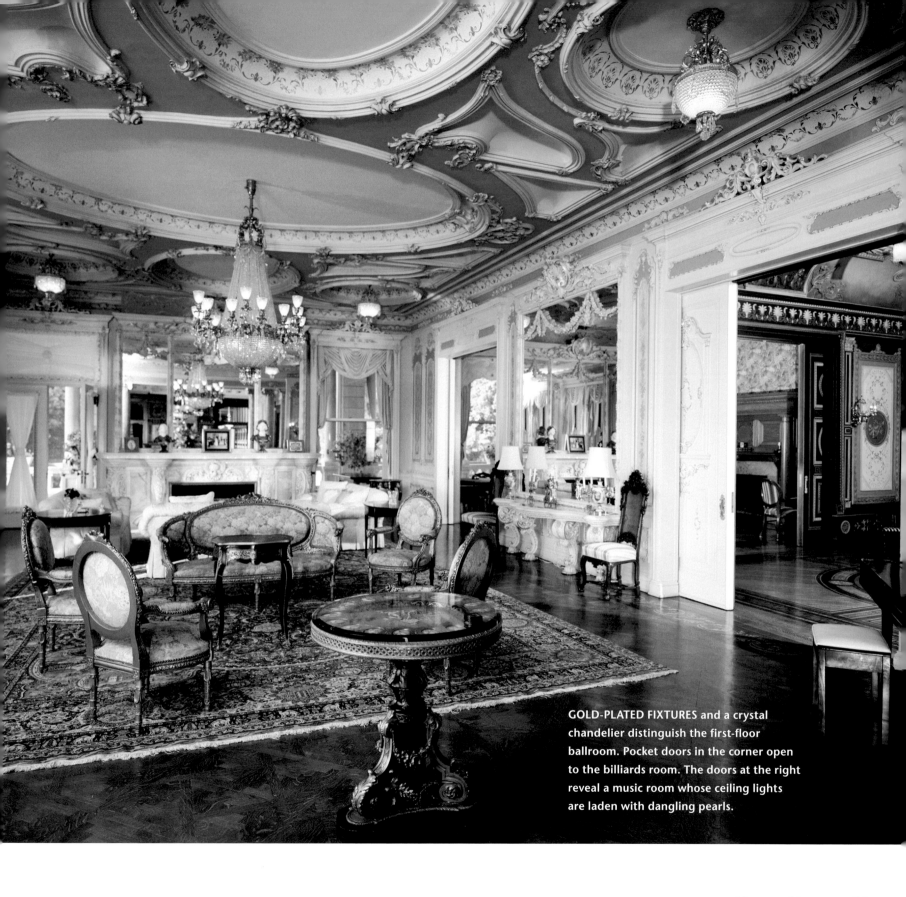

GOLD-PLATED FIXTURES and a crystal chandelier distinguish the first-floor ballroom. Pocket doors in the corner open to the billiards room. The doors at the right reveal a music room whose ceiling lights are laden with dangling pearls.

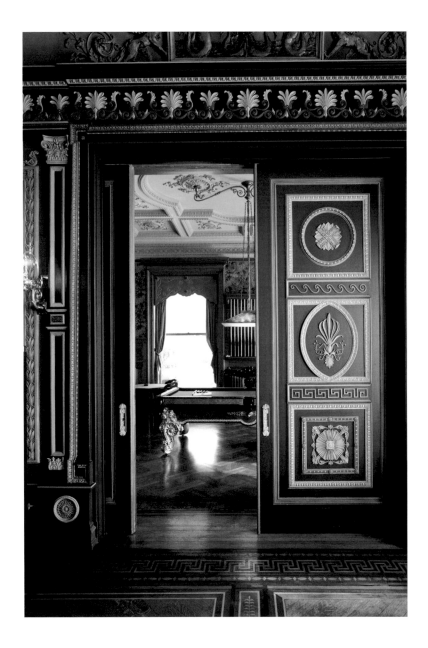

Newspaper accounts paint Bihlmire as a colorful and contentious character. During the mid-1970s, he erected a steel fence to blockade the shore path. When the city and his neighbors protested in court, the fence came down (reaffirming the path's public nature). Then Bihlmire proposed plans to build 40 new condos between the lakeshore and Stone Manor. He never won that right, but worried locals began to woo famed pianist Liberace to the mansion in hopes of creating a "Liberace museum" there. (In an odd twist, Dana Montana—owner of the Sugar Shack, a local nightclub featuring male strippers—played ambassador to the flamboyant entertainer's agent.) "I have no plans to sell," Bihlmire protested, even with tax collectors hounding him. Eventually, of course, he did, and the Bozorgis were among the buyers.

Whatever anyone might think of Bihlmire's antics in court (supposedly he once claimed amnesia as well as illiteracy), the Bozorgis say he was a clever engineer. The glass-walled penthouse endures, though it now rests in the dusty attic. The rooftop pool—invitingly refurbished—remains as well. A structural marvel, its weight is carried to the ground through massive pylons hidden in the mansion's walls.

"If the rest of the building should fall for some reason, that pool would still remain," Nader Bozorgi says. "It would just be very, very hard to use."

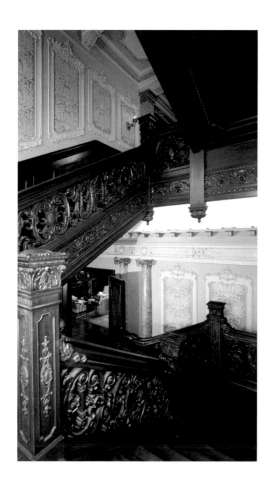

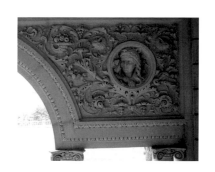

RIGHT **FEATURED IN A SERIES** of stone reliefs, Otto Young's four daughters still watch over Stone Manor. This lovely girl adorns the first-floor piazza.

ABOVE **THE BROAD STAIRWAY** in the foyer is now shared by all the residents of Stone Manor—as is the rooftop pool.

RIGHT **APART FROM THE ATTIC** and basement, each level of Stone Manor boasts a lakefront piazza. This outlook belongs to a second-story condo. The modern windows slide completely open, capturing the original open-air flavor.

A NIGHT TO REMEMBER

ENTERTAINING AT THE MANOR

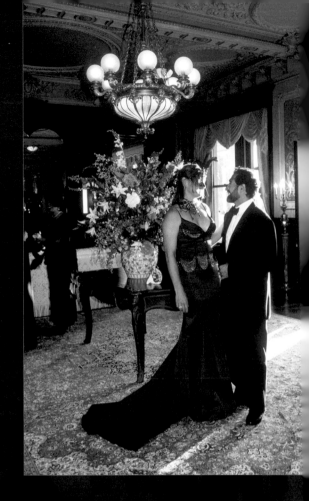

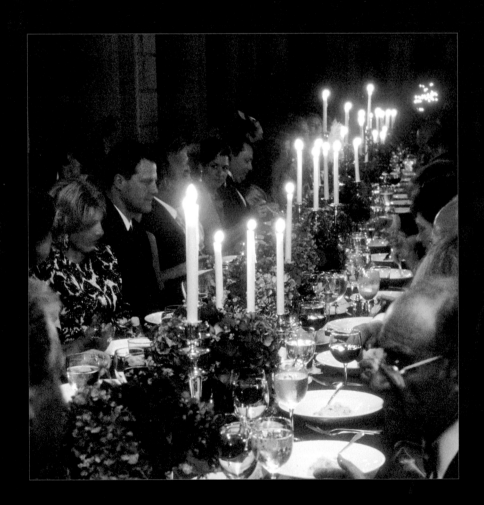

ABOVE **THE GRANDLY SCALED** piazza easily accommodated a formal dinner for more than 60 guests.

IT WAS A CONVERGENCE of perfection: the right place, the right time, the right plan. To assist with a fundraiser for their grandchildren's school in Lake Forest, Illinois, Nader and Mandan Bozorgi offered the use of their Stone Manor apartment to their son, Dr. Kenny Bozorgi. In turn, Kenny and his wife, Susan, put a party up for auction, allowing 32 couples to bid for the pleasure of an early fall evening at the mansion. The Bozorgis' theme: A Venetian Night, with cocktail cruises on the bay followed by dinner and entertainment. It was truly *una notte di ricordare*!

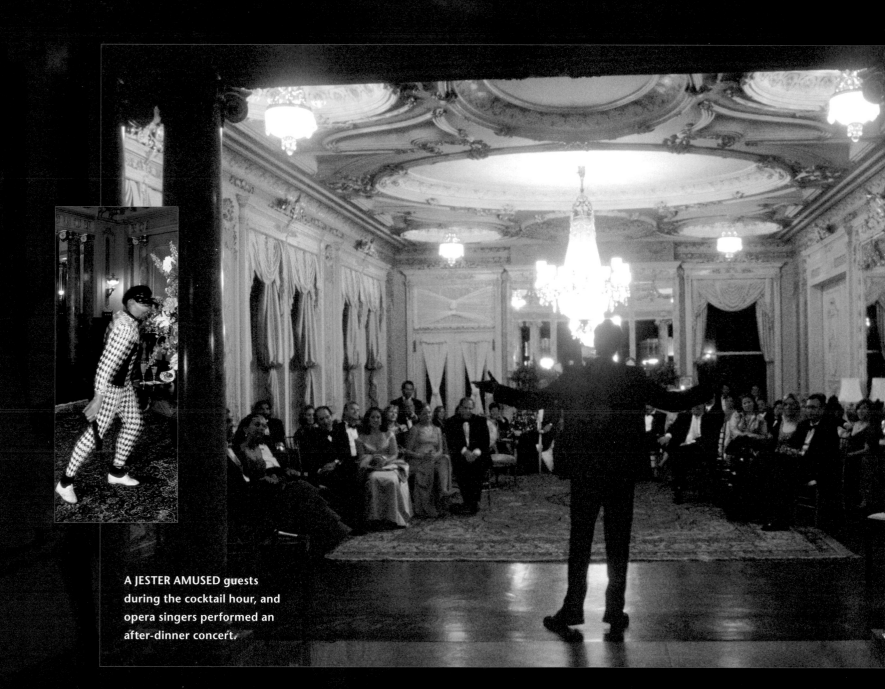

OPPOSITE **KENNY AND SUSAN** Bozorgi hosted the evening's event. Venetian masks lent a playful note to a grand fantasy.

A JESTER AMUSED guests during the cocktail hour, and opera singers performed an after-dinner concert.

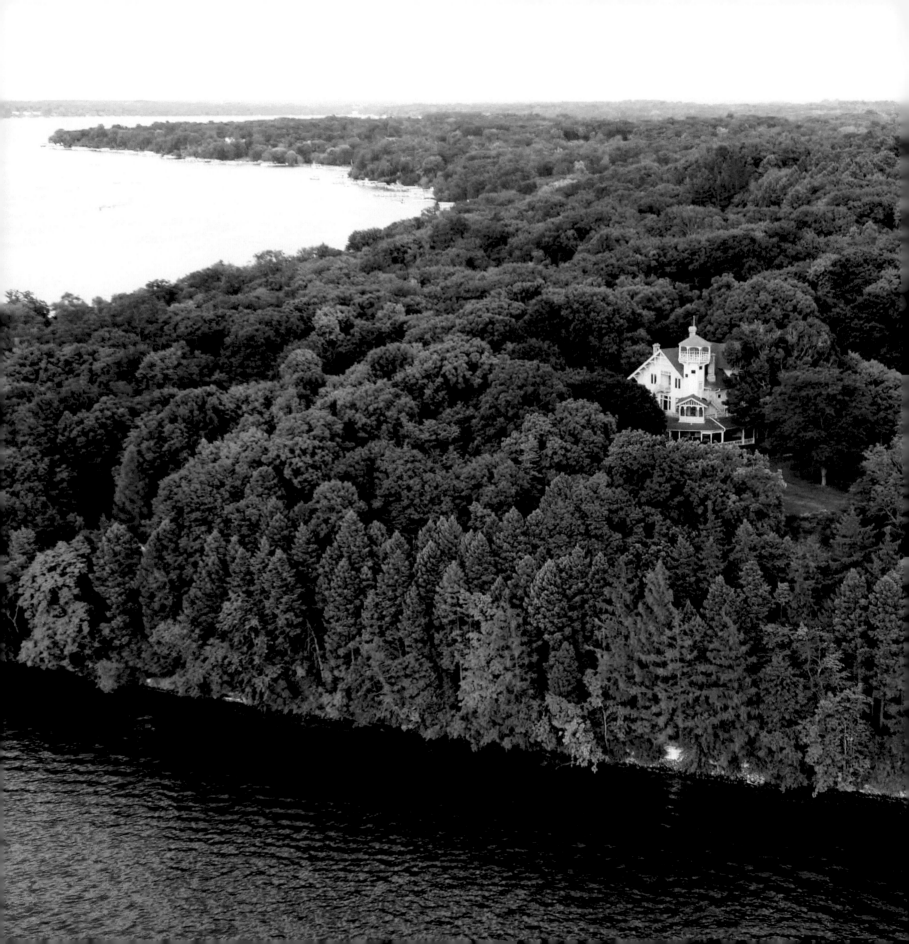

BLACK POINT

 ᴮᴵᴸᴸ ᴾᴱᵀᴱᴿˢᴱᴺ ᵂᴬˢ washing his car in one of Geneva Lake's most secluded enclaves when a township official strolled up and asked, "Have you ever thought of giving this place to the public?"

"This place" is Black Point, a splendid summerhouse perched atop a deeply wooded promontory by the same name. The Queen Anne–style mansion has been in Petersen's family since 1888, when it was built by his great-grandparents, Conrad and Catharine Seipp. Decade after decade, Black Point has been the center of a large extended family that has always valued time with each other over ostentatious living.

Giving away such a legacy might be unthinkable to some, but to Petersen, a retired attorney, it was the only sure way to save it. "I knew it couldn't last," says Bill. "Our family had dispersed, and no one in the next generation could handle the taxes and upkeep." Moreover, no prospective buyer possessed the desire and deep pockets needed to preserve an unheated antique on coveted land. So, in 2005, Petersen officially gave the house to the people of Wisconsin, along with virtually all its contents, seven surrounding acres, and more than 600 feet of the lake's wildest shoreline.

OPPOSITE **IN 1888, CONRAD SEIPP** built this summer mansion nearly 100 feet above the lake, but its four-story tower soars even higher. Originally called Loreley, the estate soon took the name of its lushly wooded perch, which the Potawatomi called *Makate Neashe,* or "Black Point."

The 20-room mansion appears on the National Register of Historic Places, but it's much more than a landmark—it's a portal to another era. Most of the furnishings are original, right down to the china in the dining-room cabinets. Since many of the pieces were brought from Conrad and Catharine's older Chicago home, they actually predate the walls around them. A furniture collection designed by architect Adolph Cudell (who also created Black Point) was featured in a temporary exhibit at Washington's Smithsonian Institute.

A WORLD APART

BORN IN 1926, Bill Petersen has summered at Black Point "since I was zero." During his childhood, grandmother Emma Seipp Schmidt was mistress of the mansion, and she readily shared tales of the estate's earliest days. The biggest difference between then and now was isolation. Before 1920, only the poorest of roads surrounded the lake, so Black Point was a world apart. Guests and family members came from Chicago to Williams Bay by train, then cruised to the estate aboard the Seipps' private steam yacht.

Petersen's uncle fondly recalled waking to sounds of the yacht's crew, who would stoke coal and toot the whistle. The vessel steamed to Lake Geneva for supplies every Friday, and until Monday it cruised the lake for outings and social visits. But during the week, Petersen says, all who lingered "basically stayed put" at Black Point.

ABOVE **EVEN THE AFTERNOON** shadows stretch out languidly on the deep veranda. Cool and inviting, it wraps three sides of the cottage, with access to several adjoining rooms.

The estate was largely self-sustaining. A successful brewer, Conrad Seipp had initially purchased 27 acres on the Point, but by the turn of the century, the estate embraced more than 100 acres, including a 40-acre farm. Eggs, chickens, milk, cream, fruits, vegetables—virtually everything came to the table fresh, including flowers cut from the estate's gardens. There was no such thing as "dining out." The household staff served an average of 20 people in the dining room or on the porch—three times a day, seven days a week. (The house had 13 bedrooms, but most had more than one bed, and they were usually filled.)

By the 1920s, traditions on the Point had changed very little, apart from the arrival of motorcars. Petersen's boyhood days started promptly at 8:15 AM, when everyone sat down together for breakfast. In fact, every meal was a congenial sit-down affair, as well as a culinary pleasure. "It wasn't a fancy menu, but we ate very well," Bill says, recounting such mouth-watering delights as homemade cherry juice, apple pie, fresh-pressed cider, white asparagus, and "a wonderful sorrel soup."

Many of the ingredients were picked by Petersen, along with his two older brothers and a contingent of cousins who summered at the Point. "It wasn't all laziness and elegant living," Bill says. "We had chores every day." Besides picking fruit and vegetables, the children helped tend horses on the farm. "And I've scrubbed this porch more times than I can count," Bill adds, describing a task that continued long after he began managing the estate in the late 1960s.

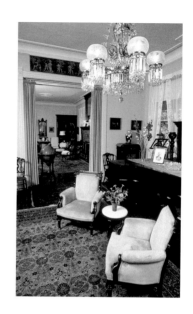

RIGHT **THE MANSION** is filled with original furnishings, many of which predate the house. For the Seipps' musical family, the Chickering grand piano was the nexus of nightly gatherings.

BELOW **AS STEAM YACHTS** gave way to automobiles, this side path became the main approach to the house. A tranquil pool with a fountain accents the garden.

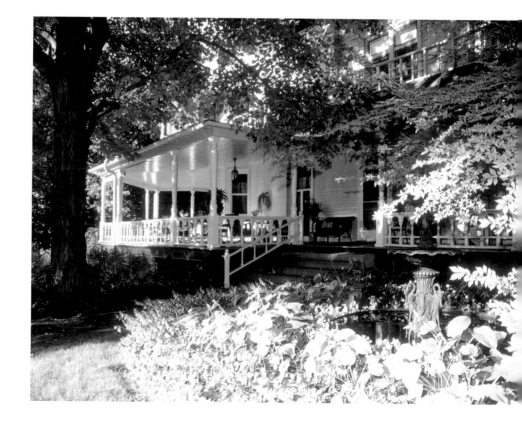

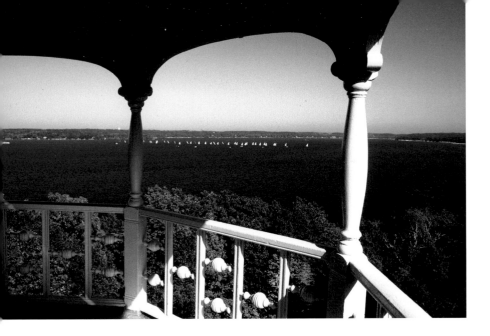

After breakfast, Petersen trekked off to sailing school or tennis lessons, and in the afternoons, all the children met with a tutor for German lessons and other mental gymnastics. (Bill's great-grandparents emigrated from Germany, and German was often spoken at Black Point.) After dinner, half the family gathered on one side of the house to read, while Bill's grandmother played the Chickering grand piano. Others stepped across the hall to the billiards room, racking up games on a table Conrad Seipp had purchased in 1871. The piano, the billiards table, and an immense wooden dollhouse made by Conrad for his daughters—all still endure, well used and well loved.

ONE BATH, NO KITCHEN

THOUGH TIME HAS left the house remarkably unchanged, it would be wrong to say there have been *no* updates. Originally, only one full bath served the house. (In those days, a dip in the lake often washed away grime, and a porcelain chamber pot was tucked discreetly under every bed.) Now the mansion has six baths, many squeezed into former closets.

Its kitchen is another "modern" update. Until the 1940s, a detached service building housed the original kitchen, as well as a laundry and quarters for household staff. That building was demolished shortly after Bill's mother, Mrs. William F. Petersen (*née* Alma Schmidt), became mistress of Black Point in 1942.

The years have brought changes to the surrounding acreage as well. The estate was divided twice during the 20th century, with land sold and homes added. Bill's great-grandmother built a charming white house in the woods so she could enjoy the Point year-round. (Now owned by another family, it still overlooks a clearing that Petersen played in as a child.) Bill's brother Edward built a lakefront house just east of the mansion, and Bill himself built a Shingle-style cottage immediately to the west. (It, too, will eventually go to the state.) Yet every spring he and his wife, Jane (now deceased), would rent out that cottage and move into "the big house" to welcome a stream of family and friends the entire summer long.

Petersen couldn't imagine it any other way. "After we were grown," says Bill, "we never even thought to ask our parents whether we were invited. We'd just come. We were spoiled here . . . and we still are."

Now it's the public's turn to be spoiled. After planning and preparation, the mansion is expected to open for limited tours in 2007.

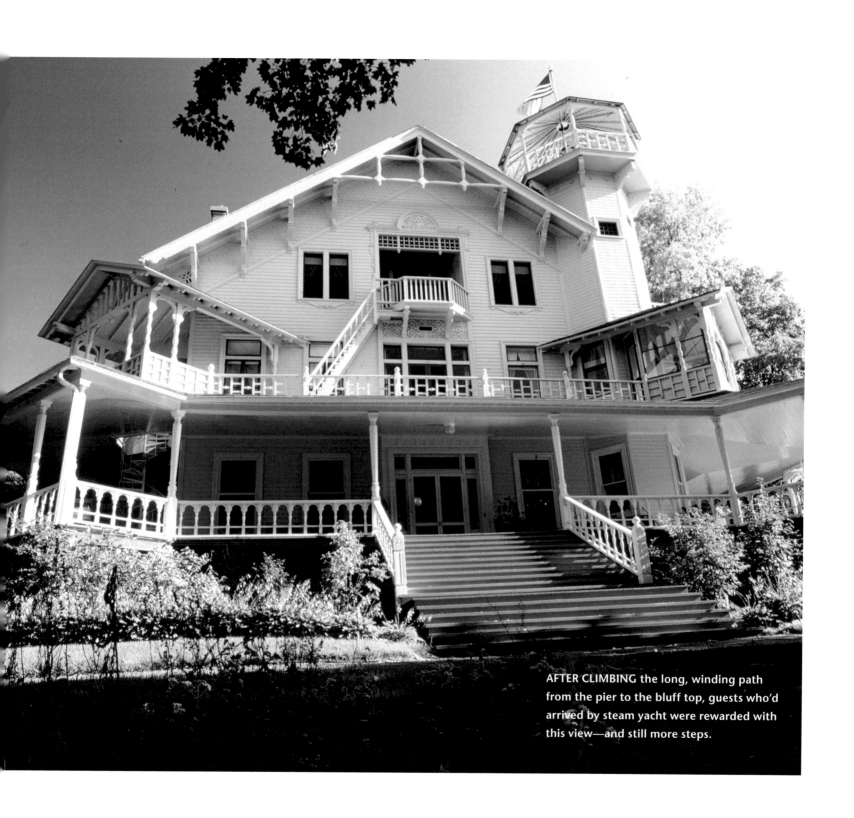

AFTER CLIMBING the long, winding path from the pier to the bluff top, guests who'd arrived by steam yacht were rewarded with this view—and still more steps.

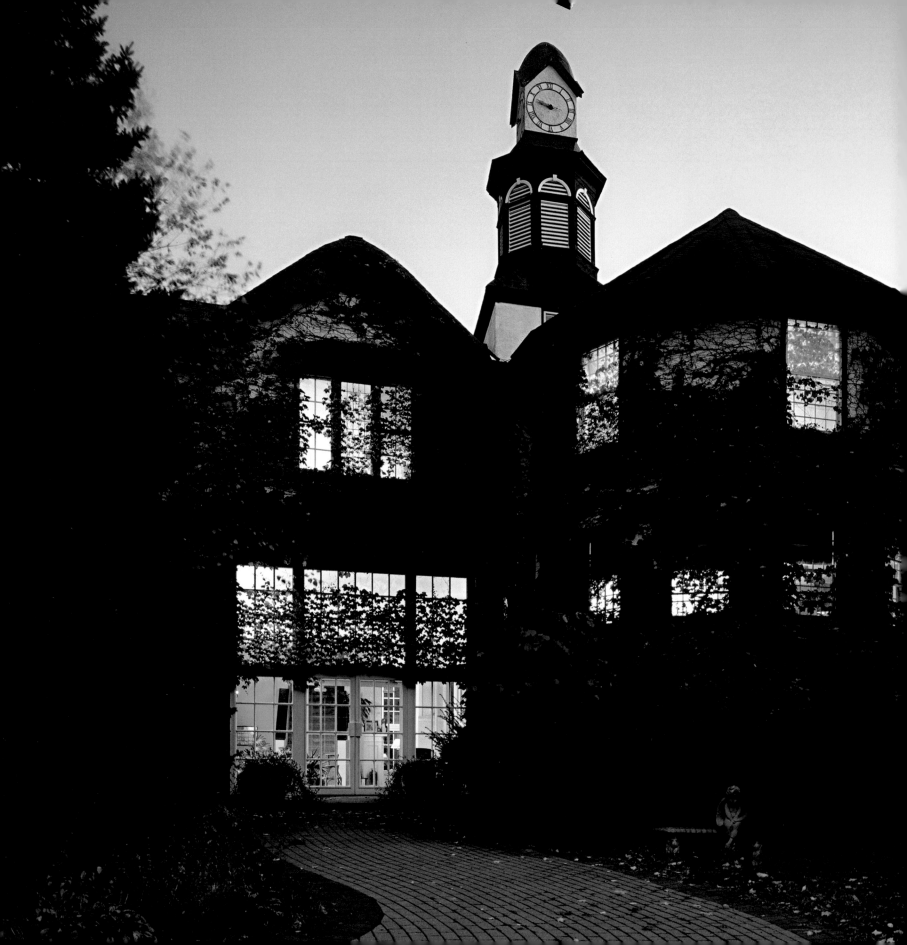

LORAMOOR

❧

I F HOMES SHOULD SUIT their owners, then Joe and Marie Martin's place is a perfect fit. It's open and casual, a little bit quirky, and definitely one-of-a-kind. What would you expect from a prolific cartoonist—or a century-old structure that began as a stable for thoroughbreds and later became a library for Franciscan monks?

The landmark building once belonged to Loramoor, a lavish 400-acre estate created by Nabisco-financier James Hobart Moore in the early 1900s. Moore's gothic mansion fell to the wrecking ball in the mid-1980s, and the stable was just days from the same fate when Joe and Marie bought it in 1988. Preservation certainly played a part in their decision, but mostly, "it was love at first sight," Marie says.

Designed by architect Jarvis Hunt, the structure originally housed 60 fine horses, a fleet of carriages, and more than a dozen horsemen. Moore's treasured animals pranced on soft wicker mats, and their oak stalls had fancy brass rails and fittings. The immense building resembled an oval ring with an outdoor arena at the center. A long, curving row of stalls (now gone) formed half of the oval. The other half (still standing) featured a central tower flanked by two-story wings, with quarters for grooms and riders upstairs.

LEFT **JOE AND MARIE MARTIN'S** stable-turned-home once belonged to Loramoor, a 400-acre south-shore estate created by financier J.H. Moore.

PROFILE
Joe Martin

Armed with a fat notebook and a suitably warped sense of humor, cartoonist Joe Martin often camps for hours at a Lake Geneva coffee shop, quietly dreaming up jokes. "I have to be in a public place to write so I won't fall asleep," says Joe, who launched his popular syndicated feature, *Mister Boffo,* shortly after he moved here from Oak Park, Illinois, in 1985.

When he's not sipping coffee, Martin walks along the lakeshore or rows a dinghy, pausing to pull out his notebook whenever inspiration strikes. He used to stroll in Oak Park, but that was far more problematic: Wary residents would mistake him for a transient (or worse) and call police. "Oddly enough, here [in Lake Geneva] I can walk around and laugh out loud and do pretty much anything I want," Joe says. "Everybody just thinks I'm a tourist."

In fact, Martin has become the world's most prolific cartoonist, according to the *Guinness Book of World Records.* Besides the offbeat *Mister Boffo,* he pens the strips *Willie 'n Ethel, Cats with Hands, Porterfield,* and the new *Haley and Hardy* (about misfit fitness gurus). With Dr. Jon Carlson, a local psychologist, he's writing *On the Edge* (a bit of "humor therapy"). All that, and he recently launched his own syndicate.

Success hardly came overnight. Martin began drawing cartoons—and reading monthly rejection letters—at 16. That same year, he married, and by 21, he was a divorced father of four boys. While running an employment agency, he met and married Marie (now his editor and the mother of his fifth son). All the while, Martin continued to write jokes, and though he began to be published at 29 in the early 1970s, it was 1986 before *Boffo* hit it big. The strip was an outlet for his "crazy jokes," he says. Some are quite dark—like the classic in which a condemned prisoner holds a slice of bread in each hand while sitting on the electric chair, "making the best of a bad situation."

In person, Martin's humor is sometimes so deadpan that it's hard to know when he's serious. But one thing is certain: This is not your average Joe.

Franciscan monks bought Loramoor in the 1950s and eventually converted the stable into their library. Even so, much work remained to make the building habitable. Joe and Marie added seven fireplaces and built multilevel platforms to define living areas in the wide-open spaces. The original carriage room became a 2,500-square-foot theater where the Martins show movies and stage full-scale productions. Among the highlights is a musical that Joe wrote to benefit the Twin Oaks Shelter for the Homeless (a 90-day emergency shelter that the couple was instrumental in creating).

Many of the stable hands' quarters have become bedrooms for visiting family and guests. The Martins are technically empty-nesters, but with five children and 11 grandchildren, their nest is seldom empty. Thanks to their "come anytime" attitude, the weekenders often number 40 or more.

For the past 10 years, Joe and Marie have had a "getaway home" on North Carolina's Outer Banks, but Lake Geneva always calls them back. "Most lake towns are dead during the week," Joe says, "but this is a lively place. There always seems to be a supply of interesting people."

OPPOSITE **THIS VIEW CIRCA 1904** shows the Loramoor stable in its original glory.

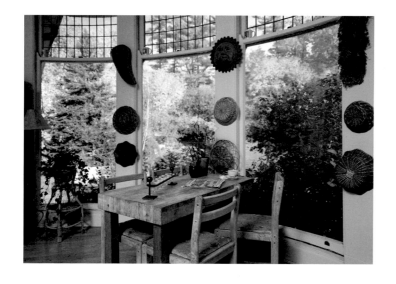

LEFT **NESTLED IN A CURVED** observation tower, this eat-in kitchen overlooks the Martins' backyard, which was formerly an outdoor arena. Convenient to the cartoonist's at-home work areas, the room is one of three kitchens in the house.

RIGHT **OPPOSITE THE DINING AREA,** the kitchen's built-in bench sits a half-story above the original stable floor. The Martins constructed raised platforms to create the adjoining rooms. Note how the windows pivot on a central axis.

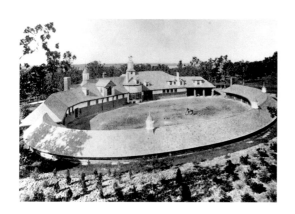

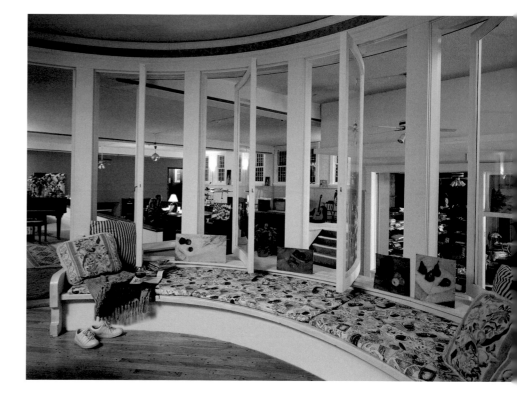

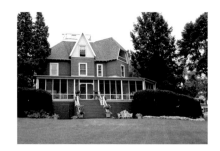

SWINGHURST

I T CERTAINLY *LOOKS* GENTEEL. While a string quartet performs on the veranda, scores of men and women, all dressed in white, sip champagne and play croquet on the lawn. But Marie Kropp—mistress of the games and of the estate called Swinghurst—has never shied away from the truth.

This is the war of the wickets.

"We've had players almost come to blows," Marie says of her annual tournament. It's spirited fun, but the competition is fierce: The players keep swinging even when it rains. "There are a lot of Type-A personalities on this lake," Marie notes.

To ensure the day-into-night event is livelier than it is deadly, she forbids husbands and wives from forming teams, decides who meets on each course, and even hires referees. But the real secret, Marie says, is "keeping everyone well fed."

A rollicking tradition, the annual croquet party was launched in 1986 by Marie and her beau, Charlie Kropp. (The couple was still dating then, but Charlie, recently deceased, already owned Swinghurst.) Theirs was a passionate pairing of a professional singer-pianist called "Miss Marie" and a single father who owned a steel fabrication company. They married at their third croquet tournament in 1989. No announcements preceded the nuptials: Charlie and Marie simply interrupted the game to hold a surprise ceremony. Later Charlie said jokingly, "We managed not to ruin a good party."

To their friends, it was an event that will never be topped.

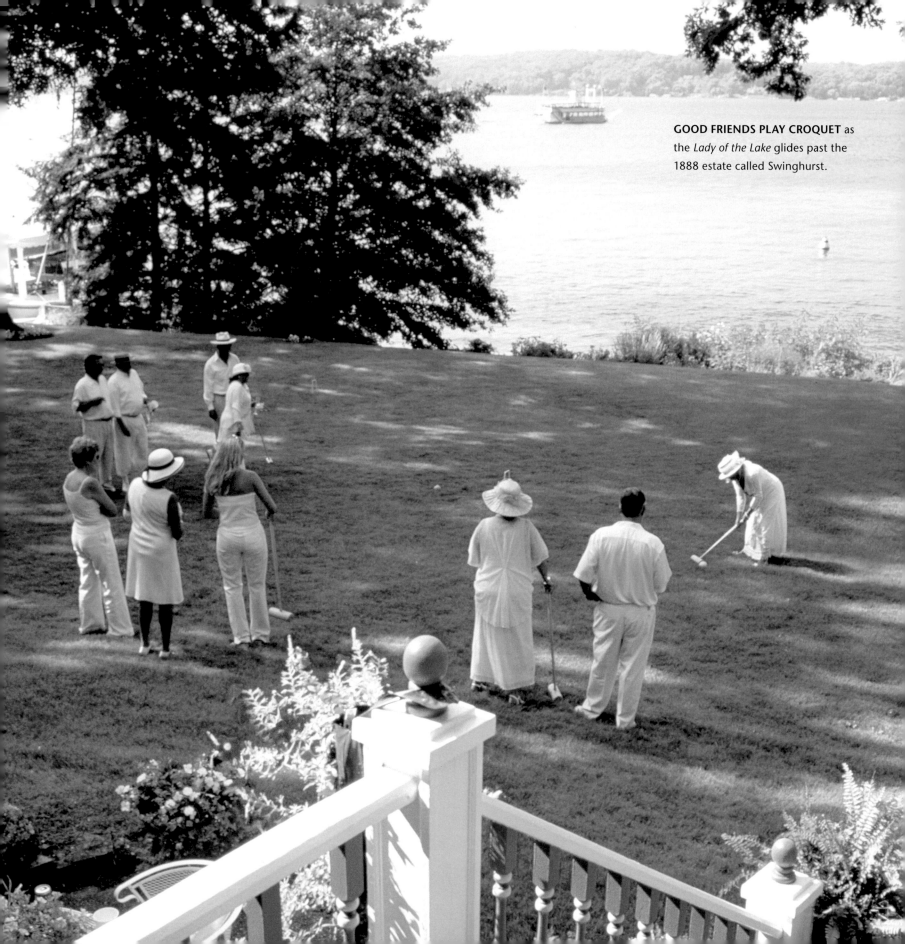

GOOD FRIENDS PLAY CROQUET as the *Lady of the Lake* glides past the 1888 estate called Swinghurst.

HEAVEN AND HERESY

ONE OF THE FIVE oldest estates on the lake, Swinghurst is a perfect setting for revelers who can be expected to adhere to a dress code—though they may question other "rules" of a rigid society. The Queen Anne–style home was built in 1888 by Reverend David Swing, a dynamic Chicago preacher and a personal confidante of Mary Todd Lincoln. Swing's ideas were so "dangerously" progressive that his enemies in the Chicago Presbytery accused him of heresy in 1874.

"It was about nothing," Marie says. "He befriended a Unitarian and an atheist." Swing was acquitted after a two-week trial, but when his accusers appealed the verdict, he and his followers moved to another church.

At times, apparently, they followed him to Swinghurst, which the good Reverend called Six Oaks. (Swing's heirs renamed it.) Fittingly enough, the house has a number of "churchly" features. Swing often preached from an attic balcony, while his followers gathered on the lawn. Inside, an unusual multilevel stairway leads to a pulpit overlooking the front parlor, while the broad steps behind it suggest a choir

LEFT **A SUNBEAM STREAMS** through the formal dining room, where the post-game feast awaits. The original kitchen was in the basement, with a dumbwaiter servicing this room.

loft. In a downstairs bath, the floor plunges to form an immense, tile-lined tub. "The style doesn't fit the period at all," says Marie. "We think he used it for baptisms." The sunken tub was originally fitted with a rope ladder.

SWINGHURST TODAY

THROUGH THE YEARS, Marie has preserved as many of the home's original features as possible, including its leaded and stained-glass windows. When she added a kitchen at the back of the house, she was careful to match the home's original style. (The home's first kitchen was in the basement, and a dumbwaiter hoisted food to the dining room.) Currently, she's finishing the attic as a painting studio. Plans include a safer stair to the widow's walk, from which "you can see forever," Marie says.

But Marie's favorite part of Swinghurst is its lakefront veranda, where she has watched warm-weather sunsets virtually every day for nearly 20 years. "Reverend Swing chose the south shore for its view of the sunsets, and Charlie and I wanted to honor that," Marie says. The veranda is also popular during the croquet party, especially when the string quartet retires and a jazz band sets up for the evening.

At Swinghurst, the guest list is often eclectic. "People used to ask me how you got invited to the croquet party," Marie says, "because it's not a typical Who's Who." Marie might respond with an enigmatic smile, but

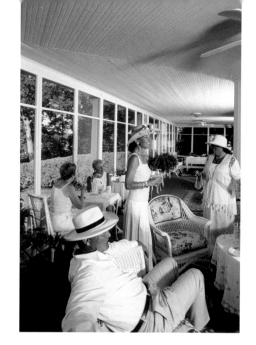

anyone who has donated time or assistance to the Carrie Ann Foundation could probably guess. The charity is named for Charlie's daughter, who succumbed to leukemia at 16.

Charlie, too, lived with cancer—to the fullest. After doctors said he had six months to two years left, he and Marie traveled the world. Their adventure lasted five years, and the couple ultimately seized eighteen years together after that initial prognosis. "[The experience] taught us how to live," says Marie, now the chairman of Waukegan Steel Sales. "It's important to be thankful and give back. We never took anything for granted."

LEFT "IT'S WHERE I LIVE," says Marie Kropp (*far right*) of the wraparound porch at Swinghurst. It's also a favorite gathering place for guests. The traditional all-white dress code may not help anyone's croquet game, but it certainly enhances the mood.

RIGHT **NOW THE CHAIRMAN** of Waukegan Steel Sales, Marie Kropp was once a professional entertainer. She still sings for friends and teaches a select group of piano students.

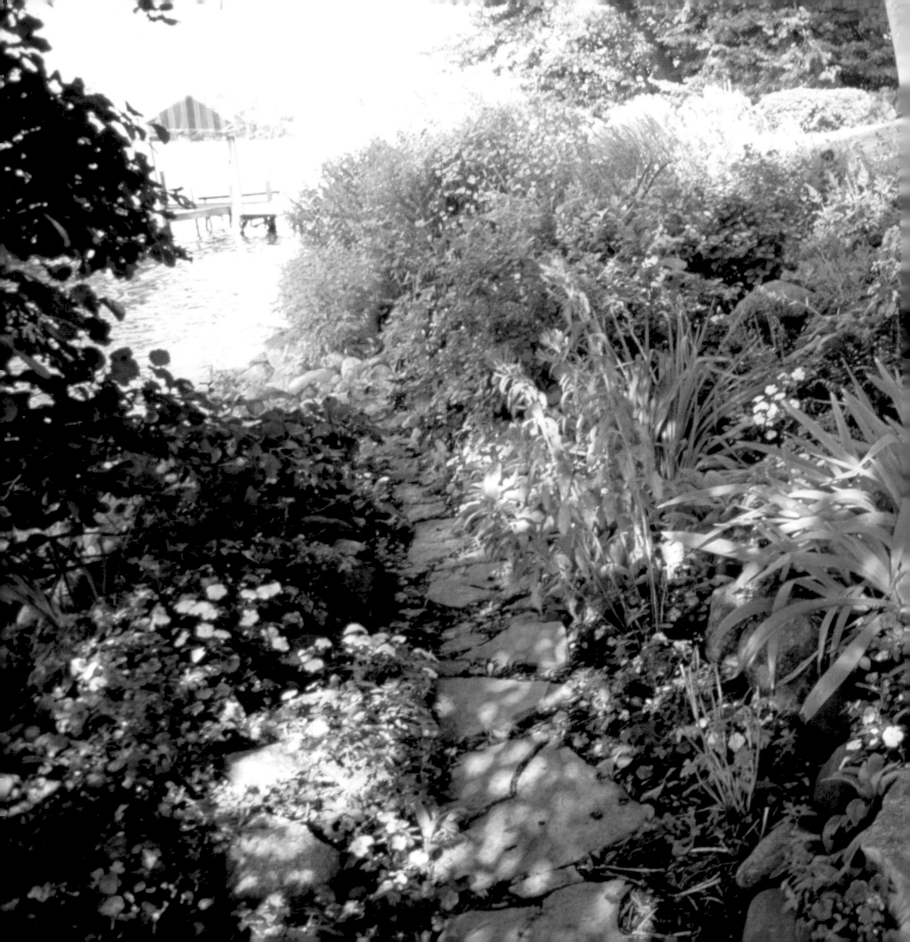

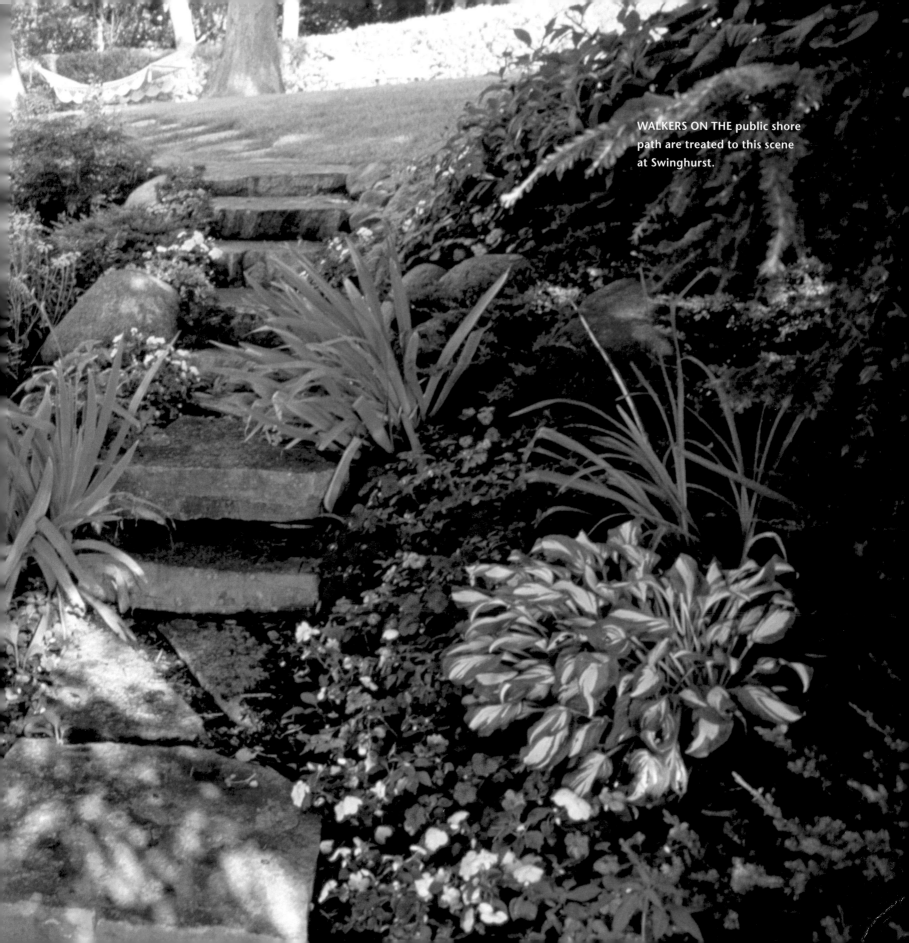

WALKERS ON THE public shore path are treated to this scene at Swinghurst.

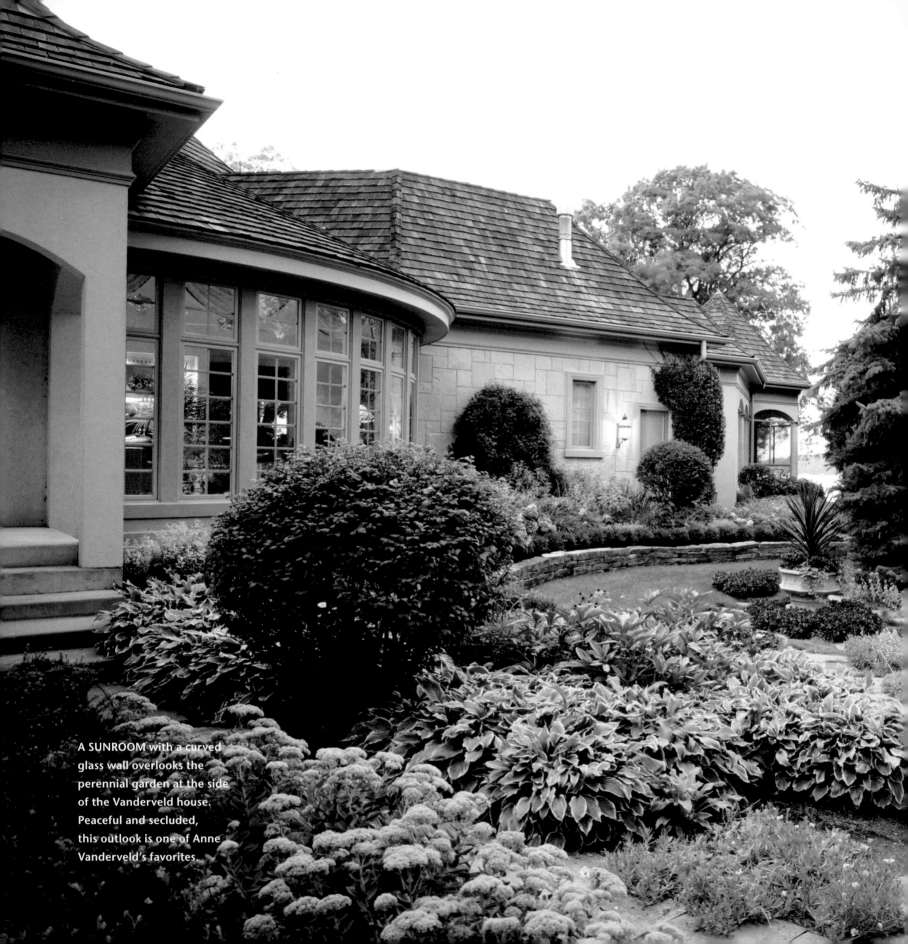

A SUNROOM with a curved glass wall overlooks the perennial garden at the side of the Vanderveld house. Peaceful and secluded, this outlook is one of Anne Vanderveld's favorites.

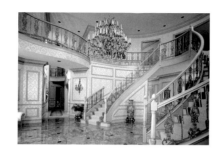

ROYAL OAKS

AT A TIME WHEN MANY GRANDPARENTS and retirees think about downsizing, Anne and Peter Vanderveld chose the opposite plan—creating a luxuriously spacious mansion where three generations could gather comfortably. "We planned everything with our family in mind," Anne says.

Called Royal Oaks for the towering trees that surround it, the mansion is the Vandervelds' third and largest address on Geneva Lake. In 1958, Peter and his brothers bought a lakeshore house to share with their families. In 1972, Anne and Peter bought a home in Hollybush, an enclave near Button's Bay. "Our four children grew up spending their summers here," says Peter, who commuted from the lake to his Barrington, Illinois, office from June until September. (He owned several refuse disposal companies.)

Long after their children left home, Geneva Lake remained an anchor for family gatherings. "The lake is a very important part of our life," Anne says. Unfortunately, each time the family grew, the house in Hollybush seemed to shrink. "First we were six," Anne explains. "Then, with all our children married, we were ten . . ." One by one, a dozen grandchildren arrived, bringing the total to 22. "We just ran out of space," Anne says.

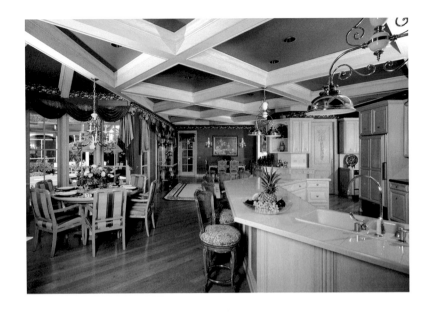

LEFT **BORDERING A LAKEFRONT** courtyard with a swimming pool, this colorful kitchen features two dining areas: one for adults (*left*), and a second (glimpsed *beyond*) for grandchildren. A table for 22 wouldn't have felt cozy on weekdays, Anne Vanderveld notes.

BELOW **THE WALK-OUT LOWER LEVEL** is a young person's paradise with pinball machines, game tables, and a working soda fountain.

ABOVE **PETER AND ANNE** Vanderveld planned their home as a multigenerational retreat. Their children, sons- and daughters-in-law, and currently a dozen grandchildren gather here throughout the year.

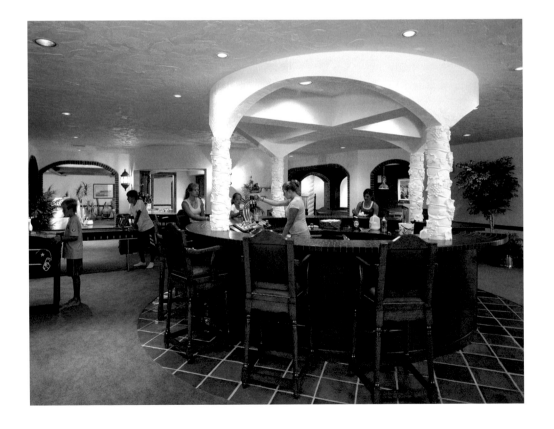

The Vandervelds spent several years planning their new home, which was completed in 1992. (They subsequently sold their Illinois property and moved here.) The floor plan balances elegant formal spaces on the main level with more casual areas all around. The walk-out lower level features a rec room. The entire second story features lake-view suites for each adult child and his or her spouse, plus two separate wings for grandchildren—one for all the boys (who currently have fun sharing a vast dormitory-style bedroom), and another for all the girls (who share a two-bedroom suite with a glamorous "Hollywood" bath).

Some families only pay lip service to togetherness, but the Vandervelds are not among them. "Our entire family is very close," Peter says. "We're truly blessed." Because all four of their children live within easy driving distance from Geneva Lake, it's not unusual to find every bed in the house filled, even on winter holidays. "Christmas is probably my favorite time here," notes Anne, who festoons the mansion with greens.

With two granddaughters now in their 20s—and one already envisioning a lakeshore wedding—the family is destined to keep growing. For Anne and Peter, it's a delightful prospect. "But we're not adding on!" Anne says, laughing.

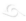

A FORMAL ENTRY COURT with a fountain sets an elegant tone for the mansion. (To view the lakefront façade, see *pages 64* and *65*.)

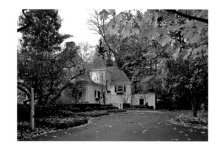

WILKIN COTTAGE

∾

I N 1979, JIM WILKIN embarked on an eighteen-month remodeling job at a historic cottage on the north shore. Though charming, the steep-roofed house was not nearly as enchanting as its mistress, Abra Prentice Anderson. As Jim and his crew untangled a warren of outdated little rooms, a far more pleasurable entanglement developed.

"He rehabbed the house and we fell in love," says Abra Wilkin, whose surname says it all. The couple married in 1986.

RIGHT **IN SPRING AND SUMMER,** songbirds alight by the water that follows this rocky path to the lake. Once furious after heavy rains, the creek has been tamed by a manmade pond uphill.

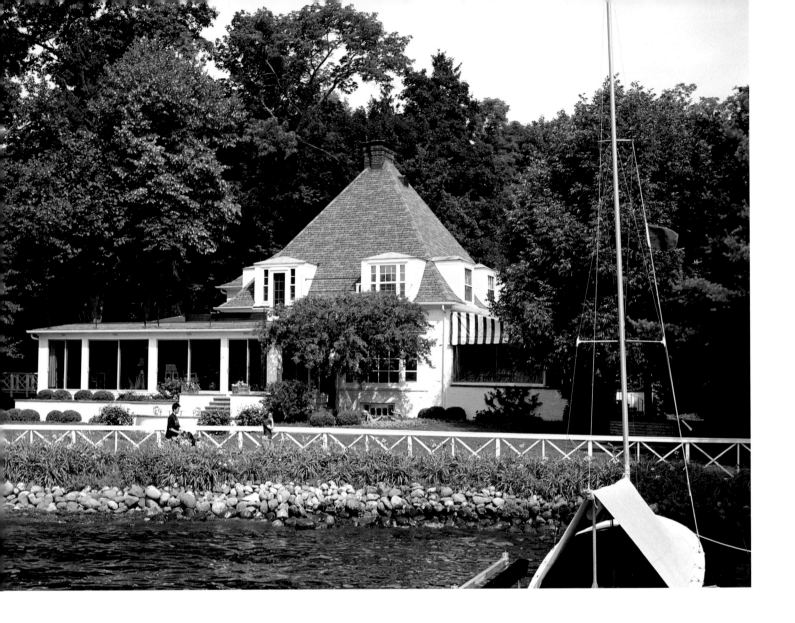

ABOVE **A RIOT OF DAYLILIES**
and a crisp white fence
hug the gravel shore path
that stretches past Wilkin
Cottage. The Wilkins savor
the early mornings and quiet
evenings, when the water
calms and turns to glass.

It's a fitting tale for a place such as this—
a storybook cottage that is lively, artsy,
and eminently comfortable, yet in no way
pretentious. The house has been in Abra's family
since her parents purchased it in the early 1940s.
She and Jim believe the structure dates to the
'30s, as a newspaper found entombed in an old
plaster wall suggests.

Like many lakefront properties, however,
the estate has a history that reaches back even

further. An old limestone-clad mansion called
Rehoboth once stood directly west on the
parklike grounds. (Too massive to maintain, it
was razed by Abra's parents.) A streambed that
winds past the cottage dates to that earlier era,
slipping under a series of picturesque bridges.

Though it's peaceful today, the stream—
which carries runoff from a nearby hill—once
raged after severe storms. Torrents of water
used to surge down its course, smashing into

ABOVE **VEILED BY EVERGREENS,** a swimming pool beside the house is the Wilkins' private oasis. A side porch overlooks the scene.

bridge-tops and overflowing the banks. "It was furious," Jim says. Once he spied two young boys flailing in the stream like half-drowned cats; he quickly plucked them out. After that, the Wilkins and a neighbor created a retention pond that now tames every deluge.

An only child, Abra inherited the cottage at 30. She and Jim have other addresses, but of Lake Geneva, Abra says, "This is home." The Wilkins come here to relax with family and friends throughout the year, and the cottage has been the heart of many a celebration. "If I had to give away everything and keep just one house," Abra adds, "this would be it."

ABRA AND JIM WILKIN

Gracious, daring, and surprisingly down-to-earth, Abra Prentice Wilkin is the only child of Abbie (*née*) Cantrill and John Rockefeller Prentice. That makes her the great-granddaughter of John D. Rockefeller, but her Standard Oil lineage—or the fact that she has become one of Chicago's favorite philanthropists—isn't something she's likely to trumpet.

Instead, Abra may tell you that that she attended public school in Lake Geneva until the early 1950s (she switched to the Latin School of Chicago in the fifth grade). Or she may talk about how mingling with the lake's socialites once terrified her. "I didn't hook up with the country-club crowd when I was growing up," Abra says. "I thought they were a little scary then. . . . But now it's fun." When interviewed by *Time* magazine in the 1980s, she said she felt uncomfortable about her inheritance, because "I didn't earn it."

But Abra *has* earned a reputation for hard work and a generous spirit. As a reporter for the *Chicago Sun-Times*, Abra covered Martin Luther King's assassination as well as the Lake Geneva riot of 1967. She has also been a columnist and magazine publisher, and is the mother of three children (from her previous marriage), all of whom grew up spending carefree days at the lake.

A recent profile in the *Sun-Times* dubs Abra the Windy City's "guardian angel" for her constant, often-quiet philanthropy. Her charitable endeavors include the Prentice Hospital for women, which boasts one of the Midwest's largest birthing centers.

Some years ago, Abra raised eyebrows by posing nude for a Christmas card, with her young children gathered around her for modesty. "It caused quite a scandal here," recalls Mike Keefe, a lifelong area resident. Abra shrugs nonchalantly. "One of my friends said, 'If I did that, I'd have to rent an entire orphanage to pull it off.'"

"I am basically shy," Abra says. "The rest is all bull and bravado."

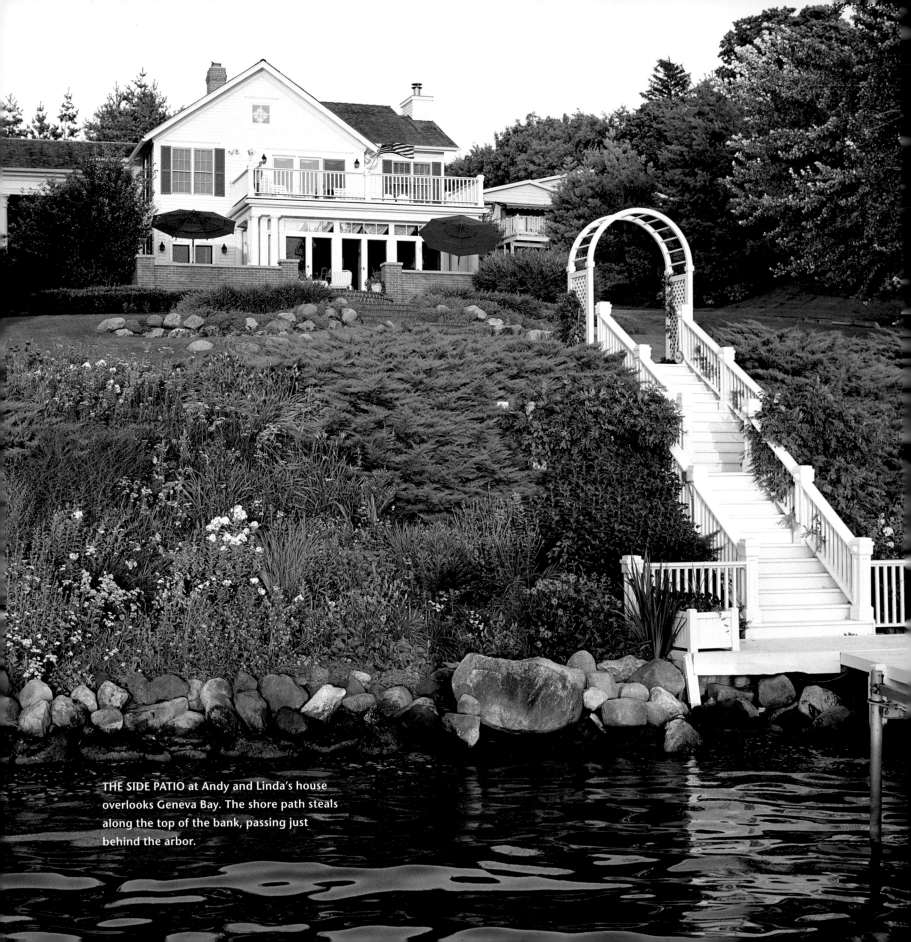

THE SIDE PATIO at Andy and Linda's house overlooks Geneva Bay. The shore path steals along the top of the bank, passing just behind the arbor.

SANTA'S PLACE

SINCE THE **1870s,** a mail boat has circled the lake from May to September, delivering the U.S. mail to lakeshore residents. Today tourists ride along, watching the daring "mail-jumper" as he or she springs to each pier, hastily stuffs a mailbox, and then leaps back aboard while the boat keeps cruising. Greeting the boat is a summer ritual for many shore-dwellers, but no one has more fun than Andy Loughlin. At the last pier on the route, he retrieves his mail wearing a jolly red cap. "Now you know where Santa spends the summer," the captain of the *Walworth II* announces.

Some shore-dwellers seek solitude, but Andy and his sweetheart, Linda Learn, are clearly people who love people. Located at the edge of downtown Lake Geneva, their white-pillared mansion creates an alluring starting point for the south-shore lake path. On busy weekends, the couple watches a parade of passersby from their lakefront terrace, and they greet everyone with a friendly wave. "We've met people along this path who have come from all over the world," Linda says, "and we love talking with all of them."

RIGHT **ANDY LOUGHLIN** and Linda Learn share a moment in their garden. Linda owns a company called Corporate Identity. When he's not making a list or checking it twice, Andy travels to China to arrange manufacturing of technical products.

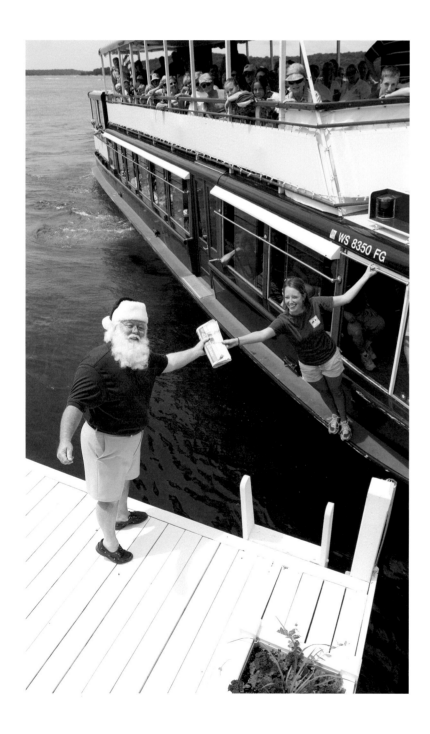

Linda first spied their home when she was a child summering at the lake. It became her "dream house," but of course she was too young to buy it then. She kept her eye on it through the years, discovering it was built in the 1870s (though a significant remodeling took place in the 1930s). Unfortunately, by the time it came up for sale in 1996, age and neglect had taken their toll.

"It was a wreck," Linda recalls, "like a haunted mansion." A back wall had rotted into oblivion, and when workers opened up a ruined ceiling, a family of frightened raccoons rained down on their heads. Renovation took more than a year and the cost ran twice the original estimate, but the results were clearly worth it.

Today Linda and Andy enjoy the house year-round. "My favorite time is September," Linda says, "when it's still warm, and the leaves are gorgeous." The weekend before Christmas, they gather here with their children and grandchildren. (Christmas Eve, notes Andy with a wink, is too hectic.)

Come summer, the crowds return, but Linda and Andy enjoy many peaceful times as well. Their lakeside patio offers panoramic views of

LEFT **WITH ANDY PLAYING SANTA,** the mail carrier on the *Walworth II* makes a hand-off instead of leaping to the pier. A summer tradition, the mail boat has delivered letters and newspapers to lakeshore residents since the 1870s, when roads were poor.

ABOVE **A NEOCLASSICAL BEAUTY,** the house has a white-pillared entry that faces Baker Street. (The lake is to the right.)

the sunset—and so does their bedroom. "We can even watch the Venetian Festival fireworks while lying in bed," Linda remarks. Very early one morning, Andy stole to the window and spotted two dark silhouettes bobbing in the bay. Curious, he got out the telescope, and two deer came into view. The pair swam straight toward him, clambered onto the shore and looked up, then leaped away.

Perhaps they were Santa's reindeer.

RIGHT **A BRICK MOTOR-COURT** welcomes guests who arrive by car. Glimpsed in the foreground, a garden with rustic stone steps climbs the steep hillside.

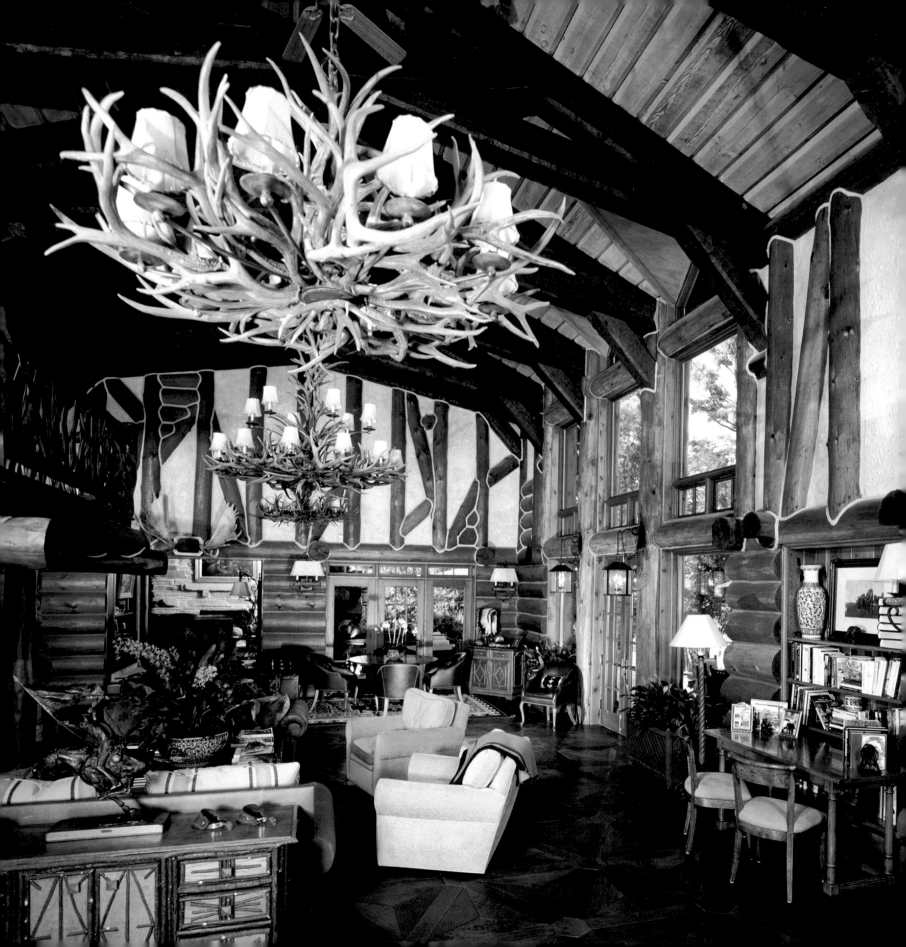

CLEAR SKY LODGE

I F GOD IS IN THE DETAILS, then Clear Sky Lodge is a slice of heaven. The home of Chicago-based real-estate developer Richard Klarchek and his wife, Michelle, the lodge has become one of the most exquisitely finished "log cabins" in the Midwest—a seamless blend of Southwestern artifacts, French fabrics and wall-coverings, and authentic Adirondack stylings.

Originally owned by a film industry executive, the house has overlooked the lake's south shore since 1920. Richard bought the lodge in 1998 because he was looking for a carefree retreat, and the lodge came completely furnished and ready to occupy. Before long, however, he had embarked on a seven-year quest to make every surface extraordinary. Rooms were stripped. Fireplaces and floors were demolished. Doors, hardware, fixtures, unadorned drywall—everything that Richard deemed "cheesy" disappeared.

OPPOSITE **AT THE HEART** of the house, a two-story great room faces the lake. An upstairs gallery (glimpsed *left*) becomes a stage for musicians during parties. The custom floor comprises multiple hardwoods laid in random pinwheels.

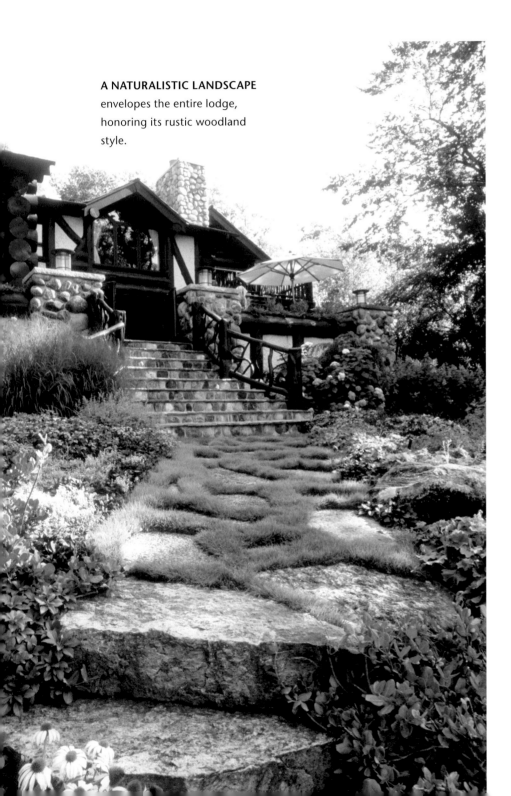

A NATURALISTIC LANDSCAPE envelopes the entire lodge, honoring its rustic woodland style.

Today when guests step through the front door, they enter a foyer with golden hand-hewn log beams overhead. The ceiling between the beams appears to be pale, rough "stone," but it's actually canvas, textured and painted to resemble pictographs from the American Southwest. A few strides ahead, tightly interwoven strips of caramel-color leather create an irresistibly touchable wall-covering. To the right is a gleaming stairway made of twisted branches, as smooth and silken as polished driftwood.

None of these elements was here before, and though a casual observer might consider the house "done," the embellishment continues. A fine carpenter and a small team of artisans have worked virtually full-time at the house for the past four years. During the week, they remodel the relatively unfinished areas upstairs while continuing to refine an already-sumptuous main level. The garage becomes a workshop where they create Adirondack-style furnishings and mock up new floor and wall treatments. (On a recent summer's day, one craftsman was making a table from tree roots that had been pulled from a north woods lake. Another was building a prototype for a new wood floor, with each broad plank cut in sinewy curves to echo the wood's natural grain.) As the weekend approaches, the crew vanishes—removing equipment and almost every trace of their presence—so the Klarcheks can move back in.

Although Richard stops short of picking up a paintbrush, it's definitely a hands-on project for him. He began by poring through more than 40 books on Adirondack style to

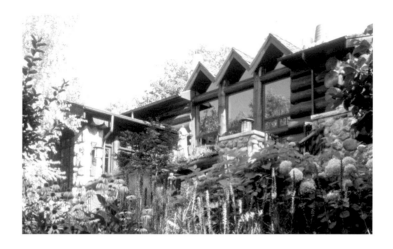

LEFT **A RAISED STONE TERRACE** offers a sequestered outlook to the lake. Windowed gables highlight the great room.

BELOW **WHERE NATURALISM** leaves off in the house, artistry takes over. The kitchen floor is fabulously faux stone.

gather ideas, and he has personally overseen every detail, from choosing custom-made light fixtures and door hardware to deciding how electrical outlets will be disguised (many are faux-painted so they blend into the wall surfaces). Inspired by an Adirondack homestead that featured pigskin covering the walls for insulation, he had pigskin panels made in France—each embossed with an intricate pattern. Then he brought the artisans to Lake Geneva so they could apply them to several walls.

The house offers visual surprises at every turn, but one of the most talked-about rooms is Richard's personal bath. With an oiled bronze chandelier, rustic handmade furniture, and a hand-painted ceiling that soars overhead, the space is so magnificent that its true purpose isn't obvious until the fixtures are noticed—and that's not immediate. The shower is completely open: The room's heated stone floor slopes subtly underfoot to a drain, and a rain-bath fixture hangs overhead. A log wall (once the exterior of the house) holds the shower controls.

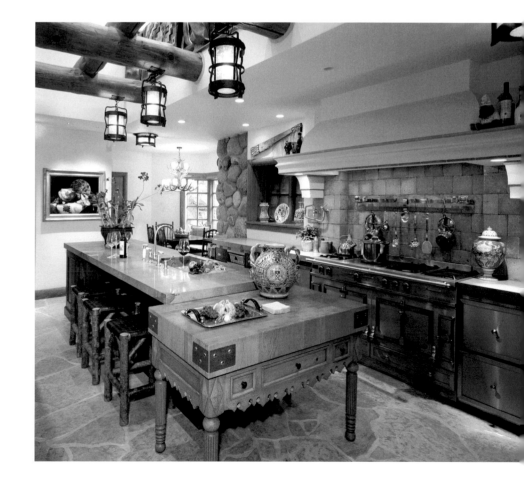

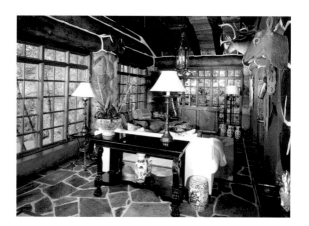

LEFT **BLUE-AND-WHITE PORCELAIN** mingles with Native American artifacts in the lakefront sunroom. The great pine logs that form the circa-1920 skeleton of the lodge were delivered from Canada by rail, then floated across the lake.

BELOW **A SCULPTURAL MASTERPIECE,** the central stairway was crafted largely from reclaimed wood. Many of the adjoining foyer's visible beams and posts are decorative additions, hand-hewn by Pennsylvania craftsmen.

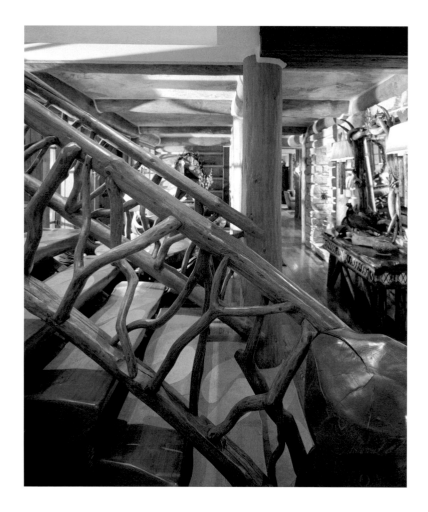

"I didn't want to put glass walls anywhere in here. It just wouldn't be right," Richard says.

Richard and Michelle have invested considerable time and energy in the house, and few expenses have been spared. But the goal for this privacy-minded couple is hardly to impress anyone—it's to create an exceptional level of comfort through authentic hand-craftsmanship. Fortunately, the members of the Clear Sky crew share the couple's passion for making the house perfect.

"It's the details that make a difference in any place," Richard says. "As long as we're doing it, we want to get it absolutely right."

OPPOSITE **WITH SEATING FOR** twelve, the dining room features French fabric panels set overhead between hewn beams. Beyond the far side of the table, hand-carved totems and handsome wine-storage units flank the entry to the sunroom. The great room is to the left.

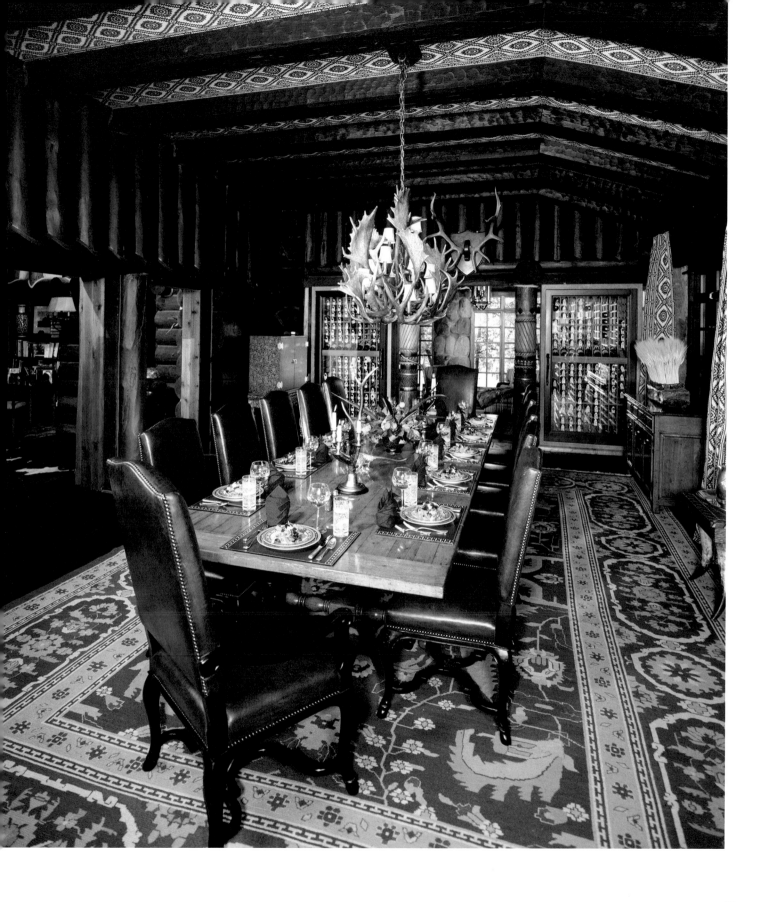

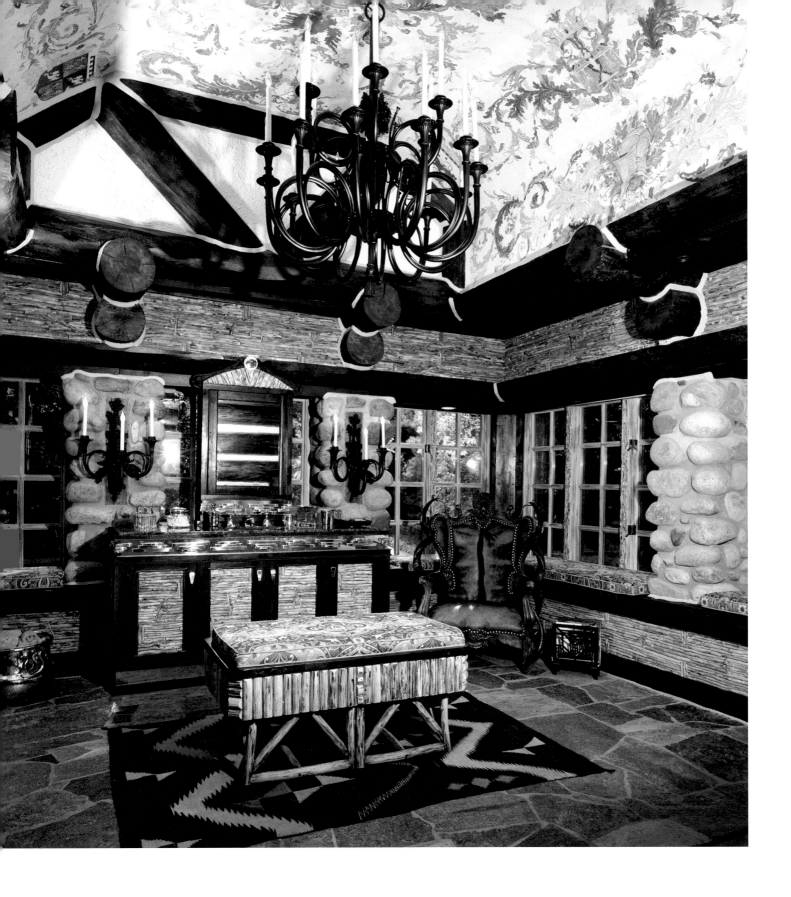

OPPOSITE **HAND-PAINTED CANVAS** inspired by French heraldry adorns the vaulted ceiling in this "gentleman's bath." Ash twigs form the intricate cornice below. Opposite the vanity, the heated stone floor gently slopes beneath an unenclosed shower (not shown).

RIGHT **A DOWNSTAIRS POWDER ROOM** features a mural of twigs, meticulously applied over birch bark. Carved from a single slab, the massive stone sink was hoisted into place with a mechanical lift. Embossed leather dresses the wall immediately outside.

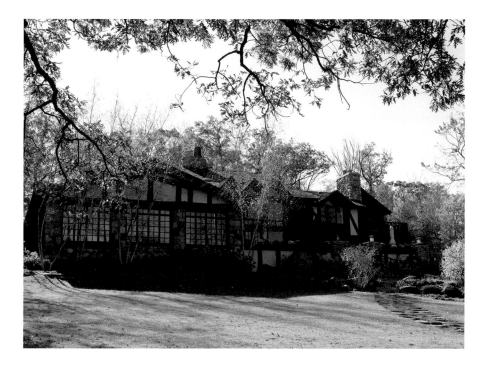

LEFT **TAKEN BEFORE** the landscaping was complete, this autumn photo reveals the full expanse of the lakefront façade. The trio of windows on the left border the sun-room. The great room is immediately to the right.

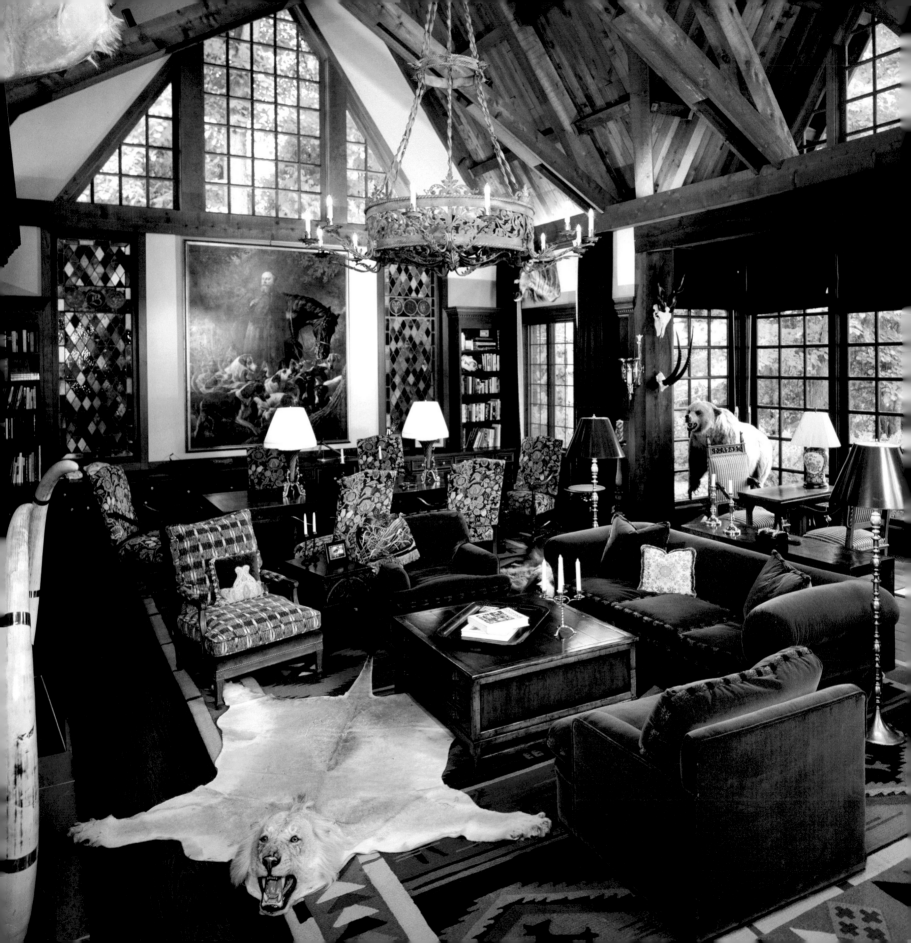

EXECUTIVE RETREAT

‏∾‎

I‎T'S A LONG WAY from a one-room school on the Great Plains to a private office on Geneva Lake, especially when you've become the founder and CEO emeritus of a multibillion-dollar enterprise. But that's the journey Dean Buntrock has taken.

He grew up in Columbia, South Dakota, an agricultural town of about 300 people, where his mother taught school and his father ran three businesses. In 1955, Dean earned a business degree from St. Olaf, a private Lutheran college in Minnesota, and he married soon afterward. Within a year, his father-in-law had passed away and Dean moved to Chicago to help out with his new family's twelve-truck garbage business.

Trash became treasure. In 1968, Dean and two partners merged their businesses to create Waste Management, with Dean at the helm. By the early 1970s, it was a publicly traded company with revenues topping $200 million. In short order, the firm won a major contract in Saudi Arabia, purchased hundreds of small companies, and became the largest waste disposal conglomerate in the world.

LEFT **DEAN BUNTROCK'S LAKESHORE** "home office" is filled with trophies from his hunting trips to Africa. Before he retired as the CEO of Waste Management, he held his company's annual strategic planning sessions here.

ABOVE **A DIZZYING SPIRAL**
stair leads to the upper level of
the coach house, which includes
additional offices and quarters
for staff.

RIGHT **ROSEMARIE AND DEAN**
Buntrock have been coming
to the lake together for more
than 20 years. "This is 'Home'
with a capital H," Rosemarie says.

Like many successful Chicagoans, Dean looked to Lake Geneva as a weekend retreat, buying a lakefront home that he would soon share with his second wife, Rosemarie. In 1984, he built the ultimate "home office"—a small Tudor-style castle that is part coach house, part caretaker's apartment, and part three-office suite.

The centerpiece is Dean's executive retreat. It's where he "chills down and goes through his briefcase," says Rosemarie. In winter, the fireplace is often blazing opposite the plush seating area. "It's a very comfortable place to settle into," says Dean, who enjoys being surrounded by mementos from his travels and trophies from his hunting trips around the world.

Although Dean is officially retired, he still spends at least two to three hours a day in his office. But coming to the lake is not just about work, of course—it's about winding down. "[Since 1984], Rosemarie and I have never made a weekend commitment in Chicago. When we're not traveling, we're always here. The lake has always been very special . . . not only as a retreat for the two of us, but as a place to enjoy with our family and friends."

During holidays, the house fills with three generations. "You don't have to plan anything or figure out an agenda," Dean notes, "not even for the grandchildren. There's always something to do, and everyone just enjoys themselves."

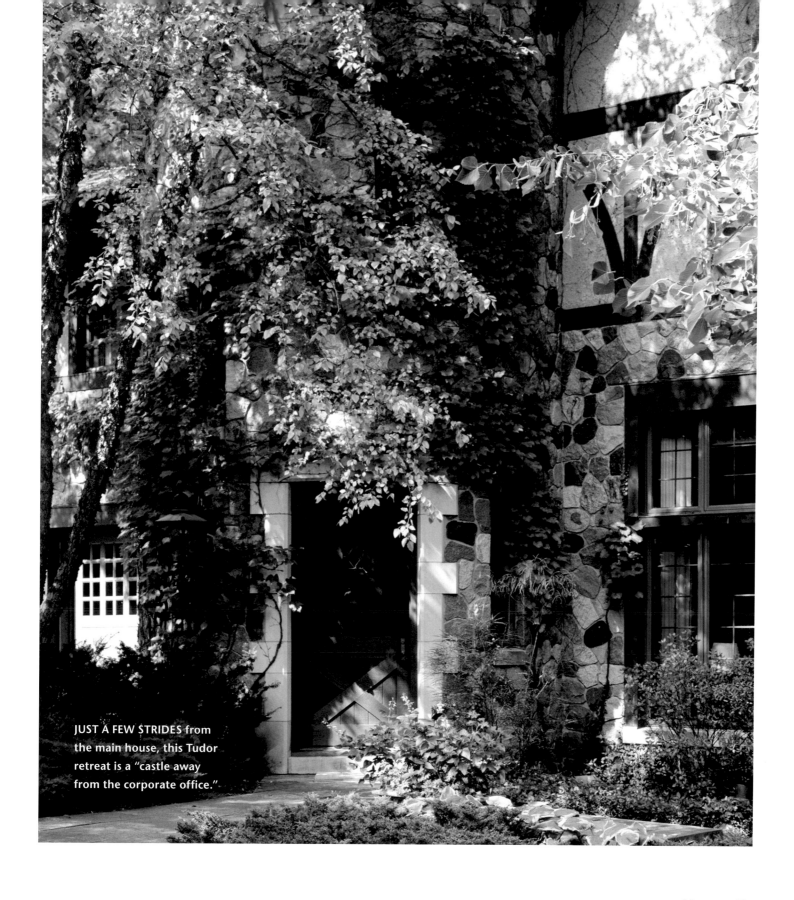

JUST A FEW STRIDES from the main house, this Tudor retreat is a "castle away from the corporate office."

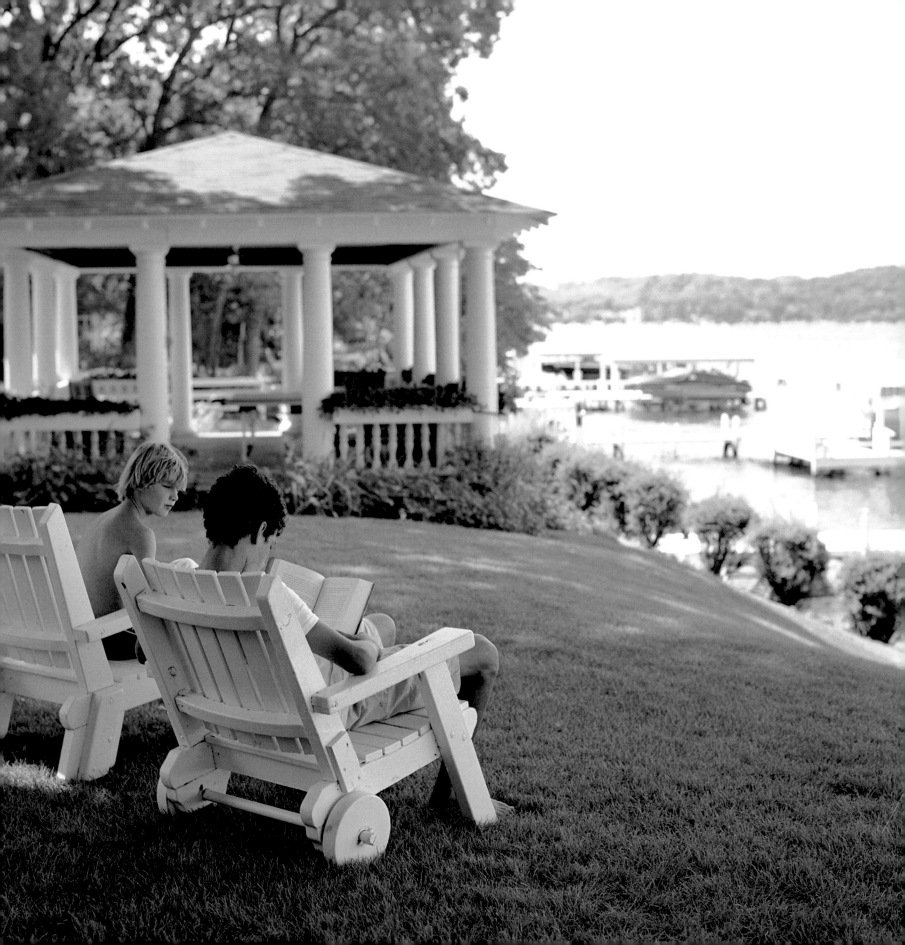

HISTORIC CLUBS

IN **1873**, TWO GENTS from Elgin, Illinois, named Alfred Lavoie and Charles Mosely came to the lake for a bit of camping and fishing. In a subsequent letter to a friend, Lavoie described how they hired the lake's only schooner to drop them at a splendid spot on the still wild-and-woolly north shore. That night—after it had rained so hard that the "straw we had been lying on was floating in our tent"—a soggy Lavoie made a proposal.

"I casually remarked that it would be nice to own a lot or an acre facing the lake for a camping ground, and [to] put up a small house so we could be protected from storms," Lavoie's letter continued. Within days, the pair had bought 16 acres for $400 (a bargain even then). They enlisted eight friends for help, and by the following year, they had built a clubhouse, divided the land into 20 lots, and sold every one.

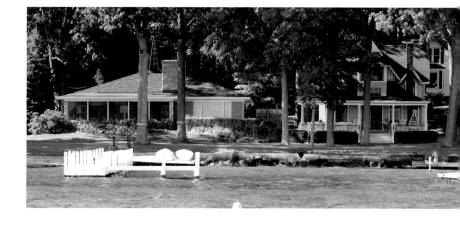

OPPOSITE **TWO YOUNG MEMBERS** of the Harvard Club relax with books by the lakefront pavilion. Founded in 1875, the former tent-camp takes its name from Harvard, Illinois, which was home to its founding members.

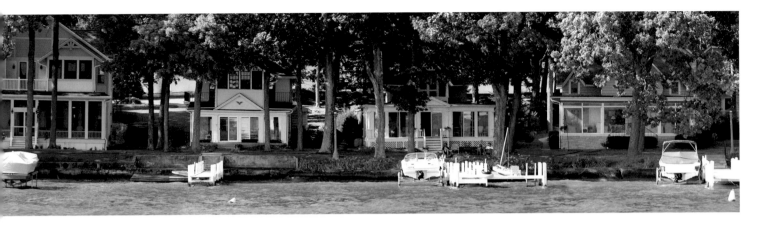

ABOVE AND PREVIOUS PAGE

LOCATED NEAR the midpoint of the north shore, the Elgin Club dates to 1873. Today it holds an eclectic array of new and historic cottages. The oldest architectural survivor was built in the 1890s.

The Lakeside Park Club of Elgin—soon renamed the Elgin Club—was officially born. Said Lavoie: "[It] became popular at once as it had many jolly boys in it."

Time and again, a similar story repeated itself around the lake. The Chicago Club, The Harvard Club, The Congress Club—these and other historic enclaves began when friends banded together to claim land for camping. For most, the goal was simply to escape the city's turmoil and oppressive summer heat. Women and children often stayed at the lake the entire season (roughly the time it took for their head-to-toe woolen bathing suits to dry out).

Club members weren't exactly roughing it, however. Men strode about in suit coats. Nearly every camp included a clubhouse for cooking and dining (many of them posh); other clubs made use of nearby hotels or resorts. The tents were typically canvas huts on wooden platforms, clustered into colonies to preserve views and open space by the shore. Eventually, all the tents gave way to cottages, many of which—like the clubs themselves—endure today.

THE CHICAGO CLUB

A SOUTH-SHORE ENTITY, the Chicago Club was founded in 1893, when two much older tent-camps—Englewood and Bon Ami—joined forces. When the property hit the market in 1977, it included about 15 acres, a vast and shady commons, and five empty, run-down cottages marching in close single-file formation toward the shore. The price was roughly $700,000.

To Chicago's Jim Riley, the club's rich history of bringing friends together made it irresistible. Riley bought the entire property, planning to reserve the waterfront cottage for himself and offer the rest to close friends, at cost. "I started making calls one weekend," Jim says. "By 4 o'clock Sunday, they were all sold and I had a waiting list." No wonder: Jim set his asking price so low that nearly everyone bought a cottage sight unseen.

Jim and his wife, Daryl, have never regretted their decision to share the property with others. "We're all friends, but everyone respects each other's privacy," Jim says. "Often we don't even know that anyone else is here."

RIGHT **JIM AND DARYL** Riley resurrected the Chicago Club in 1977. After buying all five of the club's cottages, they offered four of them to friends—at cost.

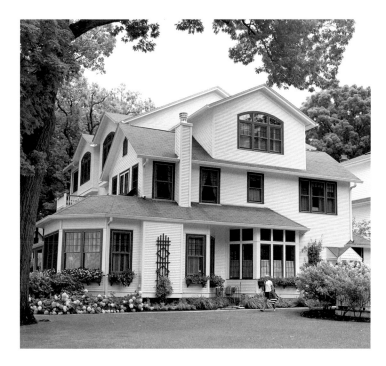

ABOVE **PART OF THE INTIMATE** Chicago Club, this 1880s home belongs to Jim and Daryl Riley. The second story contains three suites for visiting children and grandchildren, and the remodeled attic is their private haven.

BELOW **PRACTICAL AND PICTURESQUE,** this streambed channels rainwater past the Chicago Club's cottages, winding down the wooded slope.

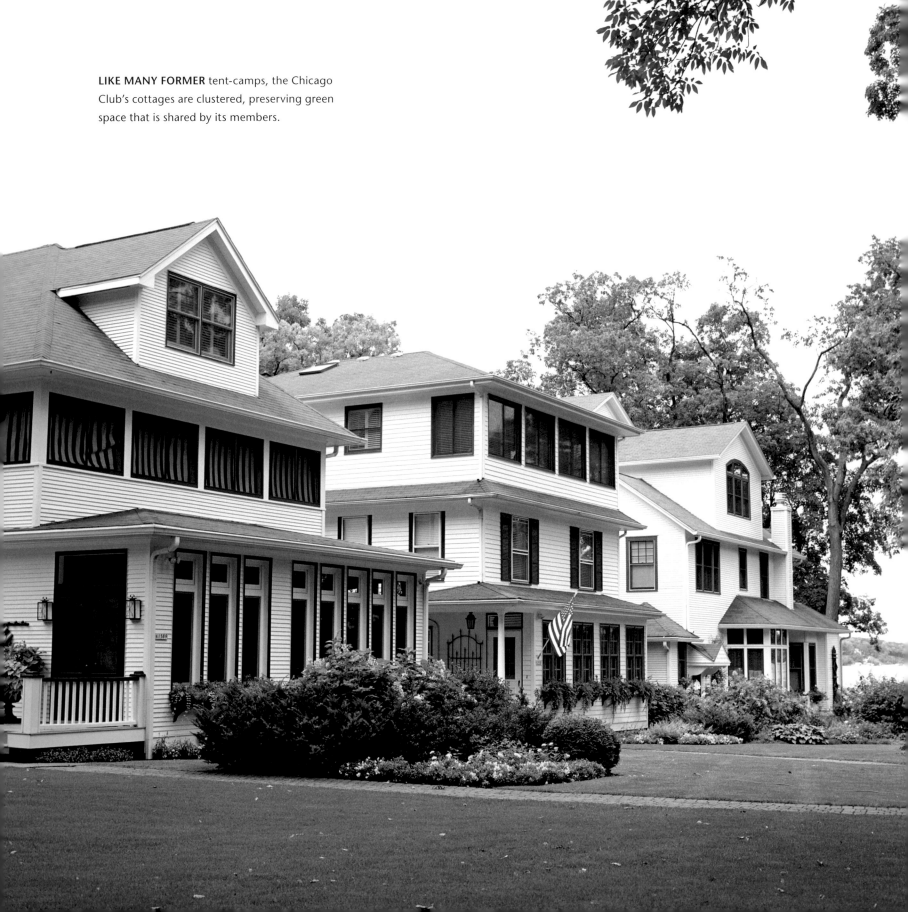

LIKE MANY FORMER tent-camps, the Chicago Club's cottages are clustered, preserving green space that is shared by its members.

Yet it is intimate gatherings of friends and family that make the compound so special, the Rileys add. When their children were young, the Chicago Club was a magical realm filled with carefree companions. "It was perfect," Jim describes. "They'd spend the summer playing with our friends' children, swimming all day and playing flashlight tag at night. Now their kids do the same thing."

Jim and Daryl have gradually remodeled their 1886 cottage, preserving such original features as Georgia red-pine floors and a tiled fireplace surround. Most recently, they transformed the second floor into three suites for their children and grandchildren, then raised the roof to create an attic-level master suite. One of their favorite getaways is a private screened porch off their bedroom, perched high among the treetops. "I read there almost every afternoon," Jim says. Daryl suffused the house with a carefree cottage spirit, and she tends the gardens as well, relishing the quiet weekdays of summer.

"To this day," Jim offers, "we both say there is no other house on this lake—and no other setting—that we'd prefer to this one. This is our *home*."

THE HARVARD CLUB

LIKE ANY GOOD ORGANIZATION, the Harvard Club has always had rules, though they've changed with the times. Alva Smith jotted these snappy bylaws in the 1920s: "No parakeets or quadrupeds allowed. Drying of laundry and

LEFT **MEMBERS OF THE** Harvard Club park their cars at the head of their sloped acreage, then stroll down a brick path to their cottages. The layout ensures peace and quiet.

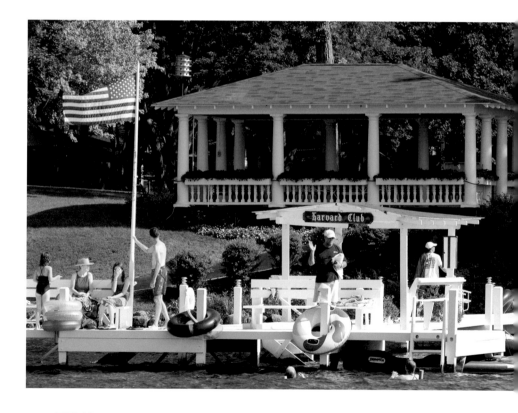

ABOVE **THE SOUTH SHORE'S** Harvard Club once forbade the keeping of parakeets and the public display of soggy bathing suits. The club's rules are bit more relaxed now—as are its members—but polite behavior is still the norm.

RIGHT **"I'M A TRUE PISCES,"** says Chicago businessman Brad Thor. "Water brings me tranquility."

RIGHT **ONE OF 19 HOMES** in the Harvard Club, Brad Thor's cottage overlooks the waterfront (glimpsed in the photo *below*).

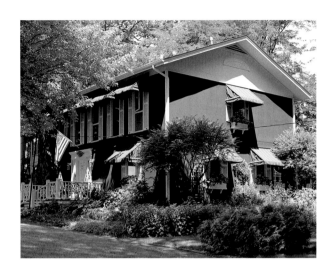

LEFT **STAIRS CLIMB** from the foyer to this second-floor gathering space with an adjoining balcony. Elevating the main living areas enhances both views and privacy.

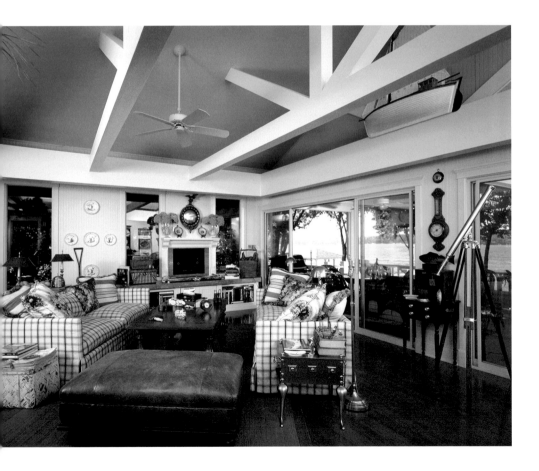

bathing suits to be concealed from the public. Children requested to behave like ladies and gentlemen." And, of course: "Fraternizing with alcoholic beverages is frowned upon." (Apparently, you could have a cocktail—you just couldn't get too friendly with it.)

Today the rules are a touch more relaxed—for one thing, parakeets are allowed—but the Harvard Club is still a very civilized south-shore getaway. No rentals are permitted, and while many of its members are weekenders, "everyone knows each other," says club president Jamie Holden. "We get together about three times a year." Holden's family has summered at the Harvard Club since 1899. "It's in my blood," he adds.

The club dates to 1875, when lumber baron Edward Ayer generously deeded 14 acres to about 20 friends from Harvard, Illinois (a town his father had founded). In the early days, the happy campers dined at the nearby Minier Hotel, where, in the words of the *Geneva News*, the lovely Mrs. Minier offered "a full corps of cooks" as well as "handsome and efficient dining room girls."

A savage fire claimed seven of the original cottages in 1963, but some were rebuilt, including the waterfront retreat now owned by Brad Thor. To help the house match the charm of its vintage companions, Brad completely renovated it. "It was just a box with a flat roof before," he describes. He started coming to the club in 1974, drawn in part by its lack of driveways and streets. (Members park their cars at the top of a lushly wooded slope, then literally step into another era on foot.) "My children could just run," he explains. The club's 19 cottages line up in quaint rows, facing two brick walkways that stretch toward the waterfront.

Brad's two sons are grown now, but both return when they can. (Brad, Jr., a novelist, has published four thrillers that include names drawn from Lake Geneva.) Brad himself comes up from Chicago year-round, drawn by the siren call of the lake. "It's the quality of life. Things that are chores in the city become pleasures here. . . . The entire scene lends itself to tranquility," he adds.

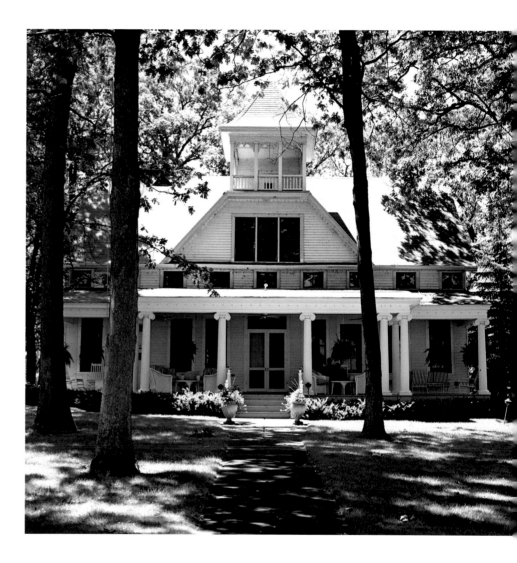

ABOVE **NAMED FOR A CHICAGO STREET,** the Congress Club has overlooked the waters of Williams Bay since 1882. This elegant clubhouse amid towering oaks is the true heart of the enclave—the members' cottages form a semicircle around it.

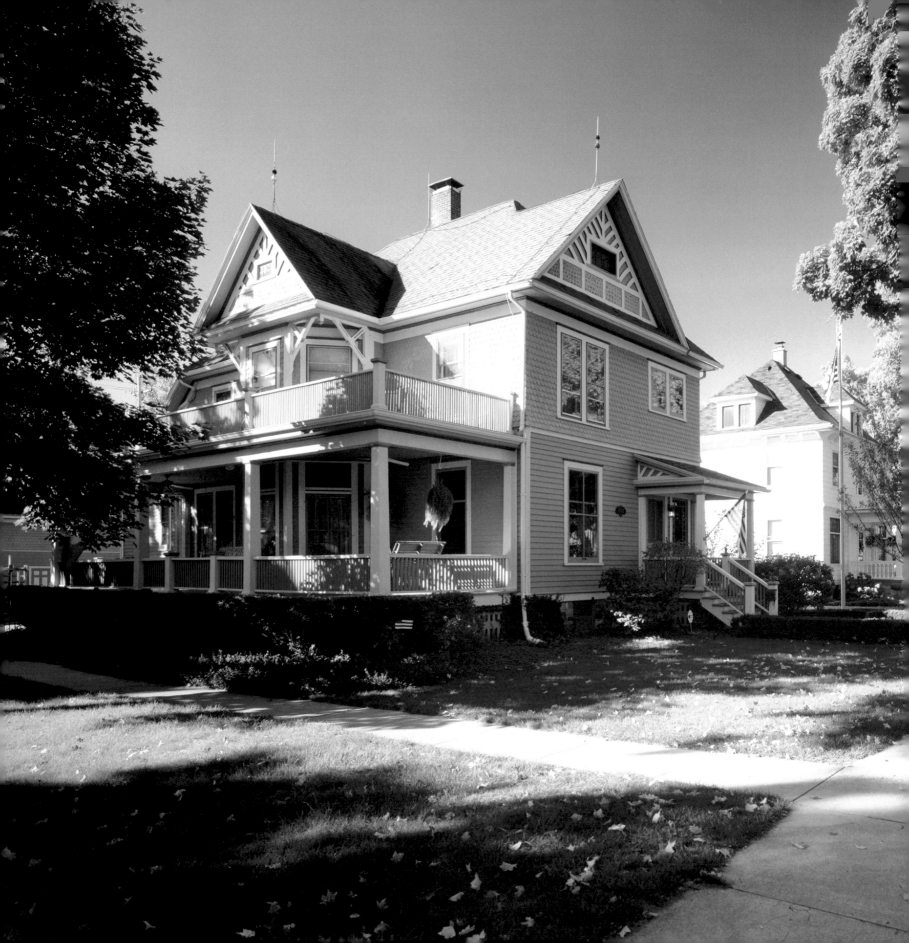

MAPLE PARK

ON WARM SUMMER DAYS and festive weekends throughout the year, a horse-drawn carriage pulls away from the Riviera Docks and begins a tour of Lake Geneva. As the horse leaves the shopping district behind, it *clip-clops* its way into Maple Park, a picturesque neighborhood filled with overarching shade trees and the city's most venerable homes. The oldest date to the late 1840s, but most were built between 1870 and 1910. Time and traffic slow as tourists take in an architectural parade of styles that includes Greek Revival, Italianate, Stick, Queen Anne, Tudor Revival, Craftsman, and more.

"Lake Geneva is very eclectic for its size," says architectural historian Carol Cartwright. The city's history is entwined with that of early Chicago trendsetters and transplanted New Englanders; as a result, its architecture became a wide-ranging tribute to fashionable late–19th-century living.

LEFT **LIGHTNING RODS CROWN** this 1880s beauty on Geneva Street. Its bracketed gables and decorative horizontal banding are hallmarks of the Stick style, an architectural bridge between Gothic Revival and Queen Anne. The old carriage house (glimpsed *left*) once doubled as an icehouse.

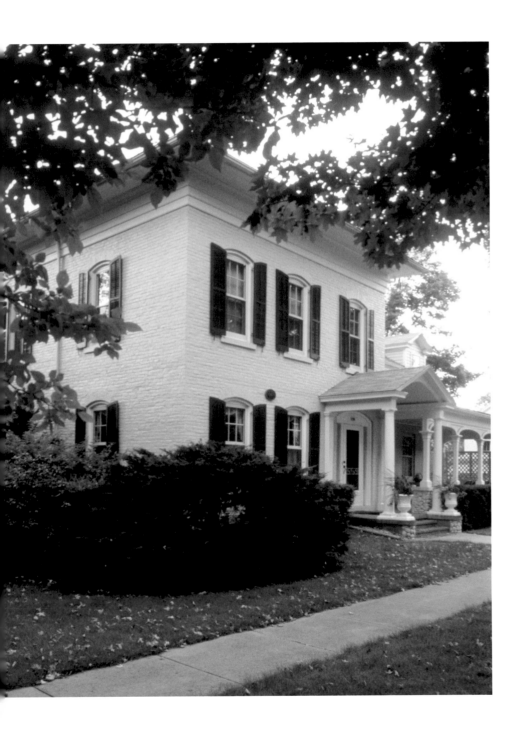

In 2005, Cartwright aided local preservationists in winning recognition for Maple Park as a national historic district. A near match to the original village plat from 1837, the district spans about 15 square blocks, stretching north from the lakefront's Library Park. Its jogging boundaries embrace more than 140 architecturally significant houses. The oldest, an 1847 Greek Revival cottage on Main Street, has sheltered such guests as Mary Todd Lincoln and Ulysses S. Grant. Other noteworthy sites include the aptly named Pioneer Cemetery, established in 1837, and the Episcopal Church of the Holy Communion, a stunning stone-walled Gothic Revival structure on Broad Street (completed in 1882). Just north of the church lies Horticultural Hall, a 1912 Craftsman-style building. It was created to showcase flowers and vegetables grown on lakeshore estates. A farmers' market is staged at the hall on Thursdays during summer and autumn.

LEFT **GENEVA STREET'S** "old Montague House" combines an 1855 Greek Revival home with an 1867 Italianate addition. (The mismatched brickwork was painted even then.) A wealthy millwright and village president, Gurdon Montague bought the house in 1871, after he sold his 90-acre lakeshore property to the Sturges family. Vernon and Joyce Haan lovingly restored the home in the 1980s.

LEFT **AT THE WESTERN** edge of the district, this home dates to the 1880s. Note the detailing of the bracketed entry gable.

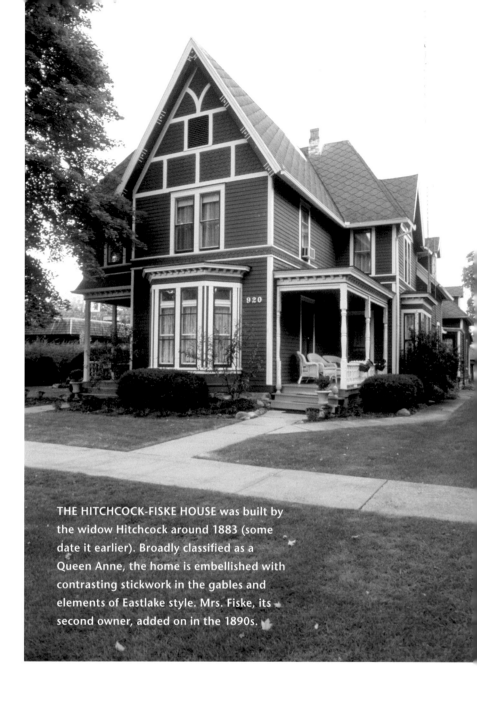

THE HITCHCOCK-FISKE HOUSE was built by the widow Hitchcock around 1883 (some date it earlier). Broadly classified as a Queen Anne, the home is embellished with contrasting stickwork in the gables and elements of Eastlake style. Mrs. Fiske, its second owner, added on in the 1890s.

LEFT **FACING CENTRAL SCHOOL** on Cook Street, this pumpkin-colored home has been described as both High Victorian Gothic and Gothic Revival. It was built in 1882 for a local doctor and his schoolteacher daughter. Come summer, impressively tall perennials fill its fenced garden with exuberant color.

JOHN AND HIS DAUGHTERS

"If an audience can catch its breath, I'm not doing my job," says John R. Powers, an author and a motivational speaker known for his wry sense of humor and fast-talking style. He's constantly on the go, flying cross-country to speak about life and success for clients that run the gamut from AT&T and American Express to schoolteachers and the Chicago Bears. "One time I hit all four time zones in a span of 14 hours," he says.

When he comes home, however, it's to Lake Geneva. "Where else would I live?" he muses. "When you move to Florida, you get old and grow ugly parts."

Formerly from Chicago, Powers moved here with his family in 1989. "It's a great place to raise kids," he notes. Back then, he'd been hosting a Chicago TV show and had invited cartoonist Joe Martin to be a guest. Martin, in turn, invited Powers to a dinner with other creative locals at his Lake Geneva home. Both the setting and the group made an impression.

"Not one person at that table earned an honest living," jokes Powers, who has won two Emmy Awards for writing and performing and has published four books, including *The Junk-Drawer Corner-Store Front-Porch Blues* and *Do Black Patent Leather Shoes Really Reflect Up?* The latter, a fictionalized memoir, is also a play that became a Broadway musical, which Powers wrote and co-produced.

Between speaking gigs (about 90 a year), Powers writes in the third-floor office of his historic Main Street home (*opposite*). He's currently at work on a PBS series and a motivational book. On hot summer days, he jots notes while relaxing in his "favorite place on the planet," a front porch that overlooks the lakefront and Library Park. To really blow off steam, he hops on a hydrobike and pedals it around the bay. "I don't pull skiers," he quips, "but it's good exercise."

Powers chose his location for its unique blend of lively in-town and lakefront living. "I like having neighbors," he says. "And I like the tourists. It's like watching an endless party."

The district takes its name from a maple-rimmed park that lies two blocks north of the beach. City founders originally envisioned this space as a public square, much like those in New England. In the 1890s, the park included a bandstand. Today, it's home to the red-brick Central School (circa 1904 with updates), as well as a soccer field and a quaint children's playground.

OPPOSITE **HISTORIANS DISAGREE** about the date of this Second Empire–style mansion overlooking the lakefront and Library Park. The plaque reads 1860, the year Dr. Alexander Palmer put a house on this site (when Second Empire was first in vogue). Recently unearthed newspaper accounts suggest that the good doctor's son-in-law, F.A. Buckbee, moved or razed that house and built anew in 1890. Some architectural sleuths—including the current owner, John R. Powers—suspect he merely remodeled.

PART IV LAKE & COUNTRY LIVING

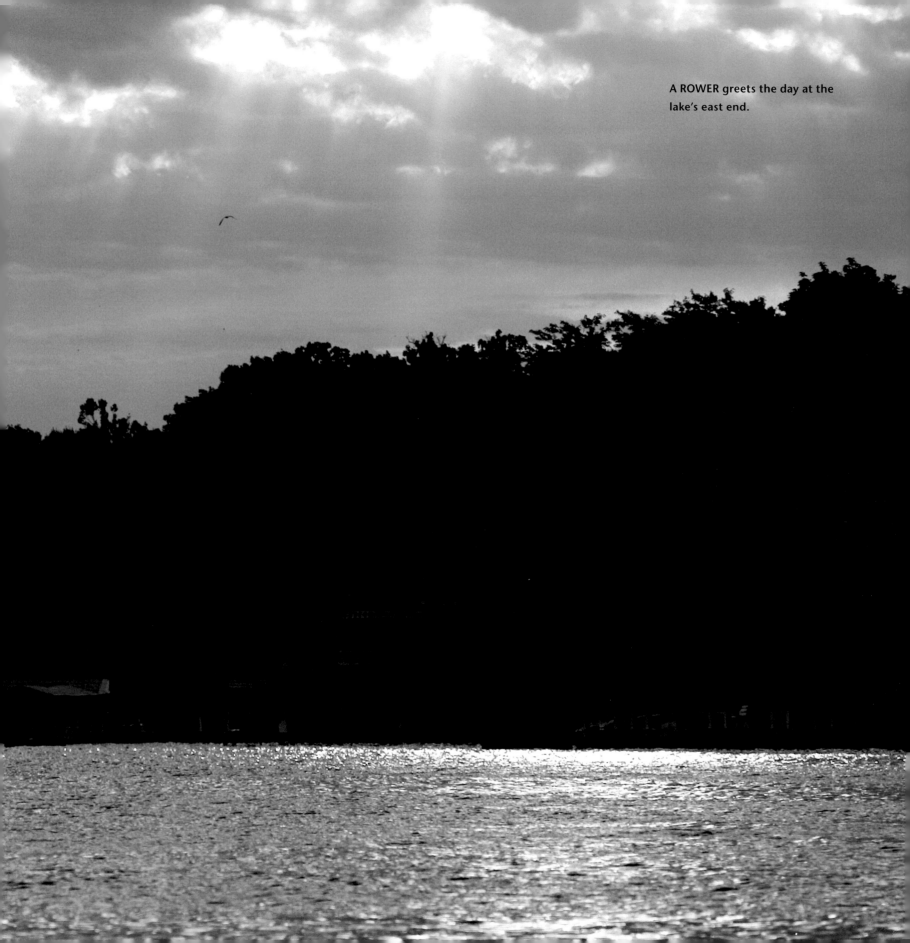

A ROWER greets the day at the lake's east end.

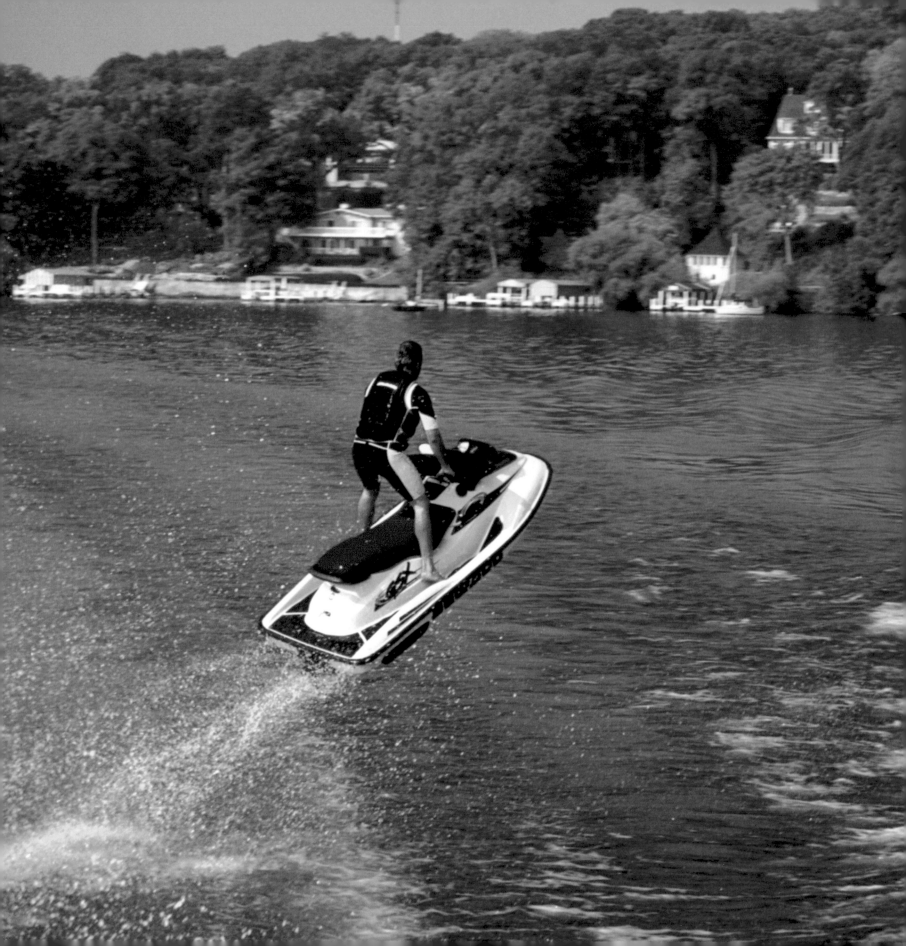

THE SPORTING LIFE

E VERY DAWN ON GENEVA LAKE is an invitation to play, especially in summer. The water beckons, calling out rod and reel as well as boat and ski. Many locals slip out before work to row or paddle along the shore or to take an invigorating morning swim. As the sun arches overhead and the breeze lifts the waves, out come the fast-and-splashy wakeboards and Jet Skis.

For others, it's the countryside that calls. From roller-coaster tours along the lake bluffs to flat sprints through the farmlands beyond, some of the best cycling trips in the Midwest are close at hand. Not to mention the glorious golfing; there's a championship course at virtually every turn. And with one state park directly on the shore and two others within a 30-minute drive, the playground expands even more.

LEFT **A CHARTERED YACHT** provided the wake that launched this daring rider into the sky. (The splashdown was equally impressive.)

RIGHT AND BELOW **EARLY MORNING** is often the best time to water-ski on Geneva Lake. That's when the water is typically calmest and the lake the least crowded—your only company may be the fishermen vying for space along the quiet shore. As the winds drop on weekday evenings, devoted skiers head out once again, stealing every possible "legal" run before the sun fades from view.

To the north, the 21,000-acre Kettle Moraine State Forest is laced with long, twisting trails for hiking, horseback riding, and mountain-biking. To the east, hang-gliders soar, dirt bikes fly, and sportsmen work with horse and hound at the Bong State Recreational Area. (It's named after a World War II flying ace, not the other "recreational high.")

Whatever your outdoor passion, this corner of the world is a fine place to pursue it. And when the day is done and all your energy is spent, you can relax at the water's edge and bask in the glory of the setting sun. What better way to unwind before the action begins anew?

OPPOSITE **A FONTANA-BASED OUTFITTER** offers parasail rides on the lake. The rides are always thrilling—occasionally, they're even "enlightening."

ABOVE **A WINDSURFER LITERALLY** soars past Stone Manor on Geneva Bay. Serious surfers often take to the water in early spring and late fall, when the winds are strong and few motor-driven craft are about. Donning wetsuits and thermal gear, they race back and forth across the mile-wide bay, undeterred by icy waters.

ABOVE **LOCAL STABLES OFFER** trail rides in the surrounding countryside, as well as riding lessons.

THE EQUESTRIAN SET

FROM ENGLISH AND WESTERN pleasure-riding to jumping and dressage, the local equestrian set is a well-rounded group. Numerous horse farms grace the area, including the picturesque and by-invitation-only Wrigley Arabians on Snake Road, which boasts a polo field. (The Wrigley family owns several properties in the area.)

Private lessons and boarding are easy to find through area stables. For the public at large, local resorts and larger stables offer trail rides through the surrounding country-side, from hour-long jaunts to 25-mile tours of the Kettle Moraine State Forest. The state's extensive trail system naturally appeals to those with their own horses and trailers, too.

BELOW **LOCATED NEAR FONTANA,** the historic Pell farm was once a stagecoach stop. Today it's home to the Wyngate Dressage Center, a high-caliber training facility. An art form as well as an Olympic sport, dressage demands perfect harmony between animal and rider as the horse performs complex routines and precise maneuvers.

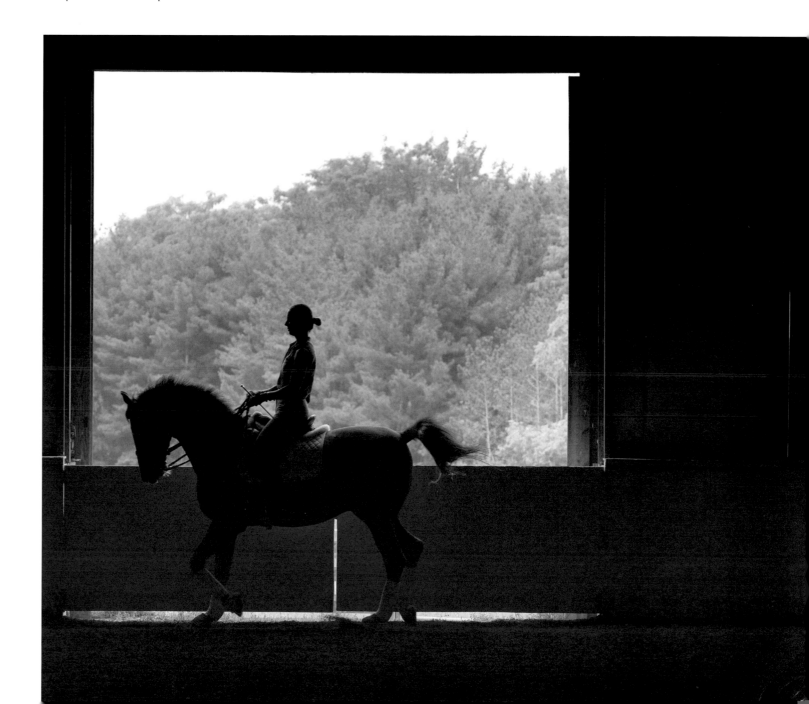

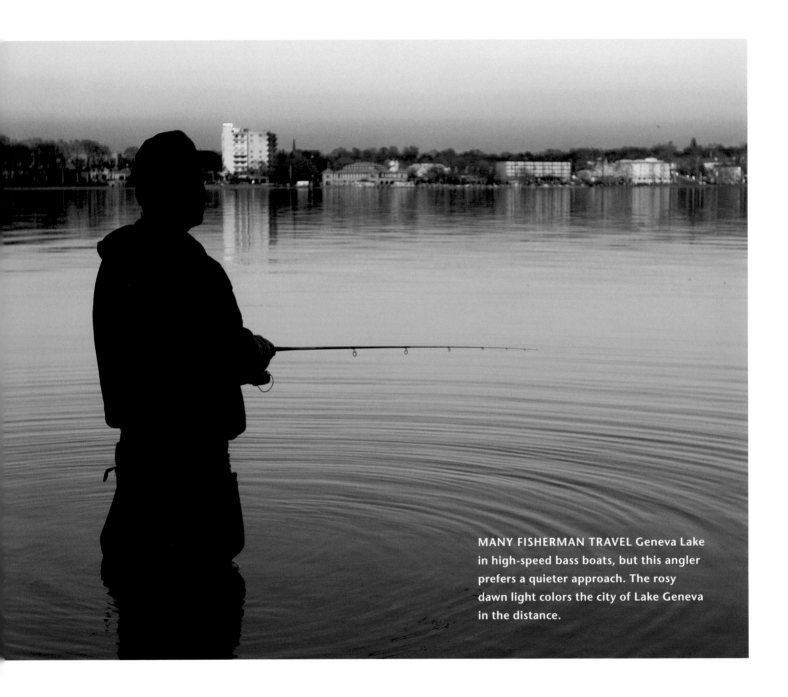

MANY FISHERMAN TRAVEL Geneva Lake in high-speed bass boats, but this angler prefers a quieter approach. The rosy dawn light colors the city of Lake Geneva in the distance.

An Angler's Haven

SOME SPORTS ARE BETTER in the dark. As night falls and the last of the sightseers pull ashore, the fishing fleet heads out on Geneva Lake. Many anglers prefer to fish when the lake is their own, at dusk and especially just before dawn, when the lake is utterly quiet.

Geneva is one of the Midwest's premier fishing lakes for bass. Thanks to the lake's depth and size, however—and a healthy population of ciscoes—it's also a place where "monsters" lurk. Thirty-pound northern pikes frequent the waters near Cedar Point and Stone Manor, and trophy-size walleye have been caught near Fontana. In 1984, the Wisconsin-record inland brown trout was hooked in this lake, weighing in at 18 pounds, 6 ounces, and measuring just over 34 inches.

Glorious Golf

WHEN IT'S "TEE TIME" at the lake, the greatest challenge may be deciding where to play. Hundreds of pastoral acres in the surrounding county have been gently sculpted into golf greens and fairways, meandering through woodlands and over rolling meadows. The farther into the countryside you venture, the more likely you are to golf under the watchful eyes of coyote, fox, and the occasional cow. From casual courses to award-winning resorts, it's all here.

ABOVE **BRUCE THOMPSON** of Fontana leaned over the side of a boat one day and discovered another "angler" in the picture. As his father reeled in a small walleye, this northern pike snatched it from the line.

RIGHT **A GOOD PLACE** for golfers of all ages and skills, the course at George Williams College in Williams Bay began as one lonely hole in 1900. Today it offers 18, all in the shadow of Yerkes Observatory.

Several courses overlook the lake itself, including the most venerable: the private Lake Geneva Country Club. Tucked on the south shore just east of the Narrows since 1895, it's the oldest club in the Midwest still on its original site. To underscore their devotion to golf, members built their clubhouse facing the golf course instead of the lake, but the club is also known for its social gatherings.

At the lake's west end, the Big Foot Country Club is private as well (with about 200 members). Established in the 1920s, their enviable course rambles over 270 hilly acres with seven natural springs. The course is named for Chief Big Foot, whose Potawatomi tribe lived on the lake until the mid-1830s.

Among the public courses, few rival Geneva National and Grand Geneva, both of which have been listed among *Golf Digest*'s Top 10 places to play in the state. With 54 holes and three distinctive courses (designed by golf greats Trevino, Palmer, and Player), Geneva National overlooks the shores of Lake Como (a "little sister" to Geneva). A few miles east, the Grand Geneva Resort boasts two courses: the links-style Highlands and the dramatic Brute, which *Golf Magazine* calls "a behemoth that ranks among the toughest layouts in the

OPPOSITE **WITH THREE 18-HOLE COURSES** on the shores of Como Lake, Geneva National is part of a gated golf community. Six days a week, one course is reserved for members only, and the other two are open to the public.

BELOW **JUST EAST OF GENEVA LAKE,** the Grand Geneva Resort boasts two 18-hole courses that were originally part of the Playboy Club. The 1,300-acre resort has earned *Golf Magazine*'s Silver Medalist Award for seven consecutive years.

RIGHT **UNIQUELY PRIVATE,** Lakewood is the personal playground of real-estate investor Dan McLean. Play is by invitation only, though McLean frequently opens his 18-hole course for charity events. The course incorporates numerous ponds, and highlights include a floating bridge and a tee on a raft. The clubhouse is pictured here.

Midwest." A relative newcomer, Hawk's View Golf Club just north of Lake Geneva is an award-winning "hill and dale" challenge, with a scenic covered bridge and a memorable hole atop an old ski slope.

When you add them all up, more than a dozen courses grace the lakeshore's close communities, and another dozen lie within an easy drive. Golfers may argue over which course is best, but if you've caught swing fever, the Geneva Lake area has the cure.

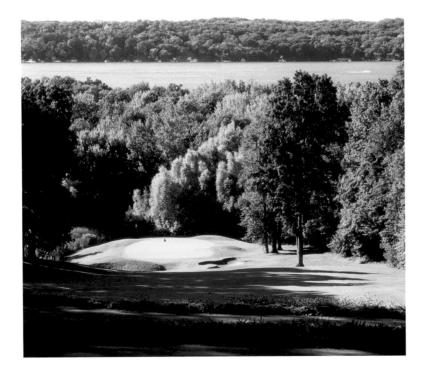

LEFT AND OPPOSITE **A PUBLIC COURSE,** Abbey Springs is perched atop south-shore bluffs, with extraordinary views of Geneva Lake. Water also plays a role on the narrow, sloping greens: Nine of the 18 championship holes have water hazards.

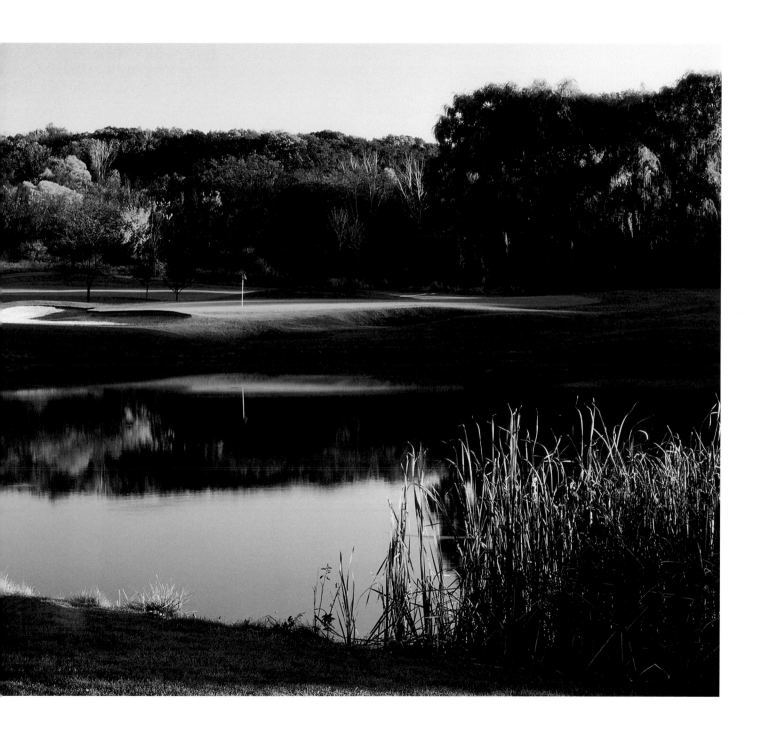

CATCHING THE WIND

FROM AFAR, A REGATTA LOOKS PEACEFUL: dozens of white sails, all pregnant with the wind, dancing a slow ballet. On board it's an entirely different picture: the skipper calling commands, the crew leaning out precariously, and the waves exploding off the hull as the boat slices through the water.

Competitive sailing has been a tradition on Geneva Lake since 1874, when the first annual race for the Sheridan Prize took place. Named for General Philip Sheridan (a Civil War hero who was visiting in '74), the prestigious event is still the highlight of every season for the Lake Geneva Yacht Club, home of America's Cup winner Buddy Melges.

Granted, the sailing here has changed a bit since the 1870s. Back then, the boats were large, deep-hulled, and over-canvassed. The first to claim Geneva Lake's Sheridan Prize was the sandbagger *Nettie*, a sloop so unstable that she required sandbags for ballast. With every change in tack, her crew had to hastily shift the ballast to keep her from capsizing, and they often wound up in the drink.

OPPOSITE **"SAILING," SAYS ONE** bumper sticker, "isn't life or death. It's much more serious than that." The jaw-clenching competitor might agree.

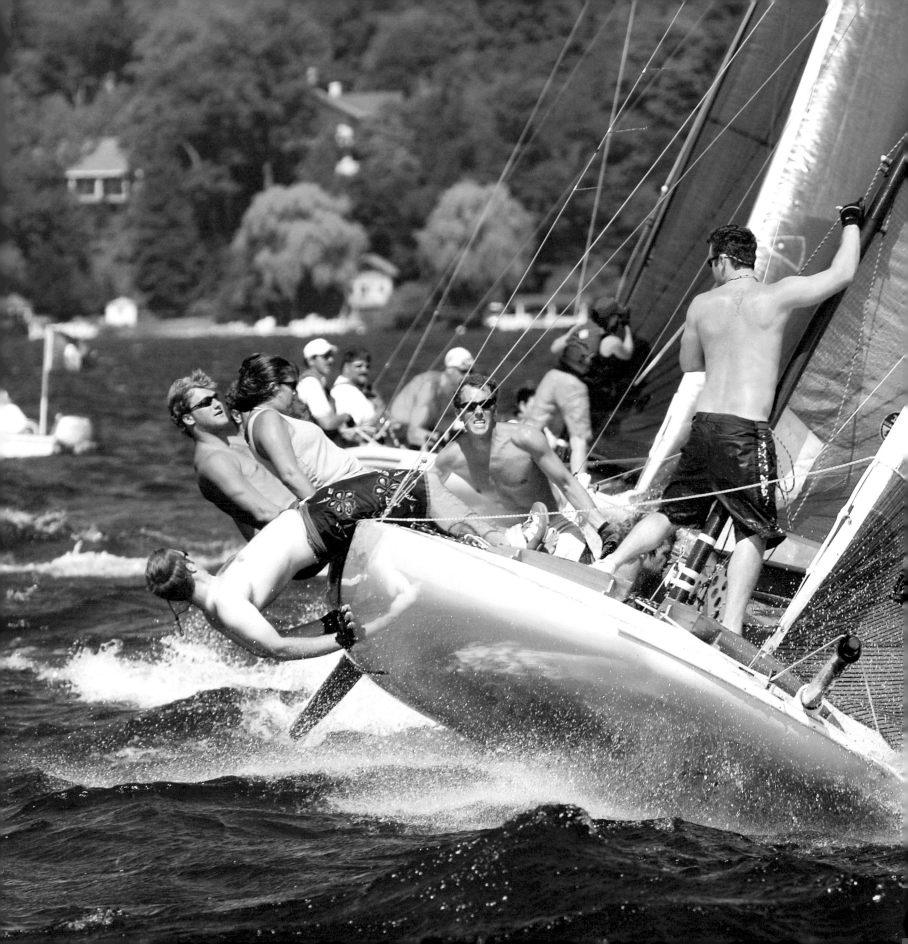

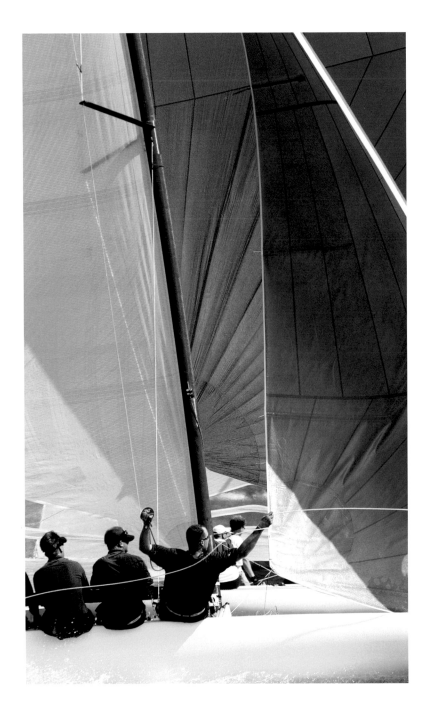

A silver trophy of the *Nettie* is still awarded to winners of the annual Sheridan race, but the boats look different today. Since the early 1900s, sleek scows have dominated the racing scene on inland lakes, and Geneva Lake is no exception. Reminiscent of great white sharks, scows are distinguished by their flat-bottomed, blunt-nosed shape.

The rules of engagement have changed as well. In those early face-offs, the boats varied dramatically in their design and their potential for speed, so the races were handicapped—meaning the first to cross the finish line might not necessarily win. With scows came the development of one-design sailing. Under this system, only "equal" boats do battle, and the fastest man or woman always claims the prize.

In the history of the Lake Geneva Yacht Club, no one has garnered more far-reaching honors than Buddy Melges or "Calamity" Jane Pegel of Williams Bay. Famous since the late 1950s, both are three-time winners of the Rolex Yachtsman or Yachtswoman of the Year award (respectively) from the United States Sailing Association. Only Ted Turner has made the list more often.

LEFT **WITH THEIR CHARACTERISTIC** flat-bottomed shape, scows were designed for swifter sailing on inland lakes. Many of the area's best sailors are former students of the Geneva Lake Sailing School, a not-for-profit institution based at the Lake Geneva Yacht Club.

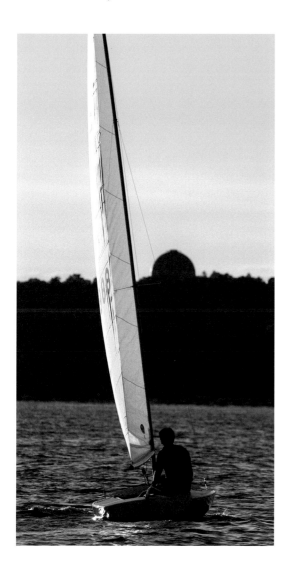

BELOW **A PLEASURE-SAILOR** steers toward Yerkes Observatory on the north shore.

PROFILE
Buddy Melges

He may be best known as the winning helmsman of the *America3,* successfully defending the America's Cup in 1992. But in Buddy Melges' mind, it's his two Olympic sailing medals—a bronze in 1964 and a gold in 1972—that stand out most. "You win for your country, not just for yourself," he says.

BUDDY AND GLORIA MELGES

Born in 1930, Harry C. "Buddy" Melges, Jr., is among the world's most successful sailors, with more than 60 major national and international sailing and iceboating titles to his name. He started racing sailboats on Geneva Lake when he was 10 years old. "I can remember every race I've ever sailed," Buddy says. "The first, the second, the third—I've always been serious about sailing."

That passion has brought Buddy many prizes, but the greatest may be Gloria, his wife. She, too, has sailed all her life. Back in '51, Buddy and his pal Bill Grunow were entering a Star-boat regatta at a Chicago yacht club. Gloria—having won the prior year—was hosting the race. As soon as he spotted her, Buddy grabbed Grunow's arm and said, "See that girl? I'm going to marry her. That's a fact!"

And it was. Their romance continued while Buddy served in Korea, and they married as soon as he returned. "He was very good at writing letters," Gloria says wryly.

The couple has a daughter and two sons; not surprisingly, they're also sailors. Harry III now runs Melges Boat Works, a company that Buddy's father started. (Buddy is the chairman.) In tiny Zenda—amid the cornfields south of Geneva Lake—the Melges crew makes world-famous racing scows. The locale gave Buddy his nickname: the Wizard of Zenda. "Zenda isn't the end of the world," Buddy quips, "but you can see it from there."

From his hilltop home in Fontana, he can see the riffles on Geneva Lake, and even when he's off the water, you can sense that he's reading the wind. "I understand this lake," he says. "It's a great training ground for sailing anywhere in the world."

The key to successful sailing, he adds, is knowing "how to present your boat to Mother Nature." That, perhaps, and his favorite low-tech weather equipment: "I go by the newspaper," Buddy explains. "If it comes in a plastic bag in the morning, I know it's going to rain."

Melges and Pegel still hoist sails today, of course, but now younger club-members are also making waves. Among the best sailors are Andy Burdick; Buddy's sons, Hans and Harry Melges; and the Porter brothers, Brian and John. The Porters' *Full Throttle* racing team has dominated A-scow racing for more than a decade, claiming the national crown seven times (and counting). And now *their* children are racing, continuing the club's tradition of success.

Although one-design racing prevails in competitive sailing, it's hardly the only game on the lake. Since 1978, the Geneva Lake Keelboat Club has promoted handicap racing with any kind of keelboat, including the newer, swifter designs such as the J/24 and the Sonar. Both clubs host races several times a week all summer long. There are also many who take to the water for the sheer pleasure of cruising. From early spring into autumn, you'll spy virtually every type of wind-driven craft here—from sailboards and tiny sailing dinghies to immense catamarans and luxury keelboats that could sail the world. When the wind gods smile, all their worshipers gather on Geneva Lake.

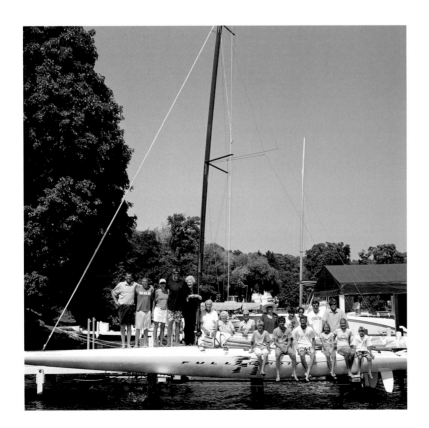

BELOW **SAILING IS A FAMILY AFFAIR** for John and Brian Porter. With their *Full Throttle* racing team, the Porter brothers have dominated A-scow racing on inland lakes.

OPPOSITE **AS THREE BOATS** vie for glory, their full sails layer, obscuring the leaders. Were this race any closer, you could step from bow to stern and join another crew.

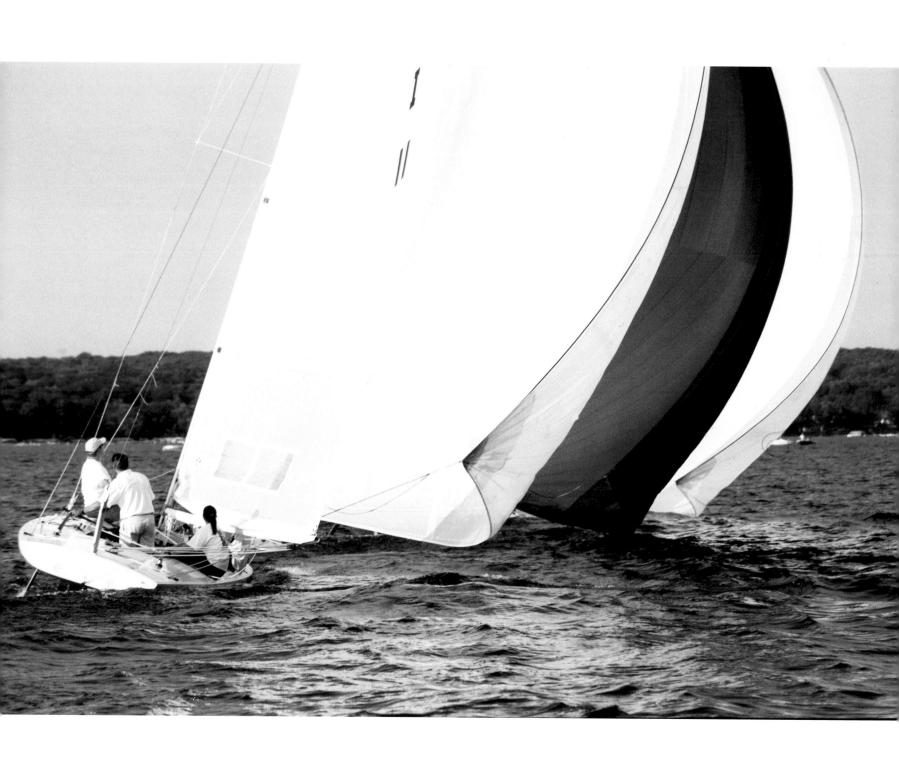

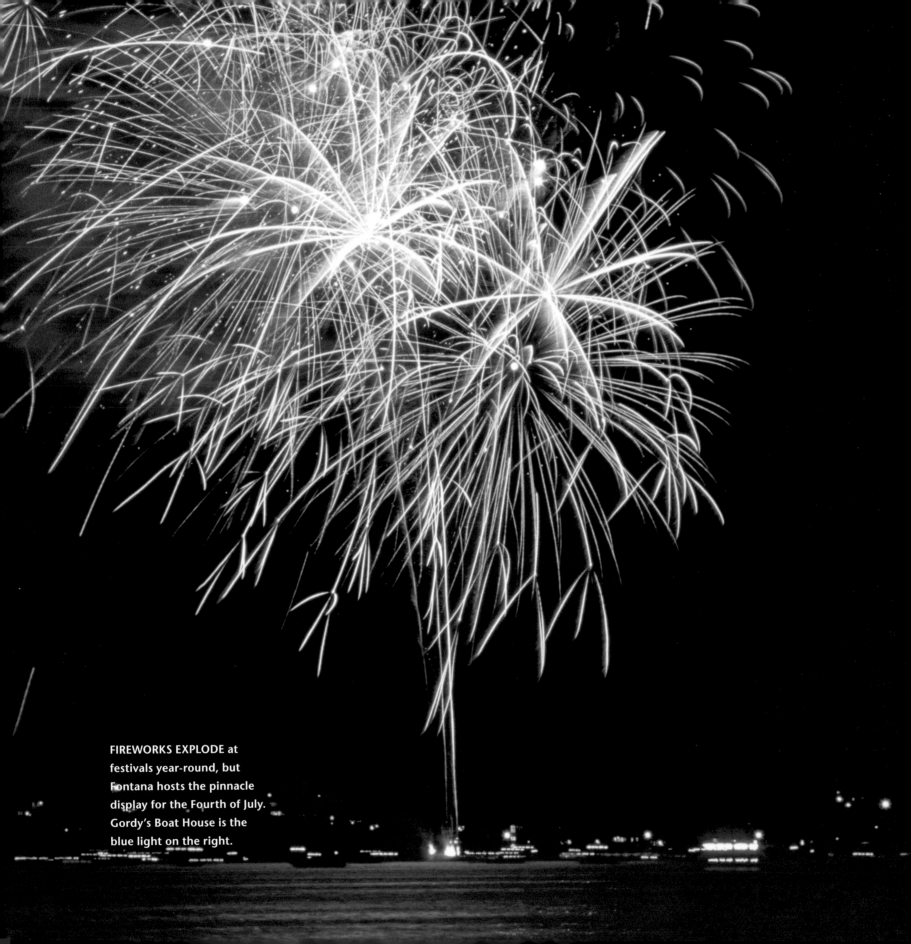

FIREWORKS EXPLODE at festivals year-round, but Fontana hosts the pinnacle display for the Fourth of July. Gordy's Boat House is the blue light on the right.

EVENTS & CELEBRATIONS

A CALENDAR AT THE LAKE looks full even before the first new entry is penciled in. This is a place of celebration and tradition—where seasons are marked not only by the changing vistas, but also by the annual events that infuse them with life. It's a richly varied roster that includes small-town festivals and black-tie charity balls and everything in between.

Spring, for instance, begins well before the pink-flowering crab trees explode into bloom along the lakefront promenades. For many, the season starts when the first tour-boat sounds its whistle on the waterfront. Others say it's when the sap flows from the sugar maples at the Covenant Harbor Bible Camp and the camp starts making syrup for their annual Maple Fest. If you're lucky enough to stroll the lakefront when the sap is boiling, you can smell the sweet steam wafting on the breeze.

ABOVE **MEMBERS OF** the Lake Geneva Country Club gather on the lawn to enjoy a private fireworks show.

LEFT **AURORA UNIVERSITY'S** lakeshore campus hosts the sensational "Music by the Lake" series. Music-lovers gather beneath a tent-top and the stars to hear symphonies, operas, and the Count Basie orchestra. A recent concert with fireworks drew 1,700 to the divinely wooded bluff.

RIGHT **A FIVE-DAY MIDSUMMER** festival held at nearby Twin Lakes, Country Thunder features such headliners as LeAnn Rimes and Tim McGraw. Locals often get a day pass, but traveling fans may camp in the fields. (The free bathing-suit showers are muddy but amusing.)

Not long after that, the athletes appear. Hundreds of runners compete in the annual Lake Geneva Marathon every May, hailed by *Runner's World* magazine as one of the best small races in the country. To show their support, volunteers manning the aid-stations often don gorilla suits and other goofy costumes, and some families hire a band.

Summer is naturally the busiest time at the lake, when every week brings something new. This is the season of art fairs and outdoor music festivals—from free evening concerts in the local parks to Aurora University's sensational "Music by the Lake" series. The Alpine Valley Music Theatre—one of the nation's largest outdoor amphitheaters—nestles in the country hills just 20 minutes north of Lake Geneva. Big enough for 35,000 fans, it draws music-lovers from all over the Midwest, hosting such shows as Jimmy Buffet, Dave Matthews, and Ozzfest. (You can always tell when Buffet is in town: The cars in Lake Geneva sprout shark fins, and the pickup beds fill with palm trees—a little taste of Margaritaville.)

Summer also holds the greatest number of food fairs and street festivals, which benefit local civic groups and charities or volunteer fire-and-rescue departments. From pancake breakfasts to corn-and-brat fests to the always-outstanding Linn Township Pig Roast, they are embraced by year-round and part-time residents alike. "Where else would you see people with personal chefs at home standing in line with their tickets in one hand and a paper plate in the other?" asks one lakeshore resident. "And they're all smiling!"

LEFT **DELIGHTFULLY STEAMY,** the west-end Lobster Boil is one of many summer "food affairs."

BELOW **DURING LAKE GENEVA'S** summer "Paint-in," artists line the streets with easels and umbrellas and spend the day painting *al fresco*. The event takes place in June.

CREWS READY the Driehaus estate for an annual midsummer bash. The 2005 party featured a pirate theme.

THIS LITTLE PIGGY went to the Walworth County Fair, which marks the end of summer.

COME AUGUST, scores of artists and exhibitors gather for Art in the Park, a juried show that has graced Lake Geneva's lakefront for more than 20 years. Williams Bay now holds a similar event earlier in the summer.

One of the most remarkable summer events is private, but every insider knows of it. Every July, Richard Driehaus hosts a theme party at his north-shore estate. The guest list cuts off at around 500, but the spectacle is so grand that even passersby can enjoy it. In the days leading up to the party, people strolling the shore path are amazed as crews swarm over the grounds of the red-brick mansion, creating an immense theatrical set. One year, the entire façade of the Georgian-style house was transformed into the Emerald City, while the rest of Oz—including a yellow brick road running through a cornfield—took shape on the grounds. Another year, a pirate ship suddenly jutted out from the mansion, and vast tropical seas—that is, colored sand—flowed over the lawn. The fireworks display that caps off each party is so eagerly anticipated that boaters drop anchor offshore to watch the show.

Events are spaced more widely in fall and winter, but they are no less engaging or varied. The transition to autumn is marked by the Walworth County Fair, one of the nation's largest and oldest. With dog shows, pony shows, flower shows, harness-racing, pig-racing, and big-name country headliners playing to $10 seats, the fair attracts an extraordinary cross-section of people. As autumn leaves begin to blaze, the classic cars roll into town for the annual rally, and cyclists gather for a "Fat Tire" tour.

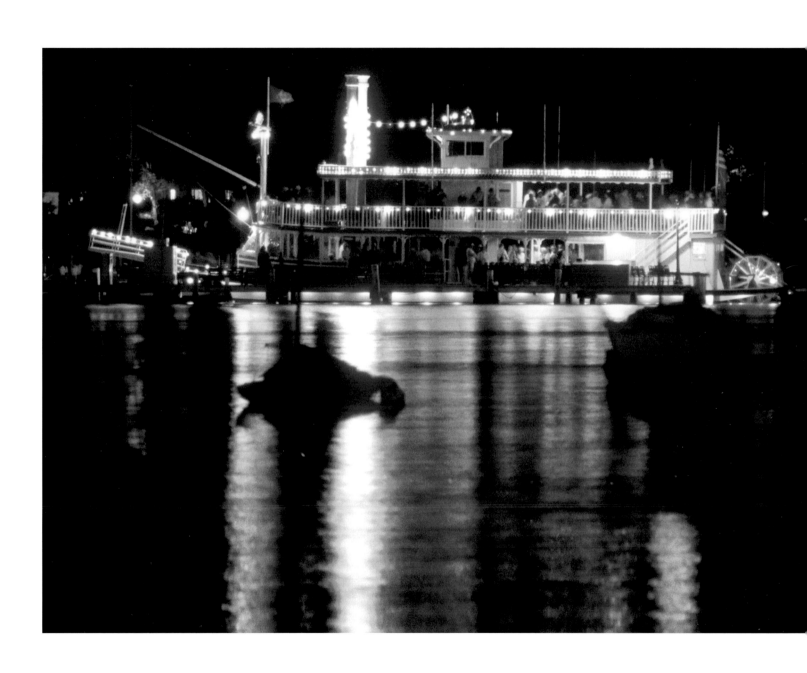

ABOVE **QUEEN OF THE TOUR BOATS,** the *Lady of the Lake* is a perfect place to party during the Venetian Fest. An August event in Lake Geneva, the festival includes a lighted boat parade and a fireworks spectacular.

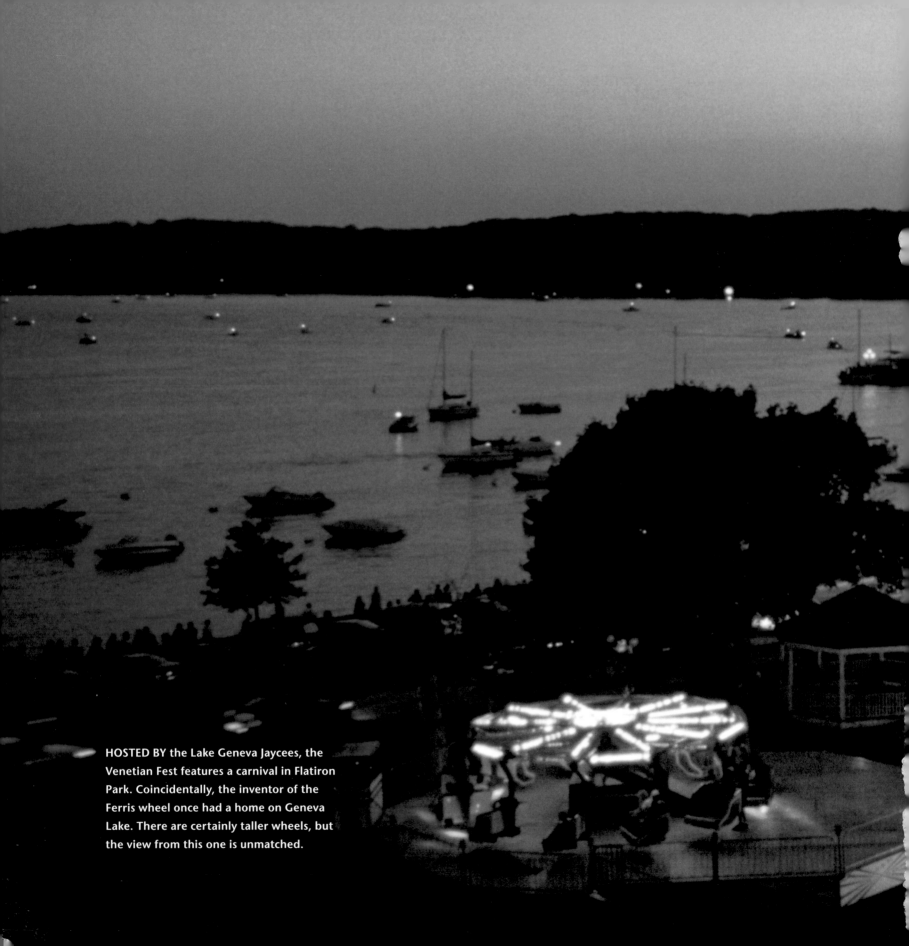

HOSTED BY the Lake Geneva Jaycees, the Venetian Fest features a carnival in Flatiron Park. Coincidentally, the inventor of the Ferris wheel once had a home on Geneva Lake. There are certainly taller wheels, but the view from this one is unmatched.

ABOVE **LARGELY FUNDED BY** private donations, the Water Safety Patrol has watched over Geneva Lake since 1920. It was founded by Simeon B. Chapin, a New Yorker who came to love these waters.

THE LEAN-AND-CHISELED SET appears in early May for the Lake Geneva Marathon, then returns in September for the annual triathlon and half-Ironman. The Olympic-length triathlon starts in Fontana with a .9-mile swim (*below*), followed by a 25-mile country bike ride and a 6.2-mile run back at the lake. Alternate events and "team relays" swell the number of competitors.

The city of Lake Geneva hosts an Oktober-fest as well as a Winterfest, and each village has its own traditions—not to mention the resorts and inns, which host a long parade of their own special events to celebrate the holidays and cure cabin fever. The fireworks that cap off Grand Geneva's Winter Carnival light the sky for miles around. After the resort's ski season has ended, snowmobiles learn to "fly" at the ESPN-featured snocross race, which takes place on the same slopes. It's winter's one last hurrah before the cycle of seasons returns to spring.

BELOW **THE U.S. NATIONAL SNOWSCULPTING COMPETITION** highlights the Lake Geneva Winterfest, always the first weekend in February. The show begins when 10- by 10-foot blocks of packed snow are delivered to the Riviera, courtesy of snowmakers at the Grand Geneva Resort's ski hill. The resort holds a concurrent Winter Carnival.

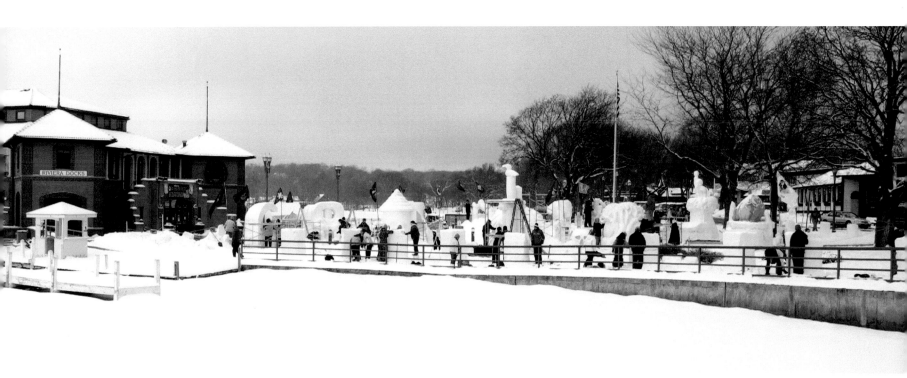

A NIGHTSPOT KNOWN for its sumptuous Italian food, Café Calamari overlooks the shore of Williams Bay. Harpoon Willie's is a casual watering hole in the same building (with an obvious nautical theme). Both are owned by the LaCroix family, *inset*.

LOCAL HANGOUTS

WITH LUXURIOUS RESORTS close at hand and romantic retreats such as the Geneva Inn along the shore, the Geneva Lake area has a "special occasion" dinner choice at virtually every compass point.

Loosen that necktie. This chapter is about the restaurants and watering holes where locals go time and again to relax with old friends (and meet new ones). Although some hangouts are romantic and even a bit upscale, not one screams "tie required," and the jacket is optional, too.

In a place with so many choices and diverse personalities, it's simply not practical to include everyone's favorite gathering spot. If you belong to the yacht club or a golf club, for instance, you'll no doubt enjoy spending time there, too (even though they're not pictured here). Furthermore, some restaurants, such as Popeye's on Geneva Bay, are so popular among tourists *and* locals that they've reached landmark status.

Here, then, is a small sampling of places that every insider knows—the quirky but beloved breakfast cafe, the favorite Friday night tavern, the places where good stories are told and born. It's just enough to whet any appetite.

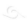

BELOW **ONE OF THE MOST** beloved and laid-back bar-and-grills around, Chuck's Lakeside Inn on the Fontana waterfront is a place known for burgers, beer, flip-flops, and fun. So many connections have been forged at Chuck's that the tavern hosts a regular "reunion" for married couples whose love first blossomed here.

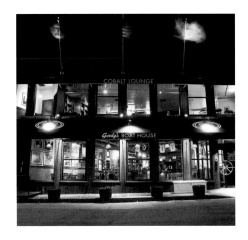

LEFT **THE LATE GORDY WHOWELL** offered $1 speedboat rides past the Fontana beach in 1955—"a one-dollar bill for a millionaire's thrill!" It was the start of a lakefront legacy that lives on in Gordy's Boat House and Cobalt Lounge, a popular Fontana eatery and watering hole owned by Gordy's son Tom Whowell and family.

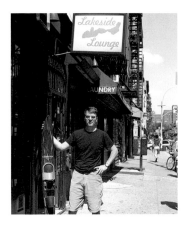

ABOVE **THE LOGO ON THE SIGN** is Geneva Lake, but the location is Manhattan's East Village. Eric Ambel and two partners opened the Lakeside Lounge in 1992. The inspiration? Chuck's bar in Fontana. "Seems like you're 18 forever in Chuck's," muses 40-something Ambel. A musician and record producer, he began summering on the lake in '69 and still visits every year.

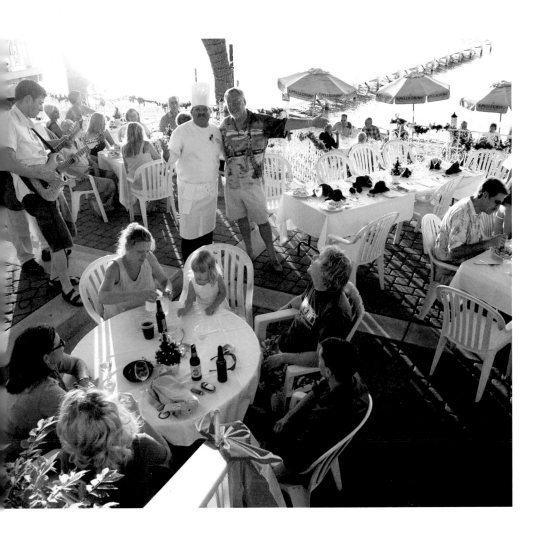

BELOW **A LOCAL LANDMARK** as well as a favorite hangout, Daddy Maxwell's Arctic Circle Diner was featured in James Patterson's best-selling novel *Sam's Letters to Jennifer*. On summer weekends, the line for breakfast often stretches outside, but no one ever seems to mind. The chocolate milkshakes are good here, too.

ABOVE **OKAY, SO IT'S NOT GENEVA LAKE**—but the French Country Inn on nearby "little sister" Lake Como definitely draws the local crowd with what amounts to a summer-long party on their patio. Owner Jim Kirschlager and Chef John Bogan host a string of events, including a weekly "Bash on the Bayou" with live music and "The Thrill of the Grill," an event that is part multicourse meal and part gourmet cooking class. Bogan's speciality is Hawaiian fusion.

Big Toys

❧

To call them "toys" might seem inappropriate, until you see the pleasure they bring—the youthful grins, the sparkling eyes, the infectious excitement with which their owners describe every detail of history or design. Whether it's classic cars, model trains, antique boats, or even amazing flying machines, Geneva Lake is known for its collectors, and while they're serious about their pastime, the underlying motive is rarely about showing off—it's about having fun.

CULLY PILLMAN SOARS in his Buckeye Dream Machine powered parachute.

PROFILE

F. Cully Pillman

"The police know all about me," says Cully Pillman with a roguish grin. Who else would drive a 1963 wheeled British tank to a local bank, waggle the (unloaded) gun turret at a friend inside, then "invade" a salon to get a haircut? A man's man and perpetual punster, Pillman is a fifth-generation area resident and the owner of Woodhill Farms, a country nursery and landscape business. He's also an insatiable big-toy collector, with dozens of vehicles—everything from the tank to a 1925 Ford Model T Huckster to an "absolutely virginal" 1951 Chrysler Imperial. "I drive them all," he says. "I'm not into museum pieces."

Few people have toured the lake like Cully, who often pilots his Buckeye Dream Machine ultralight straight up through the clouds, then pops down for a bird's-eye view of sailing regattas. On quiet summer Thursdays, he launches his own two-man submarine from the Lake Geneva Yacht Club. As the sub dives, the sapphire waters turn a cool green, and Cully and his passenger soon sit waist-high in water with an envelope of air around their heads and torsos. "I've been down to 110 feet off Black Point," he says. "All these fish go by . . . some as big as the window. It's like being in an omnitheater."

Pillman grew up in the Chicago area, but he summered at his grandparents' house in the historic Harvard Club, where he learned water-skiing, scuba-diving, and spear-fishing. After a stint in Michigan as a counselor for juvenile delinquents, he returned to Wisconsin to buy his farm just south of the shore on Highway 120 and start a family.

The rural location suits Cully's business—as well as his propensity for firepower. "Room for a trap-shooting range was an absolute priority when I was looking for land," says Cully, a crack marksman. His personal arsenal includes two cannons and a rifle with armor-piercing bullets (he aims low into the hills to spare the neighbor's cows). Although Cully is clearly adventurous, he's not reckless. "I like to have fun," he says, "but I'm very careful about everything I do."

The neighbors and local law enforcement are glad to hear it.

Consider Karl and Lucy Otzen. In 1985 they announced a mission: to collect, maintain, and share vehicles produced during the hundred-year period from 1900 to 1999, with at least one important example from each decade. At their north-shore home, they erected a magnificent post-and-beam garage to house it all, with drive-up entries on two levels.

The Otzens' 1940s collection is particularly outstanding. The jewel may be the 1947 Cadillac sedan by Fleetwood, but the Otzens' Toro dump-box turf tractor draws just as much praise. Years ago, Karl and Lucy personally used the tractor for landscaping projects. Then Karl "spruced it up a bit"—adding headlights and a leather seat for two, among other things. After that, the couple began driving the tractor to cocktail parties and in the occasional parade. It perpetually leaks fluids, but that's part of its charm.

Then there's the shiny blue 1947 Whizzer, a motorized Schwinn bicycle parked in Karl's home office. He actually rode it as a kid and luckily lived to tell about it. The Whizzer reached 30 miles per hour with only a bike brake for stopping. Another danger? "The exhaust pipe got hot enough to burn you," recalls Karl, who has been drawn to special vehicles since he could steer.

At 20, Otzen boasted to Russell Gage that he could drive Gage Marine's *Lady of the Lake* paddle-wheeler as well as anyone—and he soon had a summer job doing it. Part of the excursion fleet, that majestic paddle-wheeler still cruises the lake from early spring through autumn, and its cheery whistle blast can be heard for miles.

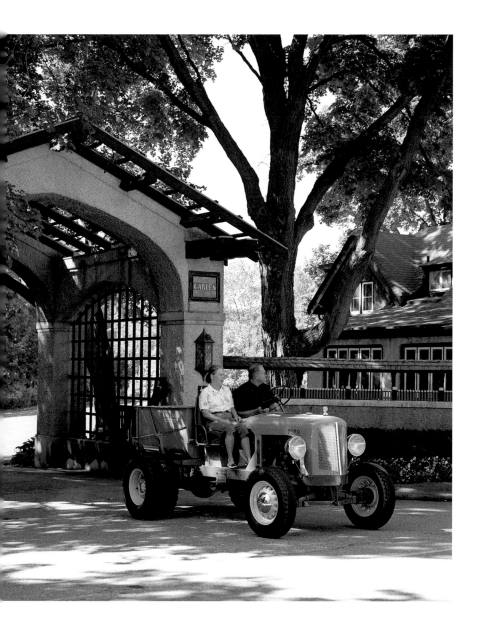

ABOVE **THE FLOOR** in the Otzens' two-story garage is just as pristine as this 1934 Packard. A rare coupe roadster, it's equipped with a factory-installed 12-cylinder engine.

LEFT **KARL AND LUCY OTZEN** take their 1940s Toro dump-box turf tractor for a Sunday drive. The charming gateway to their home, Green Gables, dates to the early 1900s, when the estate was owned by the Wrigley family.

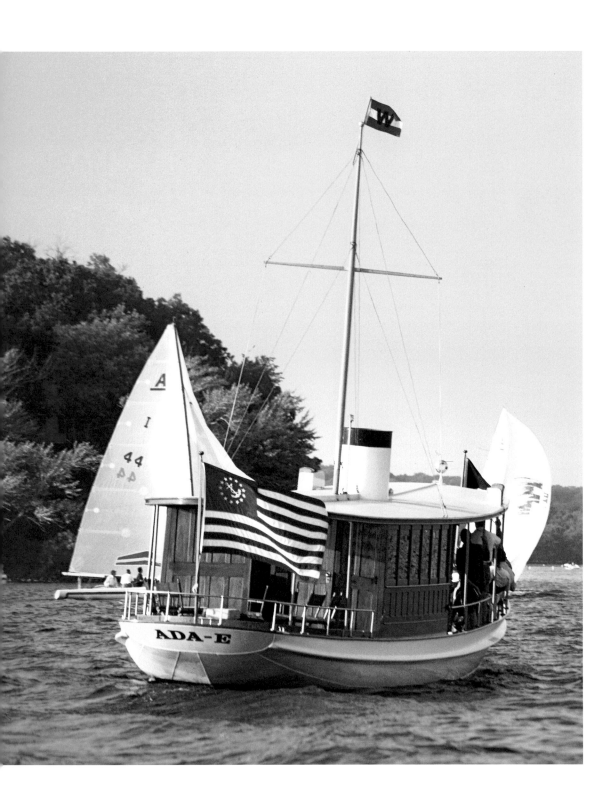

LEFT **THE PRIVATE YACHT** *Ada E* maneuvers for an ideal view of a sailing race. The 70-foot cruiser has been owned by the Wrigley family since it was launched here in 1911. It was named for the wife of William Wrigley, Jr.

BELOW **RANDY STREBLOW** represents the second generation of his family behind Streblow Custom Boats, a west-end company that creates high-speed wooden runabouts.

The *Lady* may be the largest vessel on the lake, but she's not the only beauty afloat. Where classic, antique, and one-of-kind boats are concerned, the collective fleet on Geneva Lake is unrivaled. Nautical enthusiast Larry Larkin spent two years documenting them all for his book *Grand and Glorious: Classic Boats of Lake Geneva*—from wooden runabouts and high-performance wooden raceboats to elegant yachts like his own cherished *Normandie*, a fully restored 63-foot cruiser that first sailed the lake in 1913.

Passenger trains no longer stop at the lake (they once arrived several times daily in Williams Bay and Lake Geneva), but model trains of all sizes and shape certainly do. In many landscapes, you'll find a G-scale railroad meandering through the perennials or dwarf conifers. In basement or attic rec rooms, you might find anything from the ever-popular O-scale on down to the tiniest of Z-scale layouts. In one lakeshore home (the owner prefers to remain anonymous), the trains travel from room to room, riding rails suspended just below the ceiling, with tunnels through walls.

Honors for the most extraordinary rail system go to Michael Ferro, owner of a 1919 estate called Alta Vista. The entire attic of his lakeshore palazzo is filled with a miniature wonderland depicting scenes from downtown Chicago and Lake Geneva. The tracks even pass a circus with big-top sound effects, a drive-in where automated carhops appear, and, of course, a model of Alta Vista itself.

PROFILE
Larry Larkin

LARRY AND SUE LARKIN

"For me, it's never been a question of 'Is this possible?'" says Larry Larkin, an electrical engineer, boat builder, and author of *Grand and Glorious: Classic Boats of Lake Geneva*. "When I didn't have the financial resources for something, I'd imagine how I could make it with my own hands."

Evidence of his craft looms in the enormous boat shed behind the Larkins' lakeshore home, where Larry has been building a steel-and-mahogany dream since 1990—almost single-handedly. The vessel's sleek lines and elegant clipper-style bow recall late–19th-century steam yachts that once ferried Chicago's elite to and from their Geneva Lake estates. "It's probably the first boat of its kind built since 1913," says Larry, whose first engineering job was designing recovery systems for Mercury spacecraft.

His passion for boats was fueled by boyhood visits to Geneva Lake, where he summered on Rainbow Bay with his cousins, the Peter Bates family. "Peter was a very important figure in my life," says Larry, whose father died when he was only three. "He showed me that I could think larger . . . he helped me see what was possible."

Perhaps the greatest influence is his wife, Sue, to whom he often turns for advice in both his writing and design projects. "She has more style than I do," Larry notes humbly. The couple met at Geneva Lake in 1958, when Sue was working at College Camp (now Aurora University). They married in 1960, and four years later, they bought a weekend getaway on the shore. As four children entered the picture, Larry gained a merry crew for his small fleet of antique and classic boats, including the first he ever purchased: the 63-foot *Normandie*, built in 1913. When Larry found the dust-shrouded beauty in 1955, she had been dry-docked since World War II. It took 10 years to restore her.

In 1980, the Larkins sold their Chicago-area home and moved to the lake full-time. "Whenever we have guests, the first thing they do is walk to the waterfront," Larry says. "It's a powerful attraction."

ABOVE **MICHAEL AND JACKY**
Ferro relax at the shore.

BELOW **INCREDIBLE TRAIN-TRACKS** loop around the entire attic of the Ferros' north-shore mansion. Equipped with lights, automated parts, and sound effects, the surrounding models create a fantasy world in which downtown Chicago merges with the Lake Geneva countryside. There's even a model of the Ferros' lakeshore estate.

Although flying machines at the lake are greatly outnumbered by floating and land-hugging craft, they still command attention. Several estate-owners arrive at the lake by helicopter, landing at nearby farms or airports. (Landing directly onshore isn't allowed, although at least one estate owner has defied the rules in the past.) Seaplanes, however, are common on the water. A lakeshore resident who owns one routinely takes "the scenic route" to dinner, even though the trip from his house to Geneva Bay is less than 8 miles long.

With toys like these, the only thing missing from the local collection of amazing motor-driven craft is a lunar landing module. Odds are, however, that Cully Pillman will acquire one soon. After all, he already has a British tank and a two-man submarine.

OPPOSITE **AUTUMN BRINGS** a "Weekend of Classics," which features the annual Antique and Classic Boat Show at Fontana's Abbey Resort (pictured). The Lake Geneva Classic Car Rally runs concurrently, raising funds for cancer research. A special fly-over of antique planes often tops off the "invasion" by air, land, and sea.

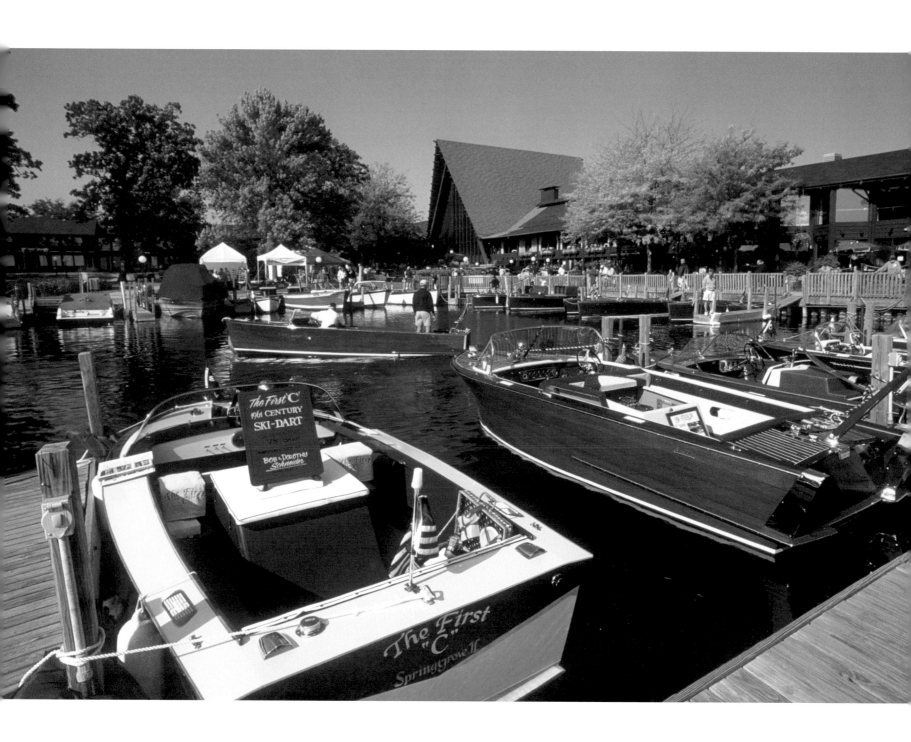

COUNTRY DRIVES

AT THE EDGE OF ANY TOWN along Geneva Lake, narrow backroads head into the countryside, slipping between emerald acres of farm-land planted with corn and soy. To the south, the fields lie flat or gently roll, spreading far beneath the sky. Directly north, the terrain folds into the Sugar Creek Valley, an often misty realm bordered by steep, forested moraines.

Snake Road—one of the most picturesque drives in the state—begins just outside the city of Lake Geneva. An access road for north-shore estates, the route is beautiful in any season, but it's especially so in fall, when overhanging maples become a tunnel of glowing gold. The historic mansions face the waterfront and were built with vast acres of woods and pasturage at their back, so the narrow lane offers only fleeting glimpses of Geneva Lake itself. Instead, the road twists and turns through shady glens and along broad-shouldered hills where horses graze in the sun.

For those who enjoy the chance to explore the road less traveled, mile after mile awaits discovery. Several outstanding tours are easy to find: They've been designated Rustic Roads by the state of Wisconsin. (Watch for the signs.) Snake Road is among them, but the curvy route on Cranberry Road and the 10-mile adventure on South Road are equally appealing. Both connect to Highway 50 just east of Lake Geneva. Even better are those unmarked surprises, including a slow route across Sugar Creek Valley on Bowers Road, and treks along country lanes that flirt with sparkling streams or stretch past fields of nodding daylilies. Just point your tires and go.

OPPOSITE **TUCKED IN A SMALL,** sun-dappled valley, historic Flowerside Farm is a highlight of Snake Road—a twisting, roller-coaster drive near Lake Geneva.

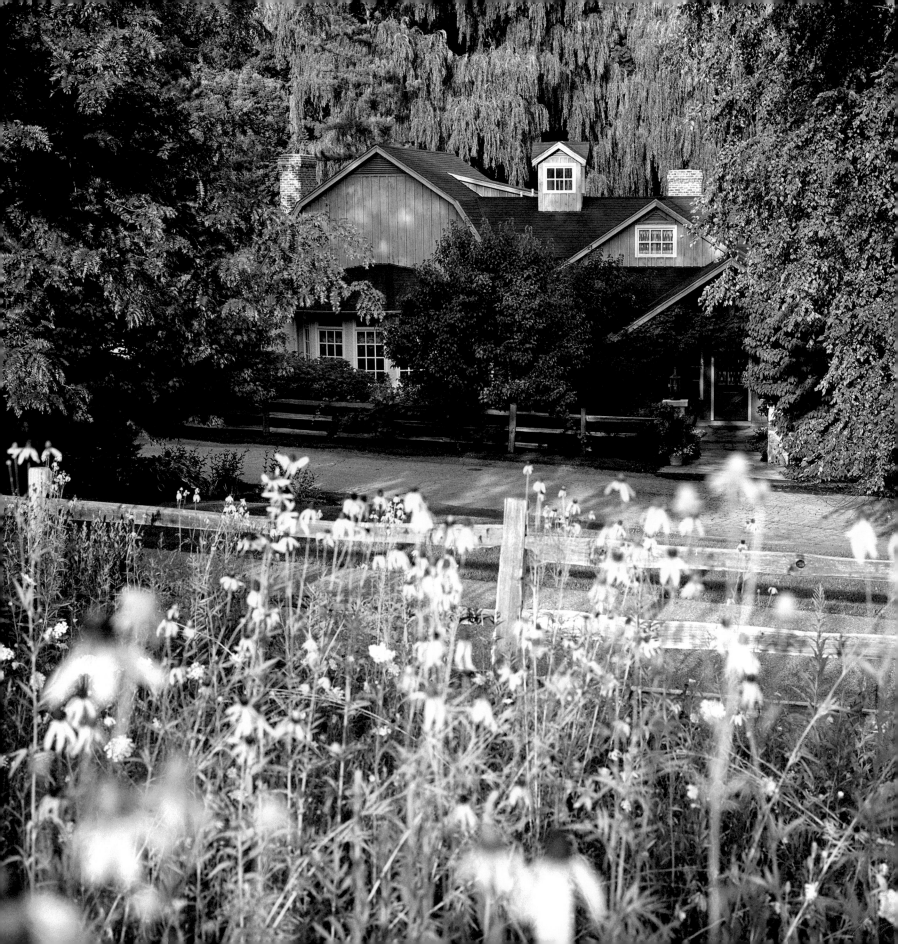

LEFT **FLOWERSIDE FARM** originally belonged to the estate of Simeon B. Chapin, whose philanthropy aided the development of Lake Geneva's Horticultural Hall and many other lasting endeavors.

BELOW **FALL "COLOR TOURS"** are always close at hand. Come autumn, the approach to the lakeshore's 700 Club wears a golden crown of maple leaves.

ABOVE **AGRICULTURE REMAINS** a vital part
of the local scene, contributing to its beauty
as well as its economy.

ICEBOATING

IT'S A THRILL like no other. With a gentle push, the boat starts to glide across the dark, gleaming ice. The wind fills the sail and the craft picks up speed. Soon the ice is rumbling like thunder beneath the runners, only inches below the cockpit, and frozen shards fly up in a face-stinging spray. Then the boat itself seems to be flying, hiking up on the windward side, almost floating in time as the bluffs along the lakeshore drift past.

Compared to iceboating, sailing on "soft water" is, well, *soft*. The basic sailing principles are the same, but the fine points differ, along with the rocketing acceleration. On good ice, a swift iceboat with a daredevil skipper can easily reach speeds topping 120 miles per hour.

On Geneva Lake, iceboating has known a history so rich that Williams Bay has rightly declared itself the "Iceboat Center of the World." Until the early 1930s, boats throughout the country were big and slow. Then Walter Beauvais of Williams Bay built the first "Beau-Skeeter," an incredibly zippy craft with 75 square feet of sail. Iceboating has never been the same.

RIGHT **COME WINTER,** many of Geneva Lake's "soft water" sailors turn to iceboating. The ideal ice is smooth, without runner-dragging snow-cover.

The Skeeter led to the development of the DN iceboat (it's named for the *Detroit News*, which held a design contest in the mid-1930s). Light enough to travel atop a car from lake to lake, the diminutive DN is still one of the most popular iceboats worldwide—and it's the top choice of Williams Bay's "Calamity" Jane Pegel. Still winning races after more than 50 seasons on the ice, Pegel became the first and only woman ever to win the national DN championship in 1960. She repeated the feat in 1963. Pegel admits that she's a little slower on the push-starts now (it's like launching a bobsled), but what she lacks in jogging power, she makes up for in steering skill and cunning.

When she's not out sailing, Pegel often mans the ice hotline for the local Skeeter Iceboat Club, reporting conditions to members. According to Pegel, Lake Geneva has offered more good iceboating days throughout its history than any other lake in the Midwest. The ideal ice is thick and smooth, without runner-dragging snow-cover—but not so slick and hard that the boats slide sideways. For safety's sake, club members don't race when the winds exceed 25 mph. (Iceboats can travel three to five times faster than the wind they harness, and they don't have brakes.)

LEFT **MOMENTS AFTER** this shot was taken, the steering cable snapped and the two-man boat—traveling roughly 70 mph—crashed into shore. Luckily, only the boat was seriously injured.

Like many iceboaters, Pegel is a seasoned "soft water" sailor as well, but racing on ice is by far the greater passion. No other sport is as complex in competition, she explains—or as invigorating. "I live for the winter," Pegel says.

BELOW **A DIMINUTIVE DN** hikes up. The most popular type of iceboat worldwide, the DN is also the favorite of Jane Pegel of Williams Bay, first woman to ever win the national DN championship.

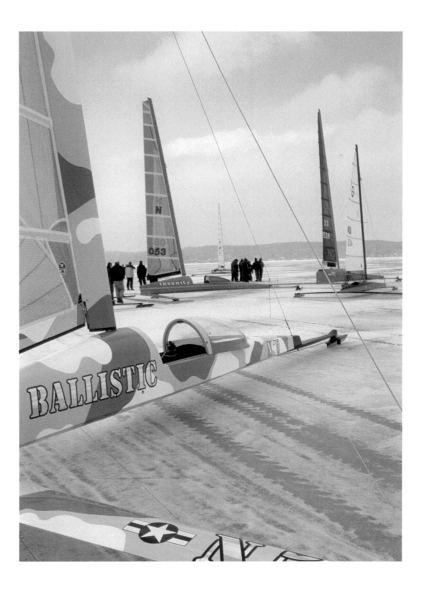

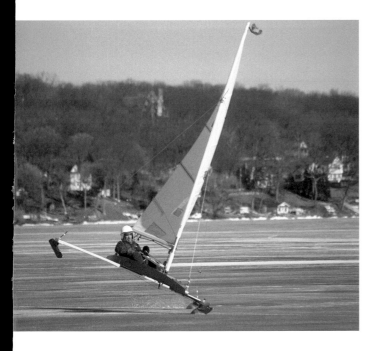

ABOVE **THIS HIGH-TECH BOAT** belongs to an East Coast resident whose daughter is an Air Force pilot. The boat matches her plane (without the jet propulsion, of course).

OVERLEAF **EVEN WHEN** the boats are still, the ice is the place to be.

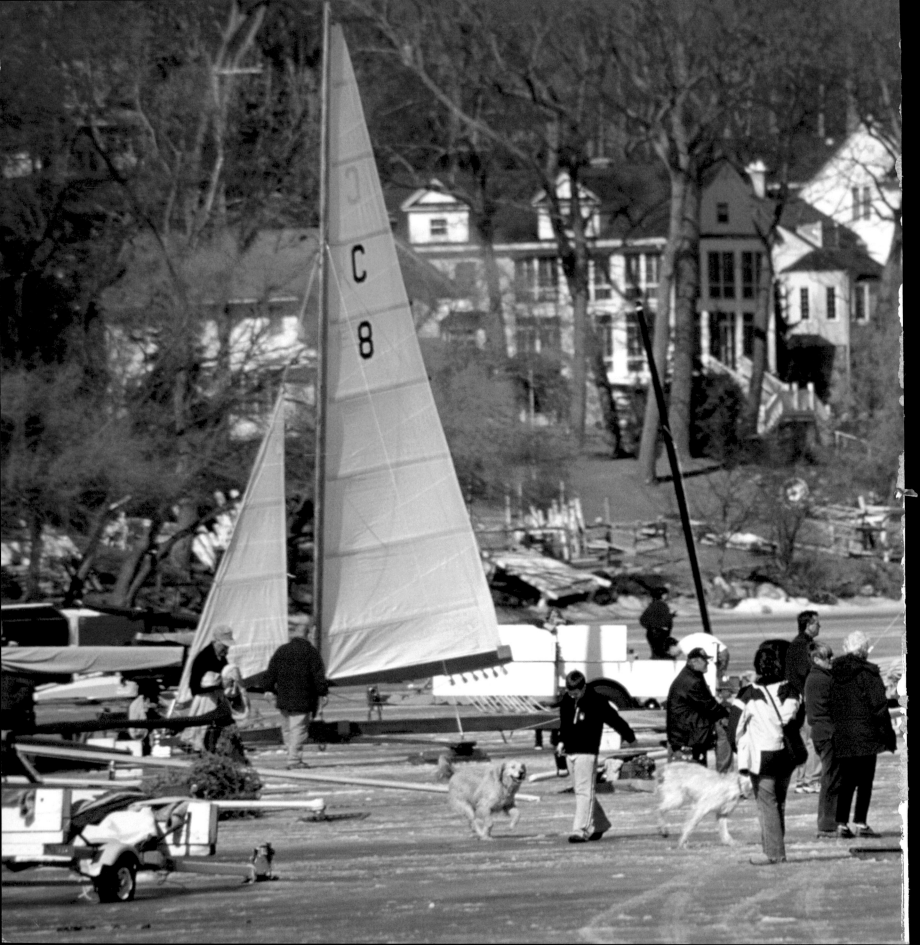

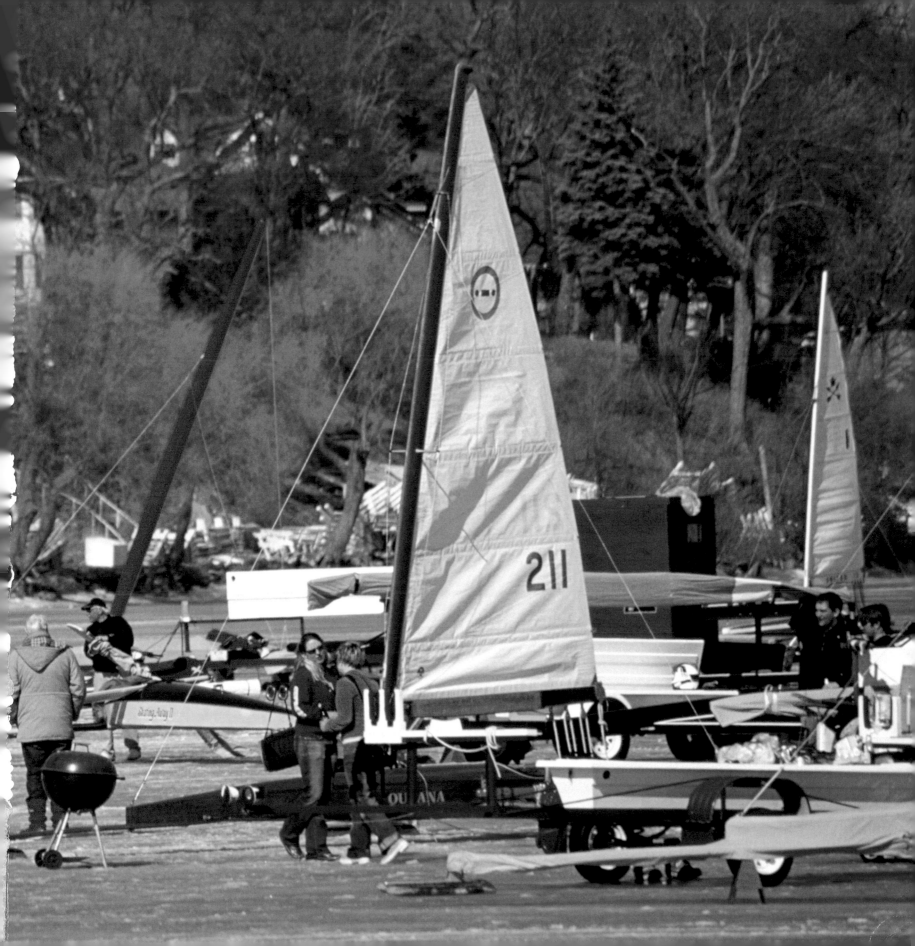

WINTER WONDERS

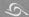

IN LATE NOVEMBER, when frigid air meets the still-warm water, Geneva Lake gives rise to delicate tendrils of steam that expand into curtains of roiling fog. Winter commences and as the freeze sets in, conversation turns toward ice fishermen and whether they're brave or just plain foolhardy. Some Januaries are so mild that anglers float in boats on patches of open water while the "true" ice fishermen stake their territory on half-frozen ledges nearby.

Most residents welcome a more bracing season for the opportunities it brings: skating on the lake, cross-country skiing, a moonlit stroll through snow-shrouded woods. In the deep hush that follows a winter storm, there is no greater pleasure than to pause in quiet reflection and admire the unfolding wonders. This, then, is Geneva Lake in all its winter splendor.

LIKE CLOUDS AGAINST a brooding sky, curtains of mist rise from the lake and veil its steel-blue surface in early winter. The vantage is the summit of Majestic Hill.

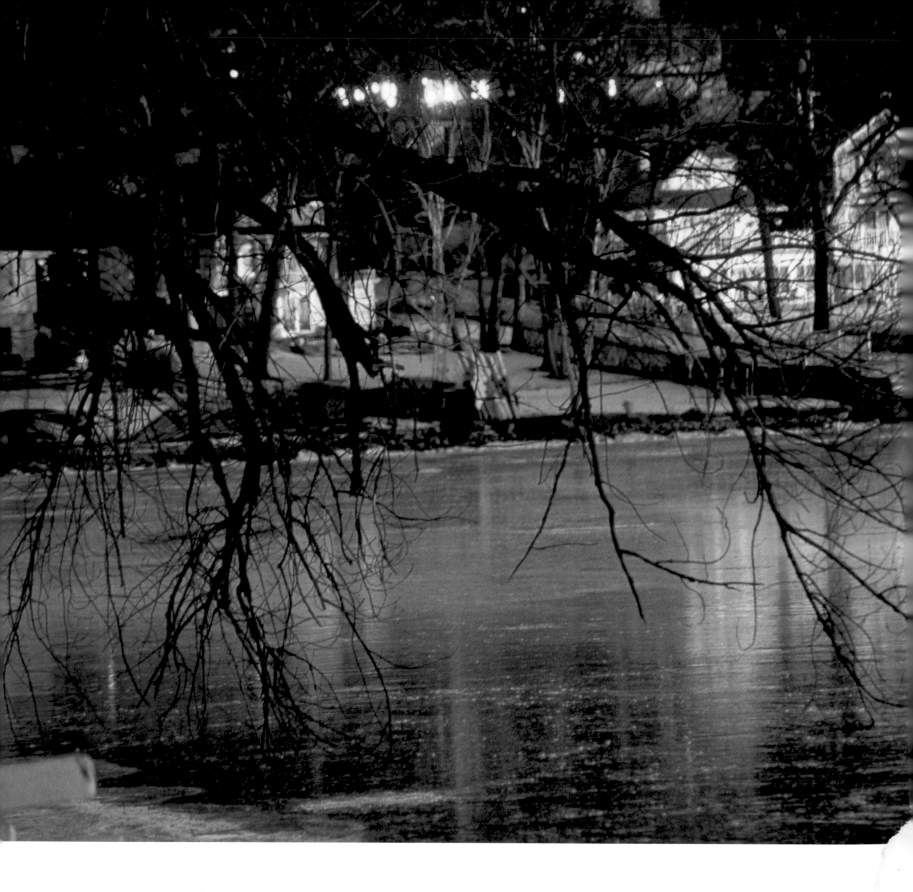

OPPOSITE **MIRRORED BY WINDOWS** along the shore, the fading sun tints the winter landscape with shades of purple and gold. Come nightfall, the clear ice will be shining and black.

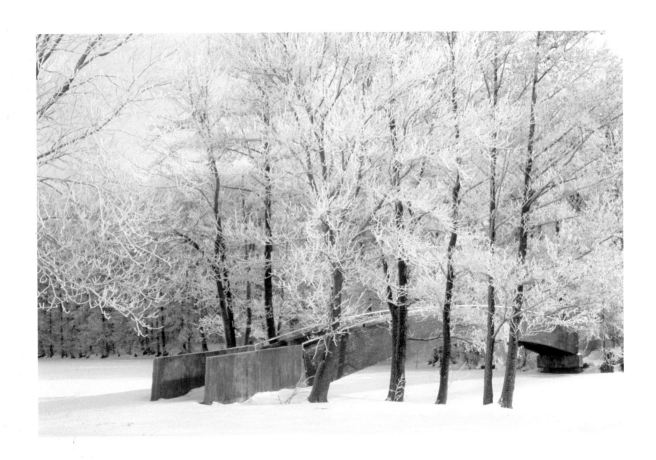

ABOVE **A FEW STRIDES** from Button's Bay, a bridge arches over the lagoon at Big Foot Beach State Park. Once part of the Maytag estate, the manmade lagoon is a replica of the lake, echoing its long, narrow shape.

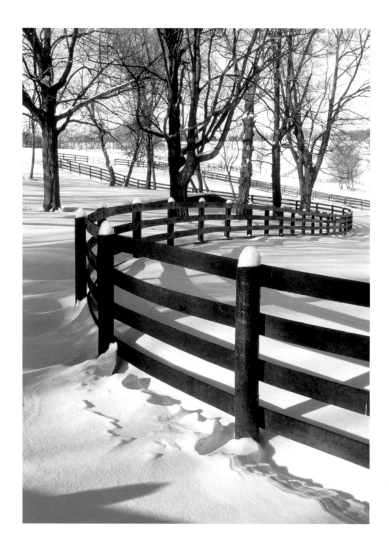

ABOVE **A FRESH SNOWFALL** and winter shadows create magic at a Snake Road horse farm.

RIGHT **FISHERMEN TAKE** the night shift in a cozy shack.

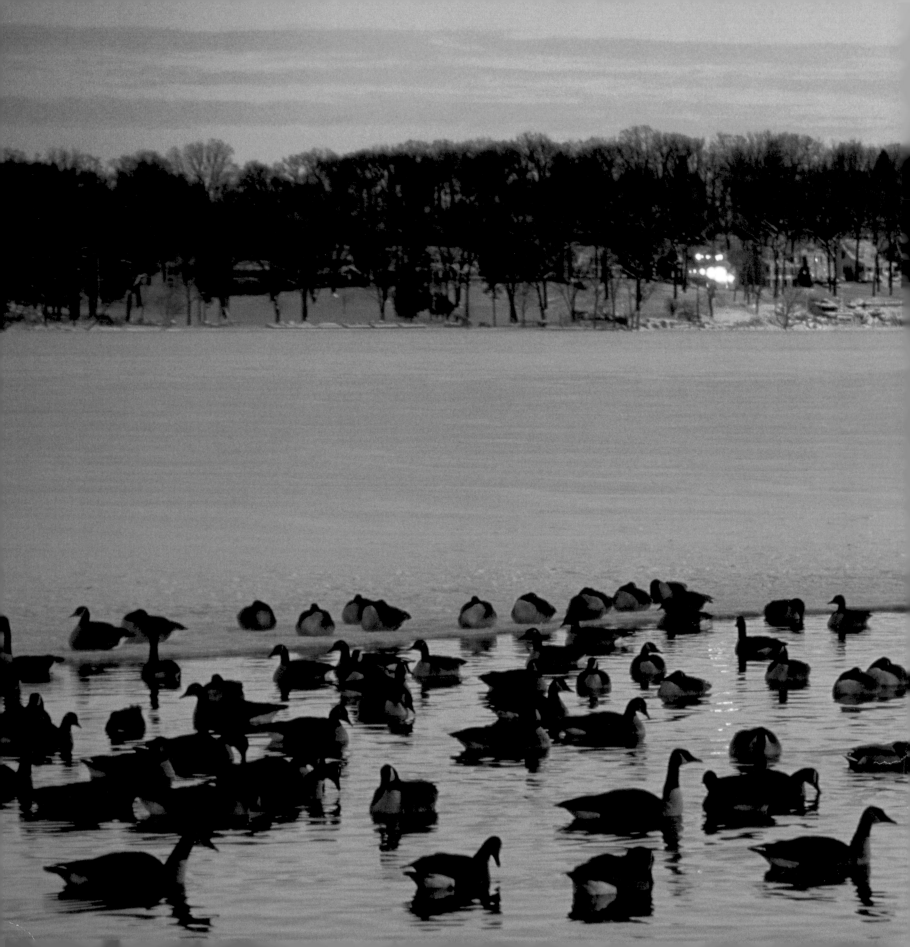

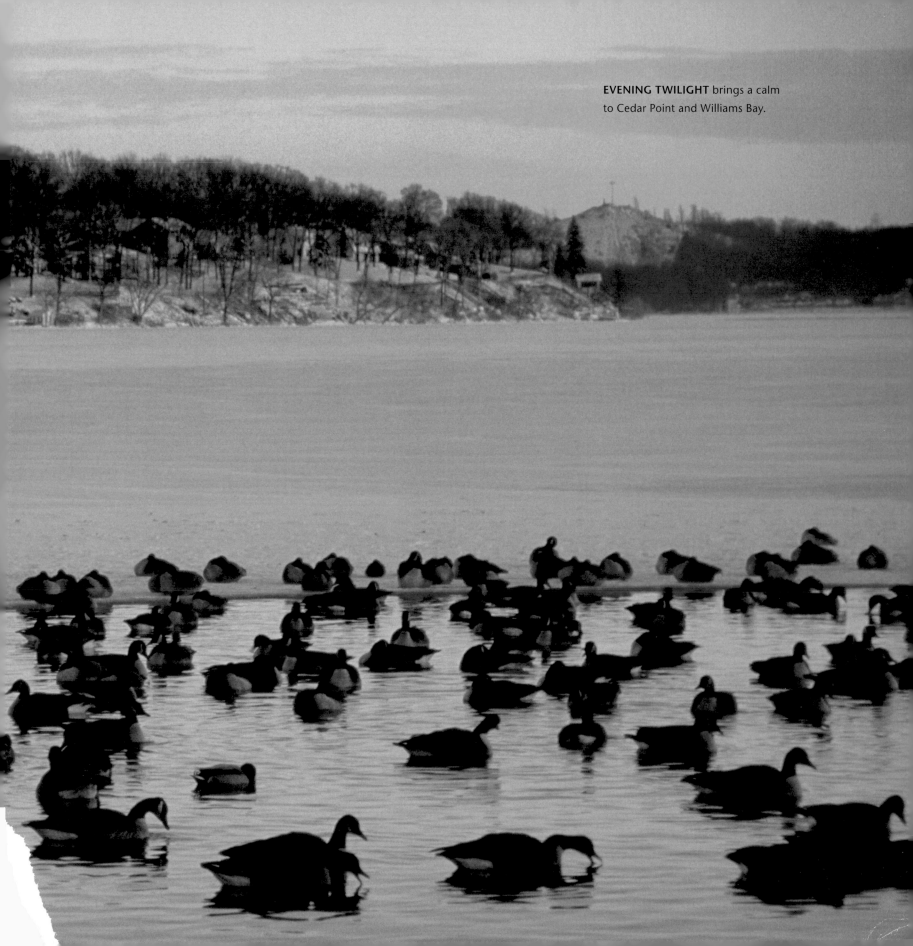

EVENING TWILIGHT brings a calm to Cedar Point and Williams Bay.

CONTRIBUTORS

Now based in Brooklyn, New York, photographer **THOMAS HAND KEEFE** grew up beside the lake. He developed a serious interest in photography while attending The Hotchkiss School in Connecticut, and became even more involved while studying at The School of the Museum of Fine Arts in Boston. These days, Tom shoots portraits and band photography in New York, but during the summer of 2005, he roved the Geneva Lake area with camera in hand—by ultralight and by boat as well as on foot. This book features the results. To see more of Tom's work, visit www.thomashandkeefe.com.

Nature photographer **KRISTEN WESTLAKE** moved here from Milwaukee in 1999, bringing herself closer to her wild subjects. Though she recently established a studio in Lake Geneva, she admits she's seldom there—she'd rather be outside. In this book, Kristen's work appears most prominently in the chapter "Clear Waters." You can see more of her photos in publications such as *Wisconsin Trails* and at www.kristenwestlake.com.

Formerly a photographer and studio manager for *Playboy* magazine, **BILL FRANTZ** moved to the area in 1978, after he married a Playboy Club "Bunny Mother" (now the mother of his two children). Bill was raised in Illinois and attended the Art Institute of Chicago. Today he has a studio in Delavan, Wisconsin, and his work spans the gamut from outdoor photography to wedding portraits to corporate advertising. Learn more about Bill at www.frantzphoto.com.

Architectural photographer **JON JANZEN** has deep ties to the lake—his family has lived here since the 1890s, and he grew up on the west end. Now a Williams Bay resident, Jon travels the country shooting locations for architects, builders, and publications such as *Countryside* magazine. His work is prominently featured in the "Homes & Havens" section of this book. "It was a real thrill to photograph homes that I've admired all my life," he says.

PHOTOGRAPHY CREDITS

Cover
Thomas H. Keefe

Front Matter
Pages 1-4: Thomas H. Keefe
Page 5: Photography Plus
Pages 6-9: Thomas H. Keefe

Introduction
Pages 10-11: Thomas H. Keefe
Page 13: Kristen Westlake

I: ECHOES OF THE PAST
Pages 14-15: Wisconsin Historical Society (WHi-1800)

Beginnings
Page 16: Wisconsin Historical Society (WHi-36482)
Page 17: Arthur B. Jensen Collection
Page 18: Aurora University
Page 19: Arthur B. Jensen Collection (top), Wisconsin Historical Society (bottom; WHi-26015)
Page 20: Wisconsin Historical Society (WHi-12422)
Pages 21-22: Keefe Postcard Collection
Page 23: Geneva Lake Museum (top), Yerkes Observatory (bottom)

Dungeons & Bunnies
Page 24: Reproduced by special permission of *Playboy* magazine, copyright © 1969 by Playboy. Photo by Dwight Hooker.
Page 26: Bill Frantz
Page 27: Thomas H. Keefe
Pages 28-29: Bill Frantz
Pages 30-31: Thomas H. Keefe

II: THE LURE OF THE LAKE
Pages 32-33: Kristen Westlake

Clear Waters
Page 34: Thomas H. Keefe
Page 36: Thomas H. Keefe (bottom), Kristen Westlake (top)
Pages 37: Kristen Westlake
Pages 38-39: Bruce Thompson
Pages 40-41: Kristen Westlake
Page 42: Bruce Thompson
Pages 43-45: Kristen Westlake

About Town
Page 46: Thomas H. Keefe (top)
Page 47: Kristen Westlake
Page 48: Thomas H. Keefe
Page 49: Clint Farlinger (top), Thomas H. Keefe (bottom left, bottom right)
Page 50: Jon Janzen (top left, bottom), Thomas H. Keefe (top right)
Page 51: Bill Frantz
Pages 52-53: Thomas H. Keefe
Page 54: Aurora University
Page 55: Clint Farlinger (bottom, middle), Keefe Postcard Collection (top)
Pages 56-57: Bruce Thompson

Exploring the Shore
Page 59: Clint Farlinger
Page 60: Thomas H. Keefe
Page 61: Clint Farlinger
Page 62: Covenant Harbor Bible Camp
Page 63: Clint Farlinger (top left), Thomas H. Keefe (top right, bottom)

III: HOMES & HAVENS
Page 64-65: Jon Janzen

Stone Manor
Pages 66-67: Clint Farlinger
Pages 68-69: Jon Janzen
Page 70: Jon Janzen (bottom), Thomas H. Keefe (top)
Pages 71-73: Jon Janzen
Pages 74-75: Bruce Thompson

Black Point
Page 76: Thomas H. Keefe
Pages 78-81: Bruce Thompson

Loramoor
Pages 82-83: Jon Janzen
Page 84: Thomas H. Keefe
Page 85: Jon Janzen, 1904 photo courtesy of Joe and Marie Martin

Swinghurst
Page 86: Thomas H. Keefe
Page 87: Bruce Thompson
Page 88: Jon Janzen
Page 89: Jon Janzen (top), Thomas H. Keefe (bottom)
Pages 90-91: Bruce Thompson

Based in Iowa, **CLINT FARLINGER** photographs the beauty of the outdoors extensively in the Midwest and throughout the United States, including the national parks. His photos have appeared in National Geographic books, numerous calendars, and such magazines as *Midwest Living, Outdoor Photographer, Shutterbug,* and *At The Lake.* Learn more about Clint's photographs at www.agpix.com/farlinger.

BRUCE THOMPSON has traveled extensively during his 30-year career in fine art and commercial photography, but his favorite setting lies just beyond the doorstep of his Fontana home. His work has been featured in such publications as *Midwest Living, National Geographic,* and *Gentlemen's Quarterly (GQ),* and he is the principal photographer for the book *Grand and Glorious: Classic Boats of Lake Geneva.* Bruce is the son of Impressionist painter Richard Earl Thompson, who sparked Bruce's own passion for art. To learn more, visit www.thompsonsfineart.com.

TERRY MAYER studied photography at UW-Madison before taking a job with *The Week,* a newspaper covering Lake Geneva and Walworth County. His photos have earned first-place awards from the Wisconsin News Association and the Wisconsin News Photographer Association. Terry makes his home in Genoa City, Wisconsin, with his wife, Robyn—also his partner in Terra Photography.

Originally from Michigan, graphic designer **ALISON MACKEY** has lived in Wisconsin since 1990. She currently works for Kalmbach Publishing in Waukesha, where she directs photo shoots and designs *Art Jewelry* magazine. Previously she was a multimedia designer for a private agency, and an art director for a Milwaukee-based nonprofit magazine written by and for inner city teens. Alison had never seen Lake Geneva before she began work on this project, but after several visits and hours spent poring over photography, she says, "Maybe I'll give tours on the shore path now."

A freelance writer and editor, **ANDRIA HAYDAY** wrote the text for the book and shepherded its layout and production. She once developed fantasy game-worlds as a creative director for TSR. Today she writes about a wide range of topics, including design and architecture. She is the author of *Adding Character,* a Better Homes & Gardens book, as well as lifestyle features for magazines such as *Midwest Living.* She and her husband live in Lake Geneva year-round.